雕
鲁
水
轻

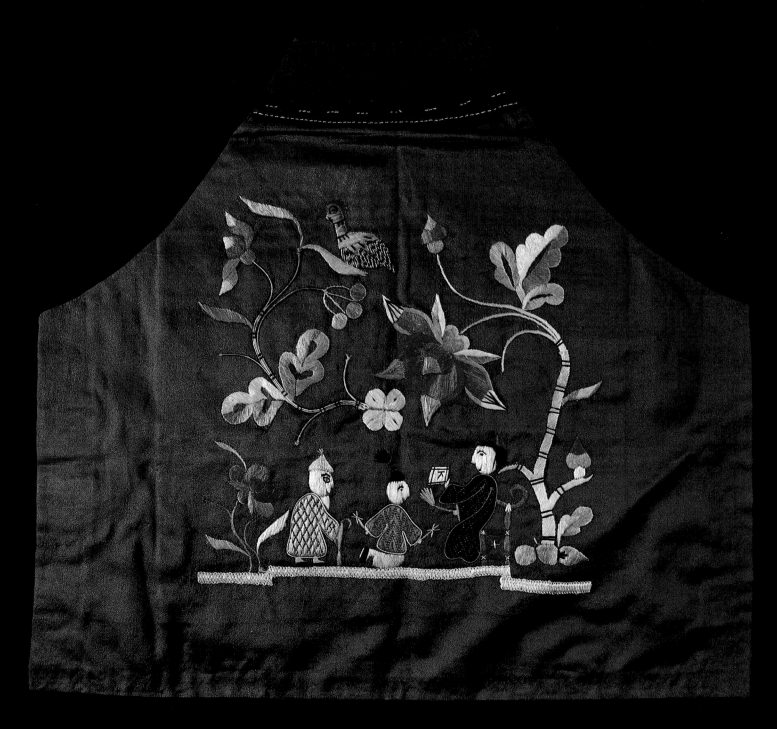

*Child's embroidered apron showing scene from
"The Third Wife Teaches the Son." Shaanxi
Province. 11" × 10".*

Nancy Zeng Berliner

Chinese Folk Art

The Small Skills of Carving Insects

A New York Graphic Society Book
Little, Brown and Company Boston

Give birth to a boy,

you want a good one,

who'll wear

blue robes

and a cap [of an official],

Raise a girl

and you want

a clever [skillful] one,

like a pomegranate

and a peony

First edition

Library of Congress Cataloging-in-Publication Data
Berliner, Nancy Zeng, 1958–
 Chinese folk art : the small skills of carving insects.

 "A New York Graphic Society book."
 Bibliography: p.
 Includes index.
 1. Folk art — China. I. Title.
NK1068.B47 1987 745'.0951 86-15215
ISBN 0-8212-16515-5

New York Graphic Society books are published by
Little, Brown and Company (Inc.).
Published simultaneously in Canada by
Little, Brown & Company (Canada) Limited.

PRINTED IN JAPAN

Map (page 16) by d'Art Studio.

Designed by Shepard/Quraeshi Associates

In the interest of the book design, certain of
the papercuts have been reproduced in
colors different from the original art.

Contents

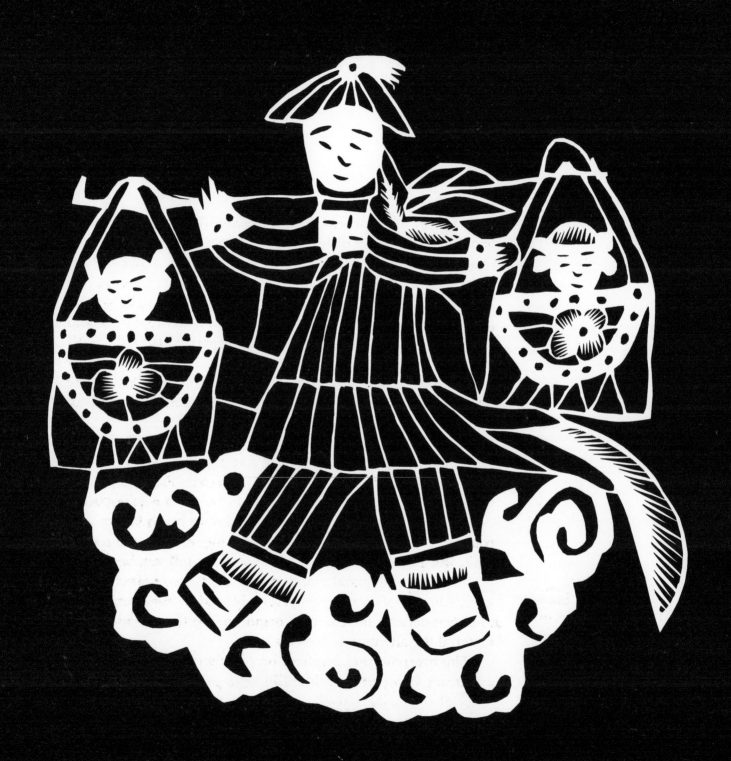

Foreword

By John M. Rosenfield, Abby Aldrich Rockefeller Professor of Oriental Arts, Harvard University

Fig. 1. Papercut illustrating a scene from "The Cowherd and the Weaving Maiden," when the cowherd takes his two children on their annual visit to see their mother in the heavens. Using a pole with baskets at either end to carry things is common in the country-side. Shandong Province. 6" × 6".

Made by peasants and the urban poor, the handicrafts discussed in this book are remarkably different in character from the luxurious furnishings that visitors see in the Beijing Imperial Palace: embroidered silk robes and intricately carved jades, enameled cloisonné vases and huge porcelain jars. The visitor might even wonder whether Chinese courtly arts and the simple woodblock prints and papercuts in this book were produced in the same nation, so great was the gulf that separated the culture of China's rulers from that of the common people. In fact, the profoundly evocative subtitle of this book was taken by the author, Nancy Zeng Berliner, from a term of contempt used by the Chinese upper classes to refer to the arts of the unlettered and lowly.

China, until the social and political upheavals that began early in this century, was highly elitist in its culture. The nation's ruling classes viewed peasant life with disdain and neither collected village handicrafts nor praised them. The old intelligentsia, the so-called *wenren* (literati), might admire natural and unpretentious objects—a brush holder made from rough bamboo, for example, or a grouping of miniature rocks to adorn a desk. But the *wenren* showed little interest in folk art, because it lacked philosophic content and moral edification. Unrecognized by arbiters of taste, China's folk art remained largely hidden from public view, and only in recent decades has the West begun to give this extraordinary body of material the attention it deserves.

The overpowering emphasis on courtly values in Chinese taste seems something of a paradox, since China, in principle, was the most democratic of the major nations of premodern Asia. A farmer's son, after passing civil service examinations, could aspire to a career as a government official and rise to high position at court. A virtuous general of humble origins might even receive the mandate of heaven and rule as emperor.

The attractive possibility of moving upward in society may well have inspired ambitious youths to master the complex classical language and customs of the court. Nothing encouraged these youths to bring rural handicrafts to the palaces of Beijing.

Earlier in Chinese history, however, there had been more lively cultural exchanges between palace and countryside. The Northern Song court collected long narrative scrolls that illustrated regional folk tales. Taoist legends were illustrated by Southern Song painters. The *ci* form of poetry, popular in Tang and especially Song times, brought colloquial language and popular themes into serious literature. Vernacular fiction flourished in the Yuan and Ming periods. The Manchu nobility, who ruled as the Qing dynasty from 1644 until 1911, were less inclined to concern themselves with plebeian culture. As foreigners of seminomadic origins, they were bedazzled by the splendors of the vast Ming court establishment and eager to assert the opulence of imperial rule.

In premodern Japan, by contrast, the educated classes favored the use of rustic objects in their daily lives and especially in the tea ceremony—pottery jars and bowls, iron kettles, lacquer trays, and bamboo vases. From the 1600s onward, folk art workshops flourished throughout Japan, their artisans seeking consciously to please their sophisticated customers. The Japanese sympathy for rustic arts was largely rooted in Zen Buddhism, which had originally come from Song China in the thirteenth century. This taste for naturalness and simplicity, however, survived far longer in Japan than in its homeland, and Chinese village artisans of late Ming and Qing periods, having no such clientele among the wealthy, worked primarily for humble patrons.

Obviously the term "folk art" refers to a great range of materials and bears different nuances of meaning. Some forms of folk art are strictly utilitarian—baskets, for example, or storage boxes given a touch of extra refinement or detail. Some are ornamental, as in architectural decorations or textile design. Others have a religious function: votive images or protective amulets. Some are made by specialized artisans such as potters or blacksmiths; others are done as a pastime—embroidery made by farmers' wives during winter months. Folk arts tend to be restrained and simple in technique. If the materials exceed a nominal cost and the techniques of production become extremely sophisticated, the result is a luxury item, not a work of folk art.

Sociological in origin is the one characteristic that distinguishes folk art from all other cognate forms, such as primitive art and popular art. Folk art is made only in a society that has (or once had) a highly sophisticated

artistic culture with advanced technology, and it is made only by population groups who are themselves isolated or remote from that culture — villagers in the distant countryside, the most submerged of the urban lower classes, or the descendants of a vanished but dimly remembered high culture. Even though folk arts usually express a local or parochial viewpoint, they often contain simplified reflections of motifs and forms taken from the high culture (in the royal palace or the great religious sanctuary) that lies on the far horizon or in the distant past.

The chief value of folk art in the modern world, according to Aldous Huxley, is the expression of social and psychological stability.[1] Folk artists have modest goals; they seek neither great originality nor the expression of their egos. They employ techniques and motifs that have been handed down virtually unchanged from generation to generation. They work for family members or neighbors, not for distant clients or impersonal organizations. Their artworks remain part of their daily lives and are imbued with a sense of wholesome pleasure and satisfaction, or so they appear to outsiders.

Admiration for primitive, naive, and folk arts is one of the foundations of modernist and liberal thought in the West. From the late eighteenth century onward, major poets, composers, and painters have sought inspiration in the arts of less highly trained and less urbanized cultures; and museums and private collectors have followed their lead. Gypsy songs or Italian street tunes appear in the compositions of Mozart, for example, or Brahms, Liszt, or Bartók. Romantic poetry celebrates the innocence of children and primitive tribesmen. The flat two-dimensionality in the paintings of Gauguin or Bonnard or Klee came from sources independent of academic Renaissance art. Cubism proclaimed its debt to African sculpture. Artifacts of tribal Africa, Oceania, and the Americas are shown in art museums from Budapest to Portland, Oregon; so also are the paintings of Henri Rousseau and Grandma Moses.

The romantic movement holds that people whose lives are "simple" enjoy a privileged state of being close to nature, the source of romantic truth. Their music and art are said to possess a primal vitality not found among those whose senses have been dulled by overeducation and artifice. Notions about the expressive values of primitive art flowered as early as the eighteenth century, and even though modern anthropology has dispelled many of the old illusions about the nobility of savage life, the ideals are still very much alive, firmly implanted in modern art by the expressionist, cubist, and constructivist schools.[2] Socialist and democratic political theory expresses great concern for the lower strata of society, which are

the ultimate sources and beneficiaries of state power.

For the past century and a half, groups seeking to preserve and study folk arts have appeared all over the world. The Arts and Crafts movement in England, led by John Ruskin and William Morris, sought to counter the ugliness and uniformity of the industrial age by encouraging traditional handicrafts. In 1857, what is now the Victoria and Albert Museum in London was opened to display huge and cosmopolitan collections of decorative and applied arts. Museums with similar intentions were founded throughout the British Empire—the Indian Museum in Calcutta, for example, as well as those in Lahore, Bombay, Madras, and Singapore.

In Japan, the movement to preserve and study folk arts (*mingei*) started at the turn of the century and soon became a powerful and enduring feature of Japanese cultural life. The critic Yanagi Sōetsu made contact with like-minded Westerners, notably Bernard Leach in England and Langdon Warner in the United States, and founded in 1936 a folk crafts museum in Tokyo to exhibit Asian handicrafts and stimulate the work of young artisans. As Japan became increasingly industrialized, however, the *mingei* movement lost its roots in village life and became a stylistic idiom adopted by well-trained art students. Today, most contemporary Japanese *mingei* have the formal traits of folk art but lack its naiveté.

In China, interest in folk literature, music, and art was particularly strong among leftists of the 1930s. Sympathetic artists and writers fanned out through the countryside to record and collect the nation's folk culture in hopes of creating a new, more democratic society. The goals of this movement were outlined by the Communist critic Chen Duxiu, then dean of the college of letters of Peking University. Chen stated that he and his colleagues wished to destroy China's aristocratic culture and the stereotyped literature of the old classics. He denounced the traditional *wenren* as pedantic and unintelligible hermits; and he called for a new culture that reflected the plain and simple ways of the common people.[3]

Mao Zedong expressed many of the same ideals in a speech at the Yan'an Forum on Literature and Art in May 1942. He stated that as a youth he once believed that intellectuals were the only clean people in the world and that workers and peasants were dirty; he later, of course, completely reversed this opinion. He urged that artists and writers learn the thoughts and feelings of the masses so that their works would be intelligible to them, for "the life of the people is a mine of raw materials for literature and art . . . , materials that are crude, but most vital, rich and fundamental. They are the only source, for there can be no other."[4]

Mao further instructed artists to take the raw material of folk art and

shape it into an ideological form that would serve the interests of the masses. This is precisely what occurred after he came to power in 1949, for despite his regime's populist ideals, it imposed ruling class values on China's folk culture. Traditional shadow puppets and woodblock prints were used for political propaganda. An iconography of heroic leftist themes replaced the old symbolic system of good fortune and prosperity that Nancy Zeng Berliner explains so vividly in this work. Folk dances were converted into highly artificial theatrical events. Further harm was caused in the 1960s by the chaotic frenzies of the Cultural Revolution, which tried either to use folk arts for propaganda or else to exterminate them as relics of the corrupt past. That folk art traditions survived at all is evidence of the depth and tenacity of China's peasant and plebeian culture —and of the poverty and isolation of thousands of villages that kept them firmly rooted in the past.

Throughout the world, traditional folk arts and handicrafts are rapidly disappearing, even where concerted efforts are made to preserve them. Folk arts may be able to resist political pressures, but they are much more vulnerable to industrialization and the growth of huge cities. Cheap plastic bowls displace handmade pottery; young people rarely have the patience and mind-set needed to weave fine bamboo baskets; children who might have continued a hereditary village handicraft seek a more glamorous life in the city. It is possible to see new forms of folk art appearing as decoration on trucks, for example, or shop signs. And urban dwellers are turning to pottery and other handicrafts for recreation, but the social environment for the kind of folk art shown in this book is becoming increasingly rare.

The material that Nancy Berliner and her husband, Zeng Xiaojun, have uncovered and present here is of incalculable value. As the most thorough study yet made in a Western language, this volume will greatly enrich the world's perception of the beauty and variety of Chinese folk art and the distinctive social climate in which it is made. Compiled as China stands on the brink of vast economic and social changes, this is a document of the artistic sensibilities and visual imagination of some of the most witty, attractive, and long-suffering of all people, the ordinary Chinese man and woman.

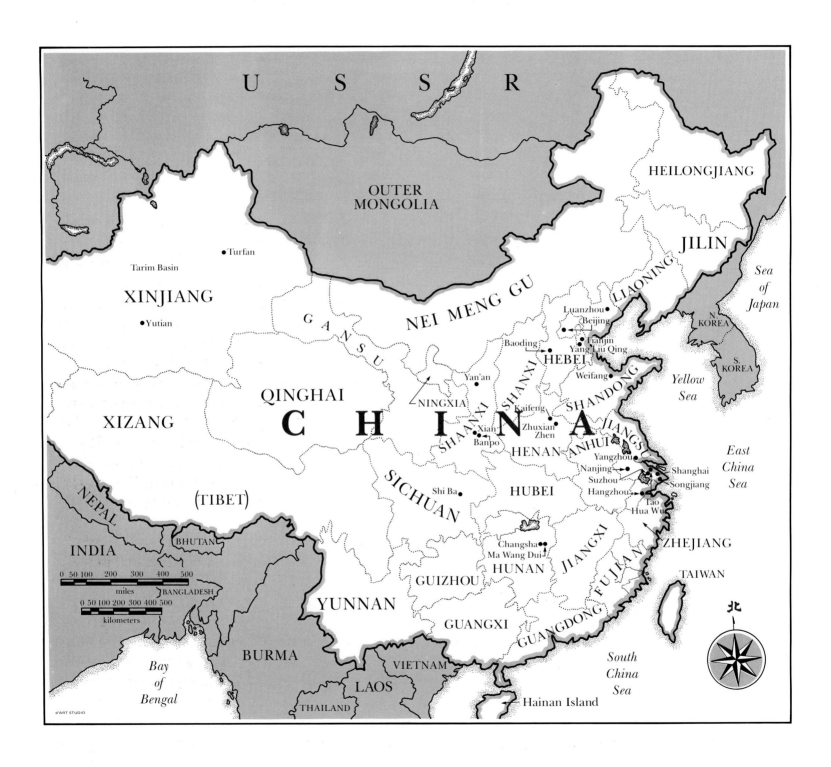

Preface

During the summer of 1983, my husband and I traveled from Sichuan's provincial capital of Chengdu for two days by train and another day by bus; we then hiked for an hour over hills, across streams, through one village and then a second before we reached Shi Ba, my mother-in-law's ancestral home. The town consisted of a courtyard compound. Within a few hours, the whole one-hundred-person population (only one of whom had ever been to Beijing) knew who we were. They all gathered in one home to greet us; all claimed to be our relatives and insisted on calling us Aunt and Uncle. We stayed for almost a week in the two-room mud house. It had a dirt floor, and a single one-foot-square window and a tiny hole in the ceiling to let in light by day, while oil lamps were used at night. The five members of the family slept in two beds; the pigs slept below the house. The source of water was a small stream down the hill from the houses, and water had to be carried up in buckets. The villagers were fascinated by our bottle opener, the likes of which they had never seen before.

We explained to these villagers that we were interested in folk art. Their faces went blank, and they said they had nothing like that in their area. Papercuts, embroidery . . . we thought of every expression used to denote such objects in Chinese. They shook their heads.

As the days went by and we felt more comfortable, we looked around the small, sparse homes. Aging wooden cabinets held old porcelain bowls. In several homes, the only furniture besides a table, a bench, and a bed was a coffin. On the walls of all the homes were fading posters of Mao, Hua Guofeng, and other leaders. One day, a cousin mentioned that in the past they had had wooden decorations on their roofs but had been forced to take them down during the Cultural Revolution (1966–76) because they

十七 | 17

were considered, like all things old, feudalist. It seemed as if folk art had been wiped out in this little town.

We were preparing to leave Shi Ba, disappointed that we had found no folk art, when I noticed a child's cap hanging out to dry. Made of white cotton, it had a few stitches of embroidery on it and two decorative ears sewn on. When I explained excitedly to the occupant of the house that this was what we had been seeking, she dragged me into her home. Sitting in the darkness, on an old trestle bed between two posts carved in the shape of fishes, was a young girl with needle in hand embroidering a white cotton cloth. It was to be part of her dowry. Out of a wooden storage chest her mother pulled a completed work. It was unlike any embroidery I had ever seen in China. Instead of glossy silk with minute colored stitching, this was a piece of off-white cotton with rough cross-stitches of black cotton thread forming geometric, flowerlike patterns. The old woman did not give me time to study the work before she pushed me into another home. There on the ground lay two striking embroidered innersoles (Fig. 175). Again, the design was dissimilar to any embroideries I had encountered previously in my study and travel throughout China. To my delight, this woman took me from house to house, digging out innersoles and embroidered flat fabrics meant as covers for the long cylindrical Chinese pillows. The villagers considered us extremely strange to be interested in such objects, which were as common to them as a bottle opener was to us. Nor had they ever associated the word "art" or even "embroidery" with these works.

The trip to Sichuan was not the first occasion on which we had come across such a situation. My husband, Xiaojun, had begun collecting and studying Chinese folk art while he was in college at the Central Academy of Arts and Crafts in Beijing. He was able to visit villages from Beijing to Xian on a cross-country bicycle trip in 1981. Going from house to house, using money his friends had generously donated to his research, he amassed an enormous amount of artwork—papercuts, embroideries, woodblock prints, and shadow puppets. These objects consequently lured me from my own studies of Chinese art and religion into the world of folk art. For so long, no one had thought of these works as art. It was an aesthetic concept, I discovered, foreign to most scholars of Chinese art and even to many Chinese people. Since Xiaojun and I met in Beijing in 1982, we have continued to research the history, origins, and varieties of Chinese folk art, an effort that has come to fruition in this book.

In our studies, we have gathered together works from many areas of the Chinese countryside. The majority originated in the provinces of Shaanxi, Shanxi, Hebei, Henan, Shandong, Sichuan, and Jiangsu — regions that have long been known for their village crafts and in which the folk arts still flourish. Moreover, these areas constituted ancient China's cultural and economic centers from the beginning of the eleventh century B.C. to the Qing dynasty (1644–1911) and are where the Han people (as the Chinese distinguished themselves from the other fifty-two minority nationalities inhabiting the country) reside.

We decided to examine those Chinese folk arts that are characterized by the longest artistic development and are to this day an integral part of the spiritual lives of the peasants. Hence, we have chosen to focus upon papercuts, shadow puppets, embroidery, dye-resist printed cloth, and woodblock prints. Many other articles are produced in the villages — clay toys and whistles, dough figures, furniture, and fanciful cake molds — but they have not reached the heights of development the other media have and are not as individualistic because of their mass production by centralized workshops. The pieces we offer here represent not only fine examples of the various techniques but also excellent illustrations of the symbols and legends that have been passed down for centuries.

The joys we have experienced in collecting and studying these artworks are immeasurable; we hope that through this book and the accompanying exhibition we will be able to share their beauty. In our endeavors, innumerable people have assisted and inspired us. Among them: the many women and men who gave their hearts and souls in creating the works of art shown on these pages; the late Teng Fengqian of the Central Academy of Arts and Crafts, who dedicated his life to collecting and researching papercuts; Professor Bo Songnian of the Central Academy of Fine Arts in Beijing; photographers Richard Stafford and Steve Burger; Zhu Chuanrong, Cheng Lian, and David Chien, all of whom contributed their efforts to our collecting; John M. Rosenfield, who offered his time and energy to inspire and enrich the project; Mary Gardner Neill, who confidently put the exhibition on its feet; John H. Bowles, who gave his constant encouragement; the Harvard-Yenching Library; Terry Hackford, whose enthusiasm allowed this book to be possible; and our parents, two in Beijing and two in Boston, all of whom trusted that the dusty, often dirty pieces of cloth and leather in our overflowing suitcases would one day be able to properly display their grace.

Chinese Folk Art

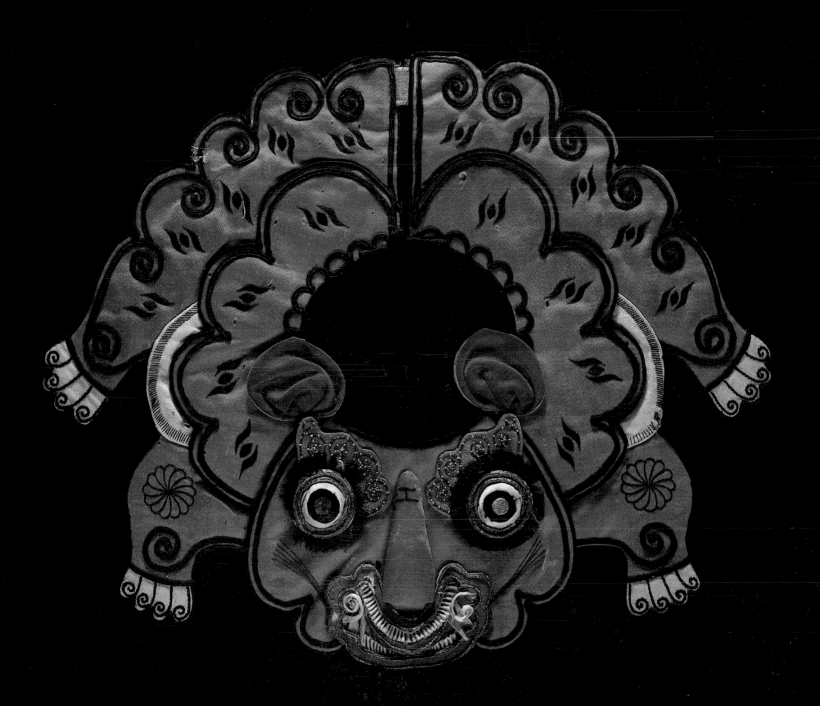

Introduction

Though the mud-brick walls of a villager's home may be crumbling, at New Year's season, fresh woodblock prints of door gods in all their colorful armor brighten the entrance. Above the doorway hang red "money hangings," *guaqian*, papercut designs expressing wishes for good fortune. The paper windows—freshly pasted up on the wooden lattice frames— are covered with more papercuts depicting immortals, legendary heroes, peaches of immortality, pomegranates for fertility, coins of prosperity, chickens, buffalo, and *qilin*, the legendary creatures who bring noble sons to heirless families. Inside the rural home, a woodblock print of the Kitchen God and his wife—who have been, as the Chinese say, invited in —is pasted above the stove so the god can keep watch over the daily activities of the family. Pillows with embroidery illustrating tales known to all are scattered on the *kang*, the brick bed connected by flues to the kitchen stove where the family spends most of its leisure time during the winter months. Children run about wearing splendid embroidered tiger hats and shoes intended to keep evil spirits away from their young, susceptible bodies.

Without such enchanting designs and colors, the smells of baked goods, the chance to eat meat and other treats, the excitement of firecrackers, and all the celebration of the New Year Festival—without all this, the cold, grim Chinese winter might be unbearable. For centuries the New Year Festival, which lasts fifteen days and is also called Spring Festival even though it takes place in the dead of winter, has encouraged the people to endure until the warmth of spring returns. The papercuts, embroideries, and woodblock prints all ensure that the spring will be fruitful, children healthy, and descendants many and prosperous.

This book serves to introduce the art that decorates the homes of the rural, common Han Chinese. The Han people make up 94 percent of the

Fig. 2. Child's tiger collar. Mothers throughout China create collars, hats, and shoes decorated with tigers to protect their children from evil spirits. The tiger, believed to be particularly powerful in warding off dangers, is often represented in folk art. Hebei Province. 10″ × 11½″.

country's population; the term excludes the fifty-two ethnic minorities, such as Tibetans, Manchurians, and Mongolians, who live within the same borders and whose folk art has been much discussed elsewhere. The common people are referred to in modern Chinese texts as the peasants, or the *lao bai xing,* "the old one hundred surnames." They are the people who, according to contemporary statistics, constitute 80 percent of the country's people today; in the past they represented an even greater proportion. In classical Chinese social theory, since the Han dynasty (206 B.C.–A.D. 220) society was divided into four hierarchically ranked classes: *shi, nong, gong,* and *shang,* the scholar-officials, the peasants, the craftsmen, and the merchants. The peasants, though they were often poorer than the merchants and the craftsmen, were to be more respected because they worked the land, providing the people with food. Nevertheless, there were regulations that clearly separated the peasants from their rulers and eventually prompted an insular culture. In pre-Han times, common people could only wear the rawest of silks and were not allowed to wear colored clothing. These rules were loosened at the end of the Han period, but even then families with just one merchant were restricted from wearing various types of silks and embroidered clothes. Regulations such as these existed to an extent through the Ming dynasty (1368–1644).

Despite the strict categorizing of classes and people, there existed (until 1927) the great equalizer: the examination system, which allowed any who so desired to try to qualify for the position of official through an examination. Though few peasants could ever obtain the schooling necessary to pass the exam, a few did succeed, giving all peasants the hope that they, too, could eventually rise and prosper. Figure 4, a woodblock print, depicts such a character, Bao Gong, who in the Song dynasty (960–1279) rose to be a minister of state. Hanging in a peasant household, it instills ambition in and perhaps even imparts some luck to the younger generation. This piece, like much of folk art, reflects hopes for the future.

In pre-twentieth-century times, the imperial household and officials' families would hire artisans to make ornaments for their homes. Finely glazed porcelains, carved hardwood furniture, glossy lacquer ware, and elaborately embroidered tapestries, made by superb craftsmen, along with scrolls of calligraphy and brush paintings contributed to the grand atmosphere in the halls of the well-to-do, who could afford to commission such works. The decorative objects in common people's homes were made by the families themselves. In creating their art, they would make do with materials both available and as inexpensive as possible. Unlike the court artisans, who employed only the finest of silks, golds, inks, and pigments,

Fig. 3. Papercut of a figure being carried by two others in a sedan chair. The piece is done in the wonderfully simple but expressive style of northern Shaanxi Province. 6″ × 4½″.

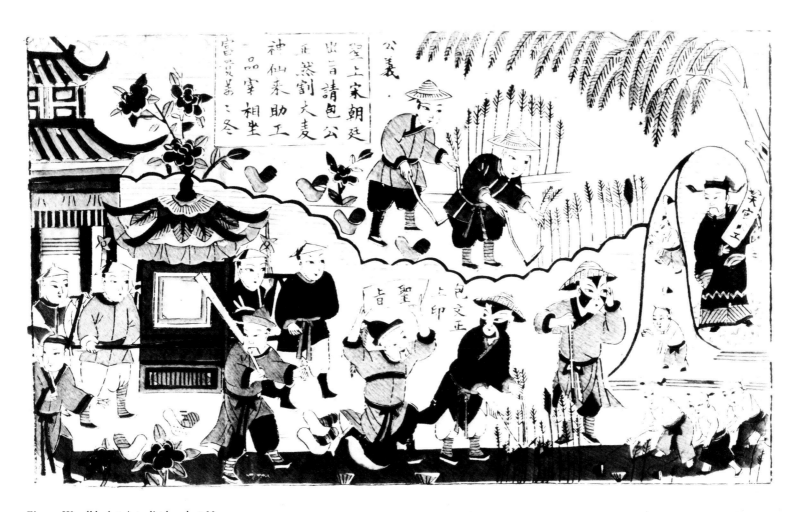

Fig. 4. Woodblock print, displayed at New Year's time, portraying the tale of Bao Gong, a Song dynasty peasant who rose to the rank of prime minister. In this scene, the emperor's representatives come to invite Bao Gong to serve at court. Scattered among the wheat are gold ingots, showing that the poor man will soon be reaping riches. A note at the top of the picture says that such an event was the result of assistance by a deity. Shandong Province.
9½" × 16½".

the peasants would use homespun cotton, rough knives and scissors, wood, and local dyes. Women, in their spare time between cooking and farming tasks, would cut images from paper to adorn their walls and windows, or embroider gaily colored children's hats for special occasions and pillows to spruce up the family bed. These objects were not intended for sale, and so those who made them were rarely concerned with perfection, which the artisans employed by the wealthy strove for.

The highest forms of art among the scholar-official class were those of the brush—calligraphy and landscape painting. The peasants, though, mostly illiterate, had no need for the brush. Scissors and knives were more essential to the lives of the farmer and his wife, who made the family's clothes. Therefore, those utensils came to shape folk art. Snipping away areas of bright red papers to fashion animals and people, carving wood to print images and creatures of good luck, and cutting leather into figures to make puppets who would act out favorite ancient tales—in this way the peasants developed their own art forms. The wealthy classes, scoffing at such cutting, snipping, and carving to create what they thought to be trifling objects of insignificant content, compared with calligraphy and landscapes, referred to the folk arts as *diao chong xiao ji,* "the small skills of carving insects." Ironically, this appellation conjures up one of the popular motifs of Chinese folk art: the grasshopper, which symbolizes the ability to rise from the peasantry to the heights of the scholar-official class.

The development of the folk arts occurred over a span of more than a thousand years; they began to flourish during the healthy economy of the Song dynasty, when more materials (such as paper, scissors, and dyes) became more affordable to the lower classes. During the subsequent Ming and Qing dynasties, the arts among the peasants matured. Most of the objects in our collection date from the Qing dynasty (1644–1911); a few are earlier, and some are as recent as the 1980s. Because individual creativity among the village people was never an important aspect of their work, most have copied with only slight improvisation the examples mothers and grandmothers have handed down to them. Hence, even the most recent pieces follow the old traditions and give a clear impression of what the earlier objects were like. On the basis of our study of those works that have survived in museums and private collections, it is indeed clear that styles and forms have not changed radically. Regional styles persevere, and we can assume that the objects seen today have much in common with those of a dynasty or two ago.

Works of folk art can be appreciated and can stand on their own as objects of art, but to be understood, they must be seen as part of a larger

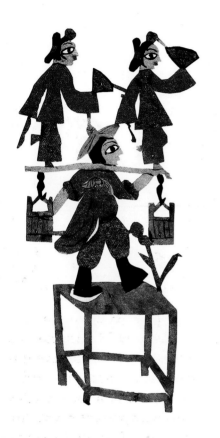

Fig. 5. Colored papercut of acrobats made by a woman for her wedding day. The coloring and line drawing are done after the white paper shape has been completely cut out. Southern Shaanxi Province. 5½" high.

新禩 朱禩 忌都 般神 紫百 罷香 地下 全天 悄過 絨綠 丹紅 對聯 神買 請門 幾聯 子揚 好画 振年 裡製 科有

Fig. 6. Woodblock print of a family preparing for New Year's celebration. The writing above the image speaks of inviting in the door gods and buying dui lian, the couplets hung on either side of the entrance. On the altar table, where the ancestors will be worshipped, are food, including a fish—essential at New Year's since it is a homonym for the word "plenty"—and incense. At the left side a child holds a string of firecrackers. To the right, floating in the clouds, the heavenly official sends down to the family, according to the sign he holds, fortune in the form of pigs. The picture perfectly reflects the gaiety and the wishes for prosperity and fortune that are so much part of the New Year's celebration in the villages. Weifang County, Shandong Province. 9½" × 16½".

tradition—a religion and a belief system. The complex belief system of rural Chinese society encompasses Taoism, Buddhism, and Confucianism, and includes a fantastic spirit world where immortals and mortals eventually reside side by side. There is constant communication between earth and heaven, between the carnal and the ethereal. Spirits and their earthly counterparts frequently assist each other. Humans may present spirits (including those of their ancestors) with food, money, and fragrant incense—all necessary for the good life above—in return for favors and the spirits' intervention in arduous worldly affairs. A young woman, for instance, might beseech a spirit to send her a male child in exchange for offerings. She might also make a papercut in the form of a pomegranate, which, with its many seeds, represents fertility and might influence the winds of fate. Other pieces of folk art state appeals for different kinds of good luck, using the shape of a gold coin, for example, to express the artist's hope for prosperity. Over the centuries, numerous symbols have evolved, representing people's many desires; these symbols are manifest in folk art works.

Just as there exists belief in the spirits, there is also a belief that visual images and symbols can initiate change. Thus, folk art has roles both tangible and intangible: it might brighten and adorn otherwise somber homes

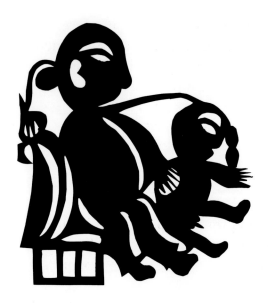

Fig 7. Papercut of a woman with a boy. Northern Shaanxi Province. 4" × 4".

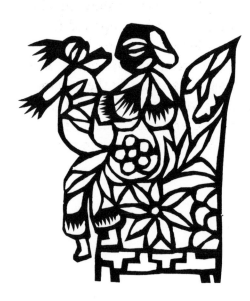

Fig. 8. Papercut of a woman sitting with her child on a chair. Shanxi Province. 3½" × 2".

as well as instill hope or express some other desire, as a tiger cap might both clothe a child and also express a mother's love and her wish to protect her child from evil spirits. In the artist's mind, the aesthetics of the work are inextricably bound with these beliefs and functions.

However, as outside observers or art historians we cannot ignore the aesthetics of these art forms. Is it not this aesthetic that intrigues and attracts us? The naive but intense quality of such folk art, a result of care and passion but not education, gives a powerful beauty to the finest of these works.

For years these arts have gone almost wholly unnoticed in China. Poets here and there, centuries ago, mentioned objects that caught their eye, but rarely did anyone take the time to do either a study or even a detailed appreciation of village people's art. Those that were literate enough to do so were more concerned with classical arts of the brush or ceramics; little else was considered worthy of the name "art," especially work done by a farmer's wife.

During the thirties in China, a certain appreciation for the works did arise, however. Among those working with the revolutionary movements that sympathized with the peasants and advocated their liberation from landlord oppression were artists who discovered the beauty of the artwork being done in the villages. These activists were looking for an art form that would help define their new revolutionary culture; they perceived folk art as the perfect vehicle. Considering its common origins and complete separation from such elite arts as calligraphy and painting, the Communists felt that the folk arts were ideally suited for spreading their own propaganda to the rural peasantry. Some of the artists in Yan'an, the Communists' prerevolution base in northern Shaanxi Province, collected papercuts from the local villagers, published books, and organized exhibitions.[1] Then they began making their own papercuts along political themes, including land reform, the value of education, and gratitude to the Communist leaders. As time went on, theirs became the only papercuts displayed.

Hence, with the Communist revolution the folk arts were transformed in the same way that folklore itself was being transformed. Historian Richard Darson describes the phenomenon as it pertained to folklore in the preface to the book *Folktales of China*: "In one sense, the Chinese Communist use of folk-lore was anti-folklore — in rejecting and rationalizing away the supernatural elements so prominent in folk expression."[2] Like the new stories, the new papercuts not only lacked the spontaneity of the villagers' works, but they grew out of a rejection of the mythical and symbolic tradi-

tions around which the art had grown. A portrait of Mao, for instance, would not evoke the same sentiments or reflect the richness of the Chinese culture and history as would an image of the mischievous Kitchen God. Traditional New Year's pictures depict ancient legendary characters and symbols with potent powers. The new Communist posters tried to evoke some of that power by association in the form of slick prints portraying the new leaders, while at the same time denying that heritage.

The height of the folk arts' destruction, both in essence and literally, came with the Cultural Revolution (1966–76). Determined to create a totally new culture, the leaders, headed by Mao's wife, Jiang Qing, proclaimed a campaign against anything old and traditional. Women burned their papercuts, woodblock printers tossed their blocks into oven fires (if they hadn't already been confiscated), and everyone put up the new posters distributed free at commune headquarters.

When the Cultural Revolution ended in 1976, old women began to bring out bundles of papercut models they had hidden away, shadow puppeteers took out the puppets they had not destroyed, and police returned woodblocks to their rightful owners to continue printing. The desire to create and ornament had not been totally suffocated, nor had the underlying beliefs been abandoned. Gradually, the folk arts have returned to life.

Today, the many modern goods on the market are attracting the eyes of the villagers. Factory-printed cloth, colorful city-printed posters, and even television are slowly becoming more available to the peasants and influencing the appearance of the rural home. The impact of these goods will inevitably result in a decline in folk art, as has already happened in the urban areas and is rapidly occurring in the districts close to cities. Now, during the present era of revival, while the artists are still busily and unself-consciously at work, is the time to appreciate and study these wonderful artworks, which have brightened villagers' homes in China for centuries. The following exploration of some of these arts should serve to enrich understanding of Chinese culture and, moreover, expose to the world its breadth.

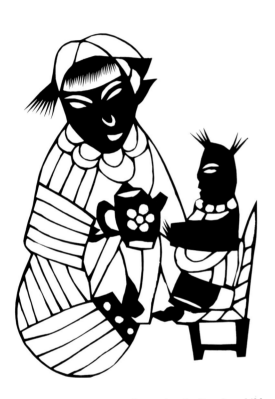

Fig. 9. Papercut of a mother feeding her child. Shandong Province. 4½" × 2½".

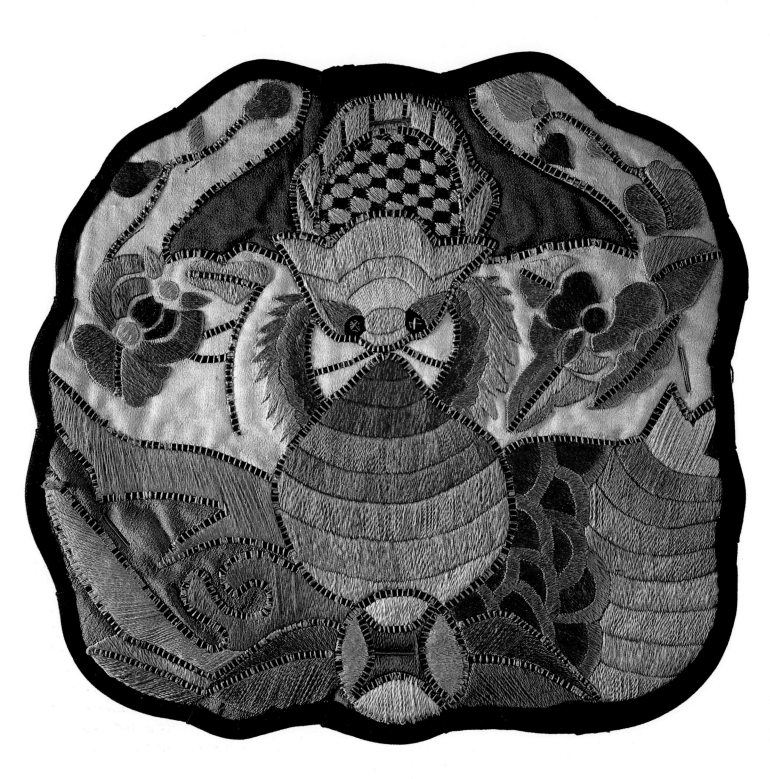

Symbols and Legends

Fig. 10. Embroidered pillow end with a variety of symbols of prosperity, happiness, and longevity. The bat, at the top, represents fu, *good luck; the peach below it is a symbol of longevity. Below the peach is the coin symbol of prosperity. On the left is a* fuo shou, *or Buddha's hand, a citrus fruit that represents wealth because it is said to look like a hand grasping money. The artist has worked into her design a variety of objects and colors that coordinate and balance each other to make a striking piece. Sichuan Province. 7″ × 8″.*

Many of the finest pieces of folk art certainly stand on their own as artworks, but an understanding of the symbolism—the visual vocabulary of which the art is constructed—enriches the appreciation of these objects and the culture that produced them. Among folk artists, symbols are the foundation on which the artworks are built; often aesthetics play only a supporting role. Unlike artists who strive to portray the world around them, the folk artist is describing the traditional ideals of his or her community. To express these concepts, he or she draws upon a vocabulary of symbols handed down by ancestors. To the artists and viewers within the community, the meanings of these symbols are as obvious as words on a signpost. So one who is not a member of the community must first study the definitions of the symbols before even attempting to comment on their execution.

In China, these symbols derive from traditional morals and the legends that have been told over and over to illustrate them; and from the simple hopes of humble people to enjoy to the fullest the few years of life allowed them. The life of a Chinese peasant is toilsome and often bitter, yet still, somehow, most people remain optimistic. When families take the time to celebrate special occasions and enjoy themselves, they create visual images to decorate and commemorate the day and to ensure a more prosperous future. Their art reflects the desires, hopes, and the values of their ideal life rather than depicting the harsher realities of their actual existence. Just as the urban landscape artist in China has traditionally painted mountains and rivers, expressing his desire for the tranquillity of the countryside, the peasant creates works that reflect hopes for long life, wealth, and more fortunate descendants.

To give shape to these desires, the village people portray objects, animals, and tales that have developed over the millennia in China. Court artists during the Han dynasty (206 B.C.–A.D. 220) created objects that often displayed dragons, winged horses, elephants, and other exotic animals in hopes that they would appear—omens of heaven's approval of the current reign.[1] The lower classes must have had the equivalent of such images. Though the specific significance of certain images may have altered over the years, the belief in the power of images seems not to have waned. Folk artists are rarely aware of the origins of many symbols, but the meanings are completely clear to them.

Traditionally, the Chinese have spoken of *fu, lu, shou,* and *xi*—luck, wealth (or officialdom), longevity, and happiness—as the basic ingredients of a happy life. These four aspects of the ideal life form the foundation for the myriad of symbols found throughout Chinese folk art. Symbols have developed to represent these concepts from a variety of sources, including homonyms, legends, and themes that in some way reflect otherwise intangible ideas. The symbol may take the form of a single motif, such as a tiger; generally associated with warding away evil spirits, tigers are often seen on children's clothes, as in Figure 11. Scenes from well-known tales are depicted in the folk arts as emblematic of the whole story and whatever hope it may hold. A scene from the tale of "The Water Seller," for example, as embroidered in Figure 25, would signify the desire for a marriage of love as well as the rise to officialdom, both of which occur in this story.

Many symbols in folk art derive from homonyms, a development perhaps unique to China. Chinese has only four hundred syllables; each syllable constitutes a word and is represented by one character. The language balances this lack of variety in syllables with different pitches, or tones. The same syllable, pronounced with each of the distinct tones, can have four different meanings. However, there are also many words that have the same tone *and* the same syllable but different meanings; for instance, there are at least forty-two words with the sound *yi* in the fourth tone. Most likely, there were originally fewer characters to represent all the words with the same sounds, and more characters developed later to distinguish the words more clearly. Certainly, many artists of the past were illiterate and found words with the same sound even more interchangeable, since they were not aware of any written characters that would differentiate the two. (Though many folk artists today are illiterate, they are capable of rendering certain important characters that themselves appear as decorative patterns in embroidery and papercuts.)

Fig. 11. Papercut of a child sitting on a lotus leaf, symbolizing continuous fertility. The child is wearing an apron with a tiger design, a common piece of clothing for infants in rural areas. Northern Shaanxi Province. 4½" × 6".

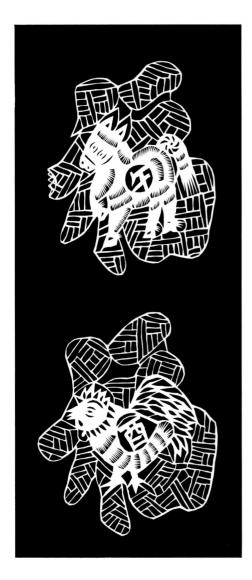

Fig. 12. Papercuts of two animals, from a set of the twelve zodiac figures, cut onto a background of the character fu, *or good fortune. Shandong Province.* 4½″ × 3½″.

And so there developed, over time, a variety of symbols with no obvious connection to the object they symbolize other than their pronunciation. The bat, for instance, *fu* (or *bianfu*), is a common symbol for luck, also represented in Chinese by the word *fu*. *Fu* literally means "blessings" and "luck." Written originally as 示畐 — a wine vessel next to the character for an offering — in the Shang dynasty (16th–11th century B.C.) when ideographs more closely resembled the articles they represented, it indicated that blessings were given in return for sacrifices to the spirits. *Fu*, then, are the blessings visited from heaven upon earth. Even today, much of worship in China consists of treating spirits well so they, in turn, will act with favor toward one's family.

Red is the color associated with *fu* — 福 — and *xi*, happiness. Since ancient times, red has been the primary auspicious color in many cultures, including that of China. In Chinese belief, because red is the color of blood, it is the color of life, and hence associated also with *yang*, the positive, male, life-giving force of the *yin-yang* polarity. The *yin* force is perceived as negative and female; *yin* encompasses such unfavorable concepts as ghosts and demons. All *yang* elements protect against evil and so reinforce life. As far back as the Shang period, the bright red mineral cinnabar was placed as an offering in tombs, probably due to its life-sustaining properties. For centuries, Chinese people have applied red paint or have pasted red paper on the walls around the gateways of their homes at New Year's time to ward away malicious spirits. Today, people still hang *dui lian*, red strips of paper inscribed with poems of good luck, on either side of their front door at New Year's; often another is hung above as well. The power of red to ward off evil was called upon when the walls surrounding Beijing's Imperial Palace, built in the Ming dynasty (1368–1644), were painted; likewise, in the year of their zodiac, believed to be unlucky, people still wear red belts. Women wear red when they marry, and children wear red at New Year's, both to protect them from evil forces and to express the happiness they bring their families. That the principal color of the Communist party is red certainly did not hurt its early popularity among the rural population.

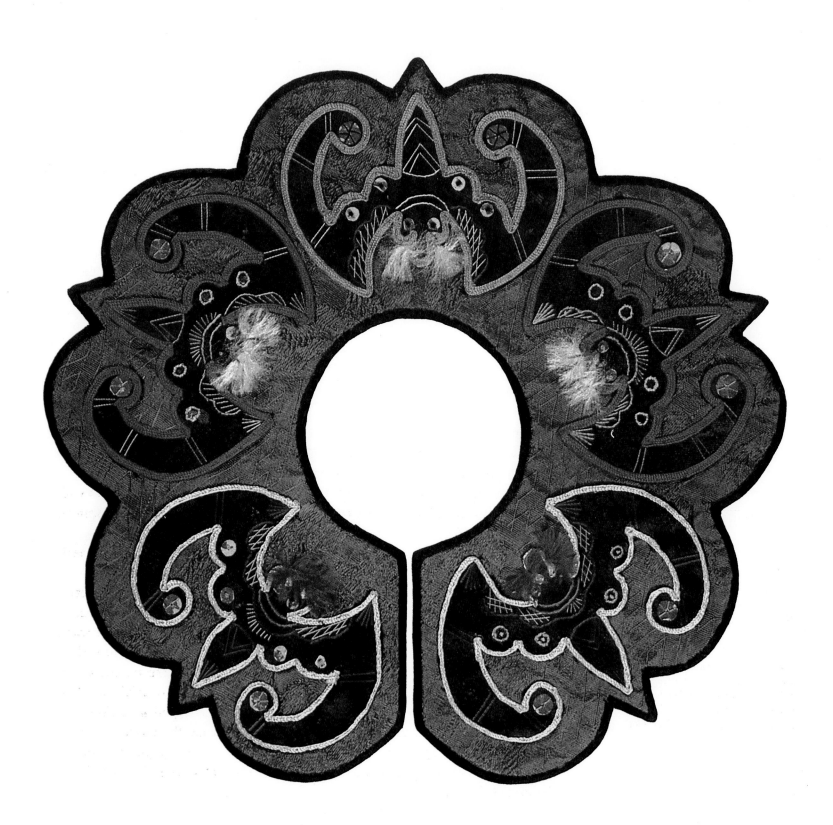

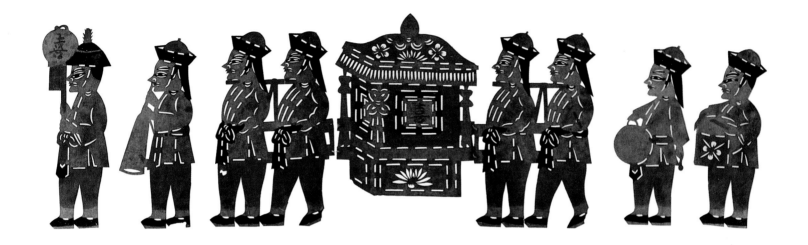

Fig. 13. Child's collar, appliqué and embroidery, depicting five bats, wu fu, which also represent the five blessings. Hebei Province. 9″ × 9″.

Fig. 14. Paper shadow puppets in a wedding procession, carrying the bride in the traditional sedan marked with the double xi characters, meaning "double happiness." Late nineteenth century. Hebei Province. Each puppet 4″ high.

Many works of folk art, especially papercuts, are done in red. In Figure 14, bearers carry a marriage sedan chair with two red *xi* happiness characters marked on it. Wedding papercuts and New Year's papercuts are almost always red. Their bright color not only ensures evil spirits will leave the family in peace but also enlivens the otherwise dark atmosphere of Chinese village homes.

One of the most popular symbols of *fu* is the bat, since, as mentioned earlier, the word is a homonym for "luck." The bat has been used as a symbol since at least the Han dynasty, though it is uncertain whether its meaning at that time was the same as it is now. A burial robe from that period was recently discovered; painted on it, among other symbols, was a bat.[2] Today the bat is often seen decorating embroideries, papercuts, dye-resist fabrics, and woodblock prints. Five bats together make up the *wu fu*, "five bats" or "five blessings," which are longevity, health, officialdom, love of virtue, and a natural death. These bats, usually arranged in a circle, often appear as a pattern in folk art. Five bats encircle the child's collar shown in Figure 13, sure to bring the infant luck. In the papercut of Figure 15, they are placed with the long-life character, *shou*, in a nicely balanced design.

Fig. 15. Papercut of five bats, three of them emerging from a vase and two of them decorating it; between the bats on the vase is a simplified shou, or longevity, character. Shandong Province. 11½" high.

Fig. 16. In this papercut a bride and groom stand on either side of the double xi characters. Below the characters is a lantern in the shape of a butterfly or bat, also a symbol of happiness. Such a papercut would have been made as a wedding decoration. Shandong Province. 3½" × 4".

Fish, *yu*, a homonym with the word for plenty or abundance, is also frequently employed in decorations to bring such luck as an abundant harvest. At a New Year's feast, a fish, if available, is always on the table so that the family will have extra of all that is needed in the coming year. This playing with homonyms also extends to such sentences as *jin yu man tang*, "Golden fish fill the tank" or "May gold and jade fill the halls." Like the interchangeability of similar-sounding ideographs in Shang and Zhou (11th century–256 B.C.) writings, these symbols have come to represent ideas because of their pronunciation. The fish and the bat are no longer just animals—they are happiness.

The word *xi*— 喜 —indicates all the happy things in life. In a sense, it encompasses all aspects of *fu, lu,* and *shou. Xi* is often linked with love and marriage. Papercuts of the character are pasted all about a newlywed couple's home and even laid atop the cakes and treats eaten at the wedding feast. Two attached *xi* characters designate double happiness and are also a common motif for decoration at marriage celebrations. They have been carefully cut out as a design on the bride's wedding dress in the shadow puppet of Figure 21. Often characters are cut out with other symbolic decorations around them amplifying the meanings, such as the marriage papercuts in Figure 16. The distinctive *xi* character is recognizable

Fig. 17. Papercut of a boy riding a fish. Because the fish produces a multitude of eggs at one time, it is a symbol of fertility. In this fanciful image, the large eyes of the fish and the boy's smiling face distinguish an otherwise abstract design. Shaanxi Province. 2½″ × 2″.

even if the artist, purposely or not, deletes some of its strokes. In the papercuts of Figure 12, two zodiac animals have been portrayed, each on an elaborate background in the *fu* character shape.

Among the legends associated with *xi* are many stories of love and marriage, favored themes in Chinese folk art. Images of weddings—such as fetching the bride in the traditional sedan chair or horse carriage, or returning to the bride's home, a custom that takes place several days after the wedding—are popular. Figure 19 wonderfully depicts such a scene, the dog and chicken accompanying the couple on their journey. Recalling that papercuts and embroidery are made primarily by women, for whom the wedding day is one of life's most important, gives this motif more meaning. Chinese legends about love depict many sides of marriage, encompassing not only joy but also fear and even tragedy. "The Cowherd and the Weaving Maiden," "The White Serpent," "The Water Seller," "The Beating of the Flour Barrel," "The Marriage of the Rat," and "The Saving of Bai Yushuang" are some of the favorites of these legends. Villagers hear and see the tales narrated and performed throughout their lives. Elders recite them to the younger generation, and opera and puppet troupes perform them on special occasions. Knowledge of these tales allows the viewer to glance at a single image—for instance, a woman or snake emerging from a pagoda—and immediately conjure up the entire tragic story of "The White Serpent."

"The White Serpent" is among the most popular tales in China. It has inspired whole operas with its vision of faithful love. In this tale, the scholar Xu Xian was strolling by the lakeside when it suddenly began to rain. He noticed two lovely women also out for a walk, caught in the storm without any umbrella. He kindly lent them his and arranged to pick it up at their home the next day. When Xu Xian arrived, he was struck by the luxuriousness of the women's mansion and by the particular elegance of one of them, Bai Suzhen. He began to visit his new friends' home often, and within a short time he fell deeply in love with and married Bai Suzhen. At this point a shadow falls on the tale of true love. Fa Hai, an evil monk who practiced Taoist arts in hopes of becoming an immortal, warned Xu Xian that his bride was actually a magic serpent—a *gui*, or monster. Xu, madly in love and not wishing to find fault with his wife, ignored Fa Hai.

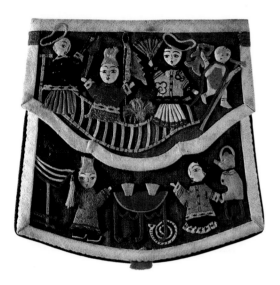

Fig. 18. Purse displaying scenes from "The White Serpent." Late nineteenth to early twentieth century. Hebei Province. 5" × 4".

One day, Xu brought home some wine to share with his wife, not aware that the liquor contained an ingredient that would cause a *gui* to return to its original form. After having a bit of the wine, Bai Suzhen excused herself from the table, saying she didn't feel well, and went to bed, asking Xu not to disturb her. Xu Xian secretly followed her and peeked into the room. There he saw his wife slowly changing into a serpent. This particularly dramatic moment has inspired much creative interpretation in the folk arts.

Xu Xian was so shocked at the sight that he fainted and became extremely ill. When Bai Suzhen discovered her husband ailing, she rushed to the high mountains to search for the best herbal medicines, which only those with special powers could obtain because they were guarded by a multitude of spirits. Bai Suzhen, in human form, brought the medicines back to her husband, and he soon recovered. Xu was so moved by her act of faithfulness that he came to love his wife even more dearly, not concerned with whether or not she was indeed a monster. The couple's continued devotion further infuriated Fa Hai, who captured Bai Suzhen and pressed her beneath Lei Feng (Thunder Wind) pagoda, where, he said, she would have to stay until the iron pillars of the temple blossomed. In different regions, the story is resolved in different ways, but in most of

Fig. 19. Papercut of a bride's first visit to her former home. Usually, a month after a woman has married, her husband accompanies her back to visit her family, a happy time for the woman, whose new home with her husband's family is probably at least one village away from her parents. Shandong Province.
2¹⁄₂″ × 4″.

Fig. 20. Papercut of a newly married couple paying the traditional first visit to the bride's family. The illustrating technique is different from that of Figure 19; here the heads are in profile, the eyes composing most of the face. This image also has a much heavier quality. Shaanxi Province. 2¹⁄₂″ × 3¹⁄₂″.

Fig. 21. Leather shadow puppet of a graceful woman in her red wedding dress decorated with the double xi characters. Eighteenth to nineteenth century. Shaanxi Province. 1 1¹⁄₂″ high.

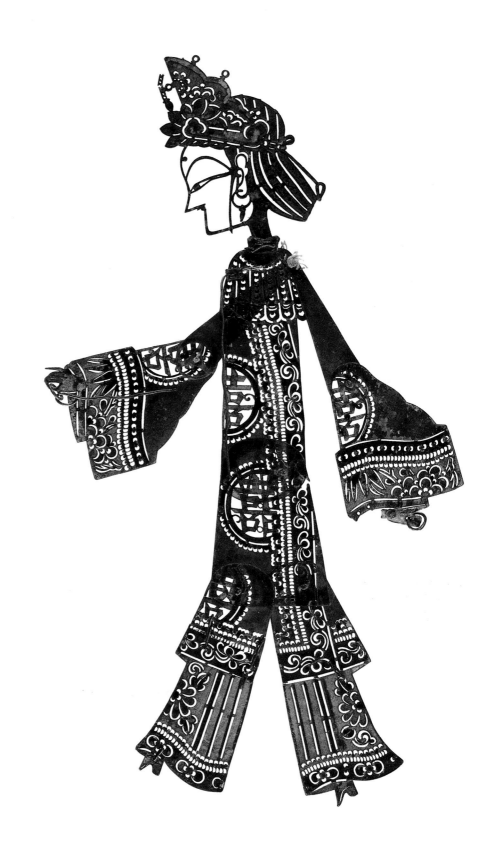

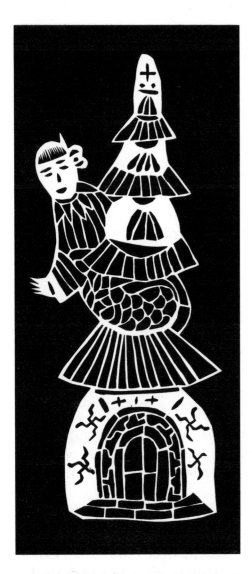

Fig. 22. Papercut of Bai Suzhen emerging from the Lei Feng pagoda. In this image, the papercut is less stylized and more exuberant than the one from Shanxi Province (Fig. 23). Shandong Province. 8″ × 3″.

them Bai Suzhen is rescued and gains her freedom on the fifth day of the fifth month, when her son, an official, comes to the pagoda to make a filial sacrifice. The operas based on the tale are usually performed on that fortuitous day, which in the Chinese calendar is also the day when *gui* enter the mortal sphere on earth.

The scene of Bai Suzhen's flight from the pagoda is marvelously portrayed in Figure 22, a papercut. From the middle of the pagoda, the human-headed serpent emerges. The artist has shaped the surfaces of the serpent and the pagoda, creating two contrasting but suitable textures and emphasizing the sudden separation of the two. Figure 18—an embroidered, appliquéd, and stuffed purse from Hebei Province—depicts several scenes from "The White Serpent." In a wonderful composition that allows several moments in time to be shown in one space, we see Xu drinking with his wife at dinner while below them the white snake coils ominously around the table leg. On the other side of the purse, which was most likely made as a dowry gift, Bai Suzhen arises at long last from her imprisonment in the pagoda, her son at the altar table beside it. Many women in China sympathize with Bai Suzhen's struggles, perhaps because of arranged marriages that have kept them from their true love. Their frequent illustration of this tale in embroideries and papercuts is an expression of that sympathy.

Another tragic tale of separated lovers is the often-told story of "The Cowherd and the Weaving Maiden." After a young man's parents passed away, his brother and greedy sister-in-law kept most of the inheritance, leaving the orphan with only the family cow. He and the cow became close friends. As luck would have it, the cow turned out to be far more than the ordinary beast. Soon it was giving the boy advice on how to solve his difficulties. One day the cow led the boy to a riverbank. There, seven lovely maidens were bathing. The seven, it turned out, were all immortals and, according to the cow, could not return to heaven without their clothes, which they had strewn on the bank. Instructed by the cow, the cowherd stole the clothes of the most gracious of the maidens, with whom he had fallen in love at first sight. The maiden, unable to return home to the heavens, approached the cowherd. Her feelings for him proved equally strong, and they soon married. The charming maiden gave birth to two children, and the family lived together blissfully—as a Chinese saying now describes happy couples, "he planting, she weaving." The young woman had been a weaver of the clouds when she resided in heaven. On earth, with her cowherd husband, she was happy to weave simple cloth. When the Jade Emperor, ruler of the spirits' world, heard of her marriage to a

Fig. 23. Papercut of Bai Suzhen escaping from the Lei Feng pagoda as her son comes to make obeisances to her in the concluding scene of "The White Serpent," a well-loved story of love, marriage, and supernatural beings. Shanxi Province. 3½" × 2½".

mortal and the resulting disruption of the weaving chambers in heaven, he was furious and demanded her return. Because the two were so attached to each other and could barely stand to part, they struck a compromise with the emperor: the two could meet once a year. Sympathetic magpies (now a symbol of happy marriage) formed a bridge on the agreed date of the seventh day of the seventh month every year so the cowherd and his two children could cross into heaven to visit the weaving maiden.

The moving scene of the annual visit is often portrayed in folk art, the details depending on regional customs. In Figure 1, from Shandong Province, the cowherd is pictured walking across the clouds, his children seated in baskets balanced on either end of a pole that he carries on his shoulder. In the colorful bed valance from Shaanxi Province (Fig. 24), the devoted husband and father pushes his children in a wheelbarrow across the bridge to where their immortal mother waits to greet them.

Besides illustrating scenes from this story in embroideries and papercuts, young unmarried Chinese women also hold a needle-threading contest on the seventh evening of the seventh month to determine who will find the finest partner. Much time is also spent looking at the sky, where, it is said, the couple are represented by the constellations Aquila, to the east of the Milky Way, and Lyra, west of the Milky Way, which actually both cross over the Milky Way on this date. Even in modern Chinese cities today, the legend is recalled when referring to the many spouses separated because of work assignments (one may be in Beijing and another in far-off Xinjiang) as cowherds and weaving maidens.

"The Water Seller" is a much more optimistic story of love. Two couples, both of wealthy families, arranged that their children, then infants, would marry when they arrived at the appropriate age, a common situation in traditional China. Time passed. The parents of the boy both died, and at a young age he fell into poverty. He had no choice but to turn to selling water to earn his living. Seeing him in such degenerate circumstances, the parents of the girl assumed the original engagement void and began looking for other suitable matches. The boy moved away and, unbeknownst to the girl and her family, became a scholar, took the arduous civil examinations, passed, and was chosen to be an official, a most respectable position. He returned to his hometown still devoted to his first fiancée and curious whether she still cared for him. Dressed up again as a water seller, he went to her house to hawk his wares. The girl recognized the boy, and immediately sent her maid down to arrange a secret meeting. Before long the couple was happily in love. Only then did the boy reveal his new position as an official, and the parents of the girl gave their ap-

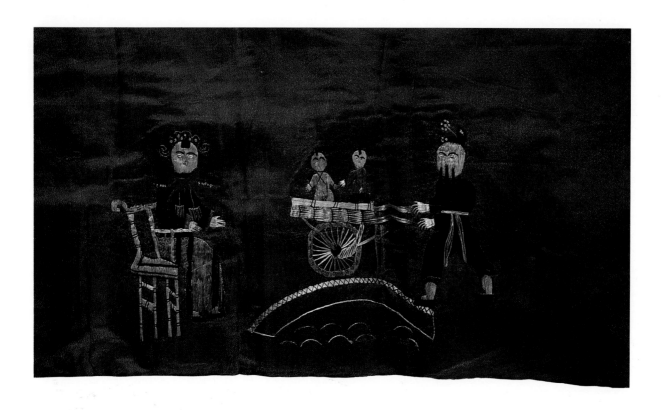

Fig. 24. Embroidered bed valance detail, de-
picting a scene from "The Cowherd and the
Weaving Maiden." Shaanxi Province.
9½" × 13½".

Fig. 25. Pillow end showing a scene from the
tale of "The Water Seller," in which the boy
returns to woo the young maiden, watching
from the window above, to whom he was long
ago promised in marriage. Shanxi Province.
6½" × 6½".

proval for the marriage. The tale certainly reflects many a young country
girl's wish to marry such a devoted husband, as well as one who turns out
to be an official. The embroidery in Figure 25 wonderfully illustrates the
boy's return, showing him balancing buckets of water on either end of a
carrying pole, and the girl, simply defined by the embroidered window,
noticing her long-gone suitor from her second-story room. Her maid, act-
ing as a go-between, has gone down to talk to the boy.

On the comic side is the much-loved tale of "The Beating of the Flour
Barrel," a favorite at the shadow theater. It is the story of a prostitute who
wanted to leave her brothel and marry; she was granted permission to do
so by the chief administrator of the district, who claimed to be sympathetic
to her. The odious fellow, however, showed up at the wedding. Still con-
sidering her a lowly woman, he tried to persuade her to sleep with him in
gratitude for his deed. She cleverly pretended to agree with his idea, but
she warned him that her husband was coming and urged him to hide in a
large, earthen flour jar. When her husband arrived, the bride quietly told
him what had transpired and pointed to where the official was hiding.
The incensed husband pulled the administrator, now humiliated and cov-
ered with flour, out of the jar, beat him soundly, and threw him out of the
house.

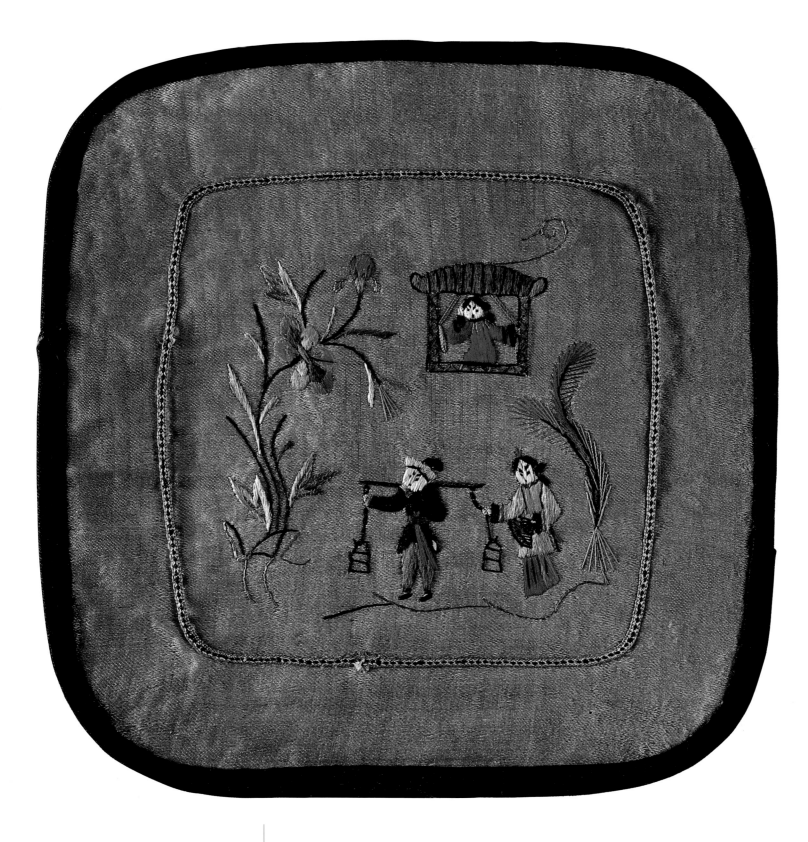

Fig. 26. Papercut of two rats carrying a rat bride in the traditional sedan chair, decorated with two coins (symbols of prosperity), in a scene from the popular tale "The Marriage of the Rat," often illustrated in papercuts. Shanxi Province. 2½" × 3½".

Besides the tales of love, tragic or comic, are the legends of the brides who find themselves in miserable circumstances. In the countryside today, as in the past, most marriages are arranged for convenience and for financial reasons; dowries and bride prices are still important for both family honor and economics in many poor villages. The trauma for a bride of an arranged marriage, of entering the home of a total stranger as his wife, and of possibly having to bend to the wishes of oppressive in-laws certainly makes a strong impression on Chinese women; understandably, many tend to illustrate stories on such themes. Papercuts sometimes depict the heroine Sun Cuie, who saved the poor young woman Bai Yushuang after she had thrown herself into the river to avoid marrying a man with whom she was not in love. Finally, Sun realized that the only way to keep the bride from killing herself was to destroy any possibility of the marriage taking place. Sun put on the wedding dress herself, entered the nuptial quarters, and murdered the groom.

Fig. 27. Papercut depicting the pomegranate as a symbol of fertility and many sons — important factors in traditional Chinese households — done in the refined style of Hebei Province. 4" × 4".

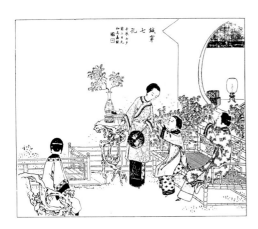

Fig. 28. Nineteenth-century woodcut illustration of girls holding a needle-threading contest on the date of the cowherd and the weaving maid's annual visit. From Wu Youru hua bao.

Another popular marriage epic often illustrated in papercuts is "The Marriage of the Rat," which tells of a mother's vain efforts to find her daughter the perfect mate. Mother Rat wanted to find her daughter the best husband in the universe. She decided that there was nothing more wonderful than the sun. But, her friends reminded her, when the clouds cover the sun, it loses its power. Then, Mother Rat decided, her daughter would marry the clouds. But, her friends cautioned, when the wind blows, the clouds become nothing. So Mother Rat decided her daughter would marry the wind. But, her friends remarked, the wind cannot withstand a wall. Then, Mother Rat said, her daughter would marry the wall. But the wall is not so strong that it can keep back the rats that eat through it, her friends said. Mother Rat decided her daughter would marry a rat, until someone reminded her that cats can eat rats in one gulp. And so it was that Mother Rat married her daughter to a cat. And the cat loved his new wife so much that he kept her in his stomach for safekeeping.

This tale is often represented by a series of papercuts portraying a wedding procession, which obviously Mother Rat has gone to great lengths to arrange. The papercuts show rats carrying dowry presents, rats playing musical instruments, and rats carrying the rat bride in her bridal sedan, while on the side the cat waits patiently for his meal.

These tales are only a sampling of scores of Chinese love stories that express the desire for happiness in marriage. Some relate the joys, though brief, of love marriages, like that of "The Cowherd and the Weaving Maiden," but in general the tales are criticisms of arranged marriages, such as "The Marriage of the Rat." It is not surprising that they are so popular with folk artists, most of whom are women.

Besides marriage, one of the most important moments of *fu* and *xi,* luck and happiness, is the birth of a son to a Chinese family. The birth and raising of sons, and even the anticipation of that birth, are events celebrated almost more than any other in the folk arts. Female children in China are looked upon mostly as burdens whom the family must spend money on to feed and raise, in the end only to marry off into someone else's home. In prerevolutionary China, many peasant families married their daughters off when they were children, to be treated as servants by the groom's family. A son, on the other hand, stays with his parents all his life, bringing a wife into the family, caring for his parents in their old age, and siring more sons to carry on the family line. According to a Chinese saying, "There are three unfilial actions; the worst among them is to have no descendants"—descendants, by definition, being sons. Even women, whom one would expect to sympathize with children of their own sex,

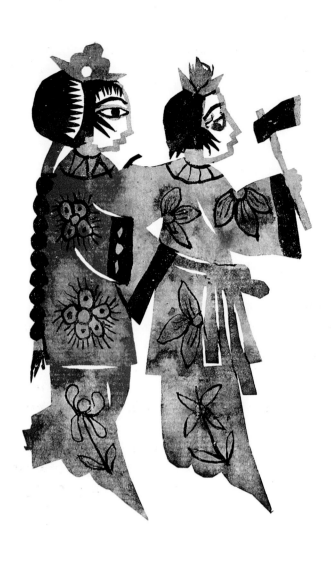

hope to have sons, if only to please their husbands and, more important in the Chinese household, their mothers-in-law. Giving birth to a female child makes a young wife even more uncomfortable in her husband's home — before the revolution such a situation would often lead to the husband taking another wife — whereas giving birth to a male child would confer upon her real status in the household.

Symbols of fertility, implying the birth of sons, abound in Chinese folk art. The word *zi* has multiple meanings in Chinese, including "child," "son," or "seed." Hence, pomegranates and watermelons, both of which are full of seeds, are commonly used in Chinese folk art to represent the desire for sons. The pomegranate is not indigenous to China, and its symbolism developed there only after the Han dynasty, when it was introduced from the West. A sixth-century legend from the Northern Qi dynasty[3] tells of the king An Dewang visiting the mother of one of his wives. Upon parting, the mother gave the couple two pomegranates. Not knowing the intended meaning of them, An Dewang threw them away. Shortly after, a tutor of the king explained that his mother-in-law had given them the fruit because she hoped it would bring them many sons. The king sent a servant to fetch the pomegranates and thanked his tutor with bolts of silk. From that time on, pomegranates became a popular fertility symbol. During the Tang (618–907) and Song (960–1279) dynasties, people often gave them as gifts. Later they were commonly presented to engaged couples, and brides would hide them in their clothing during weddings.

Fig. 29. Colored papercuts of two women with a hatchet chasing a matchmaker in a scene from a local marriage tale. Southern Shaanxi Province. All figures 4½" high.

The Hebei creator of Figure 27 used a multitude of fine cuts to fashion the charming child dancing on a pomegranate, while the artist of the papercut of Figure 30 made the pomegranate itself into a male child, emphasizing without any bashfulness his sex and intended symbolism. The Hebei pillow end of Figure 173, done almost completely in the *da zi*, seed stitch, shows a male child emerging from a multicolored pomegranate. The texture of the *da zi* stitch, composed of small knots, resembles the many seeds of the pomegranate. Also included in this busy composition are a watermelon, radishes, a lotus, a Buddha's hand (a citrus fruit), grapes, and a gourd. Gourds and teapots imitate the shape of a pregnant woman and are therefore both fertility symbols. The number of seeds in the gourd, moreover, makes it an obvious symbol, and the teapot, *hu*, being a homonym with "gourd," *hu lu*, naturally followed. The papercuts of Figures 31 and 32 depict the many ways women have chosen to portray the auspicious, bulbous shape of the teapot.

The lotus is also frequently used to symbolize fertility. Like the pomegranate, the gourd, and the watermelon, the lotus has a center that is full of seeds. The lotus is called *lian*, its seeds *lian zi*. In addition, *lian* is a homonym for "continually," and *lian zi* thus indicates that one should continually have sons. In many embroideries and papercuts, a child is pictured seated on lotus petals, representing the hope for a son. A fantastic stuffed and painted wall hanging from Shandong (Fig. 34) is such a piece. The bride's wedding collar (Fig. 33) in the shape of a blossoming lotus with all its many petals indicates the woman's potential for bearing sons. The lotus is symbolic of many different concepts in China and is often associated with Buddhism. In the Buddhist context, the lotus, which grows out of the mud, represents the idea that anyone can become a Buddha, just as the pure lotus emerges from the filth; statues of the Buddha often depict him seated on this flower of purity. However, this meaning is not to be confused with the folk artist's intent in showing a child on a lotus. The latter may have developed from the original Buddhist image, but it now has a completely separate meaning.

Another image frequently seen is a child riding the imaginary creature *qilin*, holding a lotus in one hand and a *sheng*, a musical pipe, in the other. Sometimes they are accompanied by a god or goddess of fertility, such as in the papercut of Figure 97. This image represents the Chinese hope of *lian sheng gui zi*, "continually giving birth to aristocratic sons." The *lian* means both "lotus" and "continually"; *sheng* indicates both the instrument and "to give birth"; *gui*, "noble" or "aristocratic."

Fig. 30. Papercut of a boy child in the shape of a pomegranate. The spikes, which portray the distinctive end of the fruit, add even more spark to the work and inspire excitement over the arrival of a boy in the family. Shaanxi Province. 6″ high.

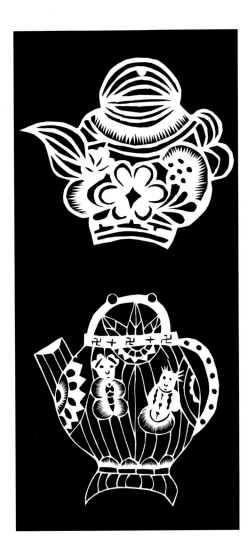

Fig. 31. Papercut of a teapot, a symbol of fertility, done in the vigorous style of northern Shaanxi Province. 4″ × 4″.

Fig. 32. Papercut of a teapot. Here a husband and wife are pictured in the shapes of gourds on the side of a teapot. The wan *character, which resembles a backward swastika, is used as a decorative element on the edge of the pot. Shandong Province. 5″ × 4″.*

An ideal family, a family blessed with both *fu* and *xi,* does not only include many sons but is also harmonious. The harmony, according to basic Confucian morals, is based on a hierarchy in which filial piety—respect for the elders—is essential. As it is the duty of a woman to produce descendants, so it is the duty of a child to care for his elders. A man's virtuousness is often measured by how he treats his parents. In the words of Confucius: "The official serves the emperor; the son serves his father; the wife serves her husband." This precept is one of the cornerstones in the education of a child. Stories of filial piety, which traditionally number twenty-four (though there are many more), are often illustrated in papercuts and embroideries as constant reminders. Guo Zhijing, a writer of the Yuan dynasty (1279–1368), while mourning the death of his father was the first to collect and publish twenty-four stories of filial piety, which previously had been orally transmitted,[4] as well as illustrated in paintings and carvings. Since then, the tales have been referred to as the Twenty-four Filial Pieties. The feats related in them date as far back as the semimythical Xia dynasty (21st–16th century B.C.).

The Shaanxi embroidered bed valance of Figure 37 tells one such tale, the story of the filial wife of Cui Shannan, from the Tang dynasty. Cui's mother-in-law had lost all her teeth and could not eat any solid foods. The virtuous daughter-in-law sacrificed her milk, which she would ordinarily have given to her son, to nurse the aging woman, who otherwise would have starved. In this embroidery, the daughter-in-law has dutifully exposed her breast, from which the older woman drinks. Off to the side, the deprived child plays with his ball, oblivious to this peculiar, almost disturbing sight. The beauty of this embroidery lies not only in the fine stitching but also in the composition, which is able to create space by the mere placement of several objects on the silk surface. The addition of the cat gives one more sense of reality.

The women who made such pieces most likely composed them around the time they married in order to demonstrate their loyalty to the elders in their husbands' families. These brides were expected to defer and literally *ketou*—bow deeply and knock their heads on the ground, or kowtow—to these relatives in the days before the revolution. (This practice is still common in many areas.) The twenty-four piety tales were so implicit in traditional education that young children had to memorize and recite them. The woodblock prints seen in Figure 35, when pasted on a wall, would be yet another reminder to youngsters of their responsibility to the family.

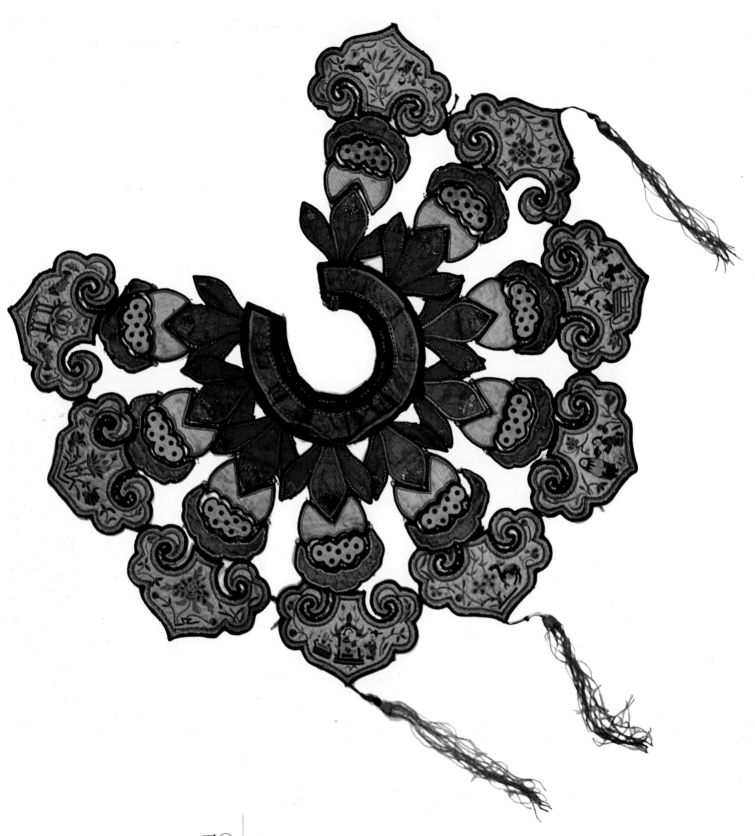

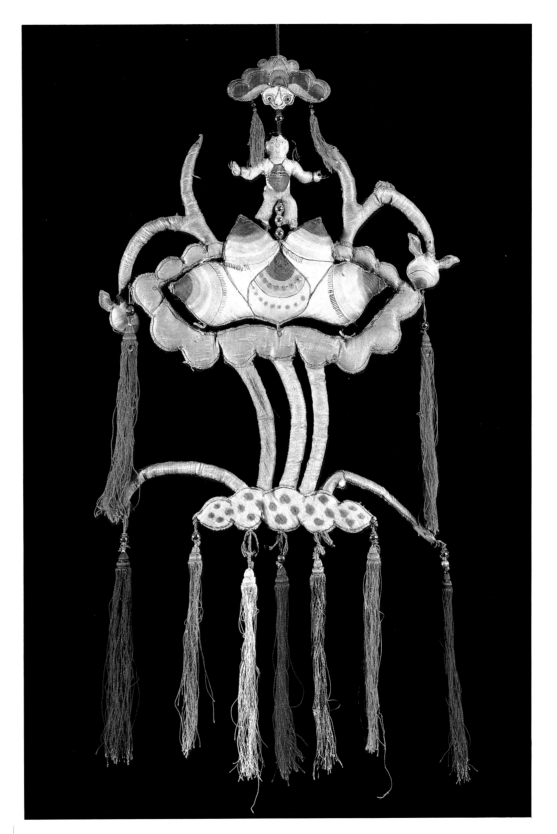

Fig. 33. Woman's wedding collar, constructed in the shape of a lotus, its red petals surrounded by the pods, whose many seeds stand for fertility. The outermost layer, finely embroidered by a clever young bride, depicts various symbols and scenes of a happy marriage. Shaanxi Province. 31" diameter.

Fig. 34. Stuffed and painted silk hanging in the shape of a lotus, out of which is emerging a young child, symbolizing the ability to bear many sons. Above the infant flies a bat of good luck. Shandong Province. 21" high.

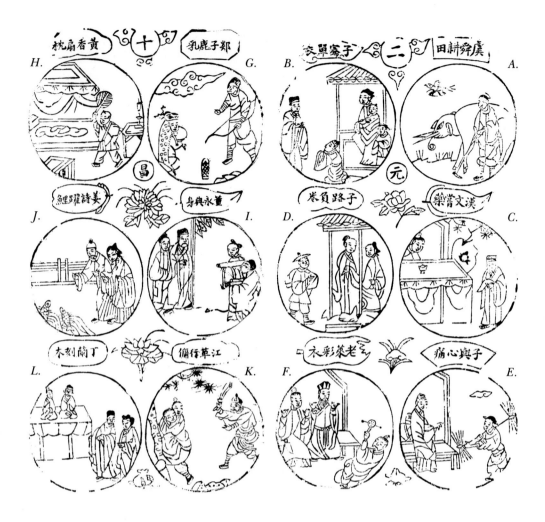

Fig. 35. Woodblock print, to be hung in a home, that illustrates twelve tales of filial piety. The tales are arranged in historical sequence, reading (as the Chinese language reads) from right to left. Shanxi Province. 13" × 9".

A. "Yushun Geng Tian," in which Yushun, the first emperor, was so devoted to his father and stepmother — even though they treated him badly — that all the animals of the world, including the elephant, came to assist him in plowing the fields.

B. "Ziqian Dan Yi" centers on Ziqian, whose father remarried after his mother's death. His stepmother was very cruel to him and made him a winter coat that was stuffed only with grass. One day, as Ziqian was being whipped by his father for coming home late, the coat ripped open and his father realized how his new wife had been treating Ziqian. He wanted to send her away, but his filial son insisted she stay lest the entire family suffer without her.

C. "Han Wen Chang Yao" is the story of Han Wendi, the second emperor of the Han dynasty, who was so filial that when his mother was ill, he would taste her medicine before she took it.

D. In "Zi Lu Fu Mi," a son walked a hundred miles to buy grain for his parents in time of famine.

E. "Zi Yu Xin Tong" tells of a son away from home who felt pain in his heart when his mother bit her finger while worrying about him and immediately came running home.

F. "Lao Lai Cai Yi," in which a son wore colorful clothes and acted like a child to amuse his parents in their old age.

To return to the four basic achievements of an ideal life, the word *lu*— 禄 —adds a more material dimension to the joys of *fu* and *xi*. In its broadest sense *lu* means "wealth," but literally it is the term designating an official's salary. The peasant relies entirely on the usually unreliable weather to bring in his yearly income, so the stable and respected salary of an official of the government has long been an attractive goal. In ancient China, it was the desire of every parent that their son become an official. Some mothers would even make miniature official's hats for their sons to wear at holiday times and birthdays in the hope they would influence their future. This hope was not a vain one, since occasionally a peasant who studied hard enough managed to pass the examination and become an official, thus attaining the highest position in the Confucian hierarchy. Today, the army offers this chance for personal betterment, so peasants hope their children will be able to join.

The deer, *lu*, a homonym with the word for the official's salary, is a symbol of the striving toward this accomplishment and is often incorporated into works of folk art. The artists of Figures 38 and 39 have cut simple but proud deer that symbolize the desire in their families for such an achievement.

The sound for grasshopper is similar to the word for official (*guan* or *guanr*, depending on the local accents), and an image of this insect—particularly outside its cage, to represent the peasant having left his village environment—is also commonly employed as a *lu* symbol. Other animals

G. "Tan Zi Lu Ru" tells of a filial son who dressed as a young deer in order to obtain deer's milk, which his parents, suffering from an eye disease, needed to drink.

H. "Huang Xiang Shan Zhen" is the tale of a son who during the summer fanned the mat and pillows of his parents' bed before they went to sleep to cool it off, and who in winter lay down before they did to warm the bedding.

I. "Dong Yong Dian Shen," in which a man sold himself into bondage to pay for his parents' funeral.

J. In "Jiang Shi Yue Li," a husband and wife went every day to a far-off river to fetch fish and water for their parents, who would eat and drink only from that river. The fish were so moved by their filial piety that they moved themselves to the family's doorstep.

K. A son carried his mother on his back in "Jiang Ge Xing Yong" to escape from war and famine. When they encountered bandits who wanted him to join their cause, he pleaded with them to let him stay and take care of his mother; touched by his concern, they acquiesced.

L. "Ding Lan Ke Mu" concerns a boy who had a carpenter carve statues of his parents after they died. These he worshipped, talked to, and fed. When he married, his wife was annoyed by this attention. Having been told by neighbors that such statues could become real, she pricked one with a needle and saw blood flow out. Her husband returned and noticed tears in the statues' eyes. After learning from his wife what she had done, he immediately ordered her to leave his house out of respect for his parents.

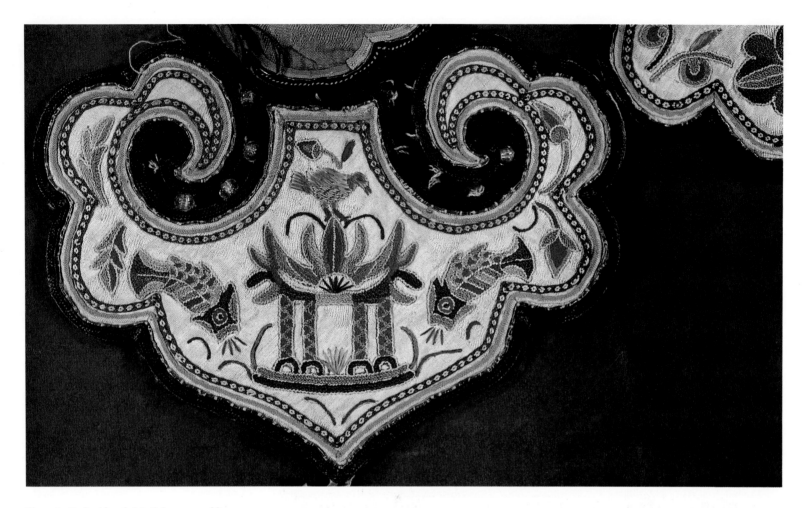

Fig. 36. Embroidered detail from a wedding collar showing two fish and the Dragon Gate over the Yellow River, symbolizing the opportunity for an ordinary man to become an official. Shaanxi Province.

Fig. 37. Embroidered bed valance detail, depicting one of the tales of filial piety. Here, a family is caught in a famine, and the filial woman offers her milk to her mother-in-law, who is starving because she is toothless, thereby depriving her son. Shaanxi Province.
16" wide.

also express this potential. The carp, a fish that spends its whole life swimming upstream, symbolizes the perseverance it takes to become an official; carp are sometimes pictured next to the Dragon Gate, a legendary spot on the Yellow River. It is said that if a carp can successfully ascend the rapids at that location, it will become a dragon—an allegory of the peasant becoming an official. A detail of one of the petals on the lotus shape of a wedding collar (Fig. 36) displays a finely stitched, colorful illustration of the Dragon Gate. The rooster with his crown is also a symbol of being able to enter that desirable world; likewise, a child riding on a *qilin*, as in Figure 41, stands for the possibility of the child succeeding as an official. The deer, the grasshopper, the fish, and the cock are all common sights to villagers, but the use of them in folk art represents more than just illustrations of the environment.

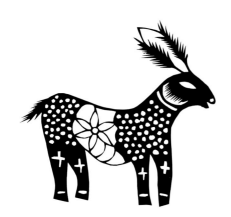

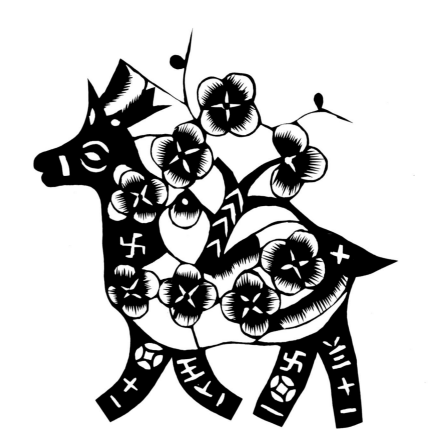

Fig. 38. Papercut of a deer, lu, *which is a homonym with the term for an official's salary and therefore symbolizes achieving officialdom and prosperity. Shandong Province. 4" × 4½".*

Fig. 39. Papercut of a plum-blossom deer, a species so named in China because of the white spots on its fur. Here the name has been taken literally and the animal portrayed with flowers growing out of its back. Coin symbols and wan *characters, representing the number ten thousand and longevity, have been cut out on the legs and torso to decorate otherwise empty areas of color. Shandong Province. 5½" × 4".*

The *qilin*, on the other hand, is an imaginary creature; full of benevolence, it is said to bring to childless families sons who have the ability to become officials. Its image has been embroidered onto cloth, cut into papercuts, dyed onto dye-resist fabrics, and carved out of wood for woodblock prints, all of which may adorn a home where a son with a promising future is hoped for. Since the *qilin* is a legendary animal, its form has never been determined, and various descriptions abound, making its many representations fascinating. Records of its appearance in ancient times note that it had the body of a deer, the hoof of a horse, the tail of an ox, the scales of a fish, a single horn (like the imaginary European unicorn), and a voice like the sound of bells.[5] An altruistic creature, it would never step on any insect or even on a living blade of grass. In Figure 41, the *qilin* with its spiked tail gives an air of excitement, anticipating a great life for the child it carries. The creature was said to appear only during the reigns of virtuous rulers, and many emperors, no doubt, would claim to have sighted one to confirm their good character. According to legends, it made its last appearance during Confucius's life. Belief in the animal goes back to at least the Zhou dynasty. The *Li-ji*, the *Book of Rites* compiled by Confucius and his disciples, refers to it as one of the four intelligent creatures — along with the phoenix, the tortoise, and the dragon — and mentions that in bygone eras of harmony *qilin* would wander among the trees.[6] In later times, images of the *qilin* decorated the walls of the small rooms where scholars sat for imperial examinations, which may have encouraged the belief that the creature could deliver sons who could pass those exams.

Tales of famous men who rose from poverty to officialdom are commonly illustrated as inspiration. A popular woodblock print in Shandong depicts the story of Bao Gong, a peasant who was beckoned by the emperor's messenger to become a minister during the Song dynasty. In the upper portion of the picture, as the farmers harvest the wheat, gold ingots appear on the ground to represent the prosperity that will result from officialdom.

As mentioned, the *lu* symbol stands not only for the hope of becoming an official but also for the hope for wealth, a desire the Chinese people are less reluctant than other peoples to express. Since before either Buddhism or Taoism became official religions, there has been a God of Wealth, whom peasants and businessmen specifically worship and to whom they make sacrifices in the hope that he will bring them fortunes. Every household in prerevolutionary times would invite this spirit into their home by pasting his portrait on their walls in the first days of the New Year. At New Year's time the most often-heard greeting among friends is

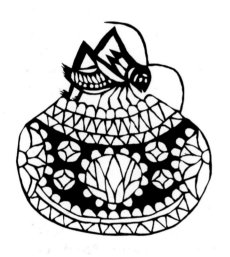

Fig. 40. Papercut of grasshopper emerging from its cage, a metaphor in Chinese imagery for a village person becoming an official. Shandong Province. 3″ × 3″.

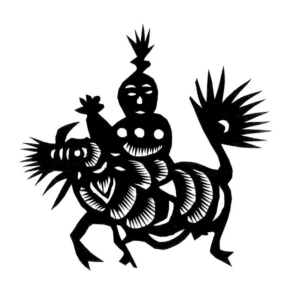

Fig. 41. Papercut of a boy riding the legendary qilin, *said to bring children who will become officials to families with no sons. Shaanxi Province. 3½″ × 3½″.*

gong xi fa cai, "Congratulations and may you be prosperous." In a society where the disparity between the peasants and the wealthy has been so great, it is no wonder that such aspirations are often expressed. In fact, prosperity is so significant in Chinese family life that paper models of money and luxury items are sent to the dead in the afterworld so they can enjoy that which they probably could not afford during their lives on earth. Gold and silver ingots, often displayed on the God of Wealth's portrait (see Fig. 208), are of course obvious symbols of prosperity. The child on the Sichuan bed valance of Figure 43, surrounded by plum blossoms, grasps an immense gold ingot in a wonderfully straightforward expression of the mother's desire for her child.

Today the most common symbol for prosperity in China is the ancient coin, round with a square hole in its center. Cowrie shells were one of the earliest forms of currency in China, and many have been found in Shang tombs. The Shang also began using metal coins in the shape of knives. The round coin with the hole in the center first appeared during the Eastern Zhou period, but it wasn't until the Qin dynasty (221–206 B.C.) that a square center hole appeared. In traditional Chinese astronomy, the circle represents the heavens, and the square the earth. Dynasties succeeding the Qin continued to mint their currency in this same form but with different characters, designating the time period on the face of the coin. Other shapes evolved as well, but until the twentieth century, the circle with the square hole was the most prevalent coin. Early on, people began to believe in the good-luck power of some of these ancient coins, such as the *wu zhu* coin of the Han dynasty. Many people hung coins around their necks, or around children's necks, to ward away evil. At marriages today in some villages, coins are thrown along with dates and chestnuts onto the couple's bed in order to assure descendants and prosperity. (The words for dates and chestnuts are, respectively, *zao* and *li,* being homonyms for "early profits.")

The coin can be seen everywhere as a decorative pattern—in embroideries, papercuts, woodblock prints, dye-resist textiles, and even on rooftops of many village homes—in which eight or more curved tiles are arranged in the shape of one, three, or five interlocking coins. Two coins linked together are often painted on signs hung over shops to attract good fortune. In the New Year's picture of Figure 210, the money tree is laden with gold coins, which the children around the God of Wealth are gathering up. In folk art, solid areas are rarely left blank, and the coin symbol or a series of overlapping coins is frequently used to make an otherwise vacant space more exciting. In the papercut door hanging of Figure 42, coin

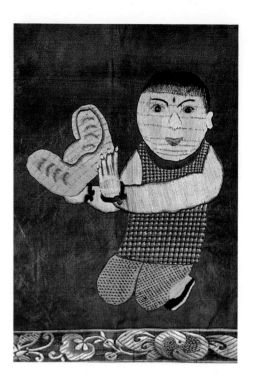

Fig. 42. A guaqian *papercut meant to hang in a series across a doorway; as its name "door money" implies, it is said to bring prosperity to a household. Interlocking coin symbols create a lace pattern at the top of the piece, and another coin shape forms the center of the cloud shape hanging below the rectangle. Shaanxi Province. 9½" × 4¼".*

Fig. 43. *Detail from embroidered bed valance of a child holding an oversized gold ingot, symbolizing prosperity. Sichuan Province.*

Fig. 44. *Detail from the center of a dye-resist quilt cover. The whole of the quilt's design pivots around the ancient coin (a square within a circle), which stands for wealth. Sichuan Province.*

symbols have been used to create a decorative pattern.

One story in particular expresses hopes associated with *lu*, especially the common desire to come upon sudden wealth, and that is the tale of Liu Hai. At the age of ten, Liu Hai, who lived near Zhongnan Shan in Shaanxi Province, was orphaned and left with only an axe that had belonged to his father. Every day he would go into the mountains to cut wood and then to the market to sell the wood, earning just enough money to buy a bowl of noodles. One day, Liu Hai was wandering in the forest and stopped to rest at the entrance of a cave, inside of which was a stone Buddha. The Buddha called to Liu Hai, asking that he put down his axe and come into the cave. Poking his head inside, Liu Hai smelled incense burning and saw the giant Buddha.

"The axe will keep you poor all your life," the Buddha advised. "Put it down and come into my temple." "But I cannot leave my axe," said the poor lad; "it is the only thing my parents left me." "I usually do not speak," answered the stone Buddha, "because I have found that all the evil in the world is caused by talking. But I have seen you go by here many times, and I decided it was time to speak with you. I want to help you leave the bitter sea [a Chinese phrase meaning the difficult life of mortals]. I want to be friends with you." "But I do not have anything to give you,"

remarked the puzzled Liu Hai. "That does not matter," replied the Buddha. "I can see that you have the ability to become an immortal. You don't have to cut wood every day. I have a lot of money." And suddenly gold coins spurted out of the Buddha's mouth. He breathed again and sucked them all back in.

Delighted, Liu Hai was persuaded to become friends with the Buddha. He often went to the Buddha's cave, cleaned it and took care of the Buddha. In return, the Buddha let him play with the coins, making them into trees, *qilin,* and all sorts of wonderful shapes. One day Liu Hai said, "Why don't you give some of this money to the poor people?" "Those people don't have luck," answered the Buddha coldly, and abruptly sucked back all the coins.

A few days later Liu Hai encountered a beautiful woman on the mountain. She asked to borrow his axe, explaining that there was a *lingzhi* (a magical fungus that if eaten could impart immortality) which she wanted to move to an old woman's house. Her motive was not simple good will; she had long watched Liu Hai in the forest and, from a distance, fallen in love with him. But her guardian, the old woman, had made a pact with her—she would only let the girl go live with the boy if she could bring her the *lingzhi.* Liu Hai, enchanted by the young woman, agreed to help. The two succeeded in bringing the *lingzhi* to the guardian, who, Liu Hai discovered, was the mother spirit of the mountain. They then escaped. Infuriated at having lost her servant, the mother spirit sent a tiger in pursuit of them. Liu Hai killed it with his axe. Next, the vengeful spirit caused the mountain to split open, hoping the waters would drown them, but the lovers sat on pieces of wood and floated to safety.

Frustrated, the mother spirit consulted the stone Buddha. The next time Liu Hai went to cut wood, the Buddha accosted him. "The girl you have fallen in love with," he explained, "is not a girl. She is a fox demon, and you should kill her." Confused, poor Liu Hai returned to the girl and repeated the Buddha's words. The girl explained that the mother spirit had persuaded the Buddha to deceive him and that the stone Buddha was not as powerful as Liu Hai believed. Indeed, he had no magic powers. On his head, she explained, was a gold *chan,* a legendary three-legged toad that could spit gold coins. She convinced Liu Hai to take his axe and cut off the *chan.* Liu Hai did so, now comprehending why the Buddha had never allowed him to bring the axe into the cave. Thereafter, the mother

Fig. 45. Papercut of Liu Hai and the chan, *crafted in a manner very distinct from Figures 46 and 47, though all portray the same theme. In this piece, the artist has cut away various-sized shapes and forms within the body of Liu Hai that bear little or no relation to the figure but still create a vibrant effect. Shaanxi Province. 3½" × 2½".*

Fig. 46. Papercut portraying Liu Hai and the three-legged toad. Hebei Province. 4″ × 4″.

Fig. 47. In this depiction of Liu Hai, the boy is riding one three-legged toad while another, within whose body is a coin shape, flies above him. The contrast in the treatment of the boy, formed primarily of rectangles, and the darker toad, with round dots on his body, makes them two distinct figures. The lines connecting the toads and the coins add movement to the piece. Shandong Province. 4½″ high.

spirit never attempted to make any trouble for Liu Hai, since he had become so wealthy and powerful. He traveled about distributing the *chan*'s coins to poor people, and so many began to call him the Living God of Wealth.

The most common image of Liu Hai is of him riding the three-legged toad and holding aloft his string of coins. The papercuts in Figures 45 and 47 show the happy lad saddled on the creature, his coins flying about him. In the embroidered child's bib of Figure 48, he is dancing along, accompanied by colorful coins. A length of lotus roots below his feet and a gloriously blossoming lotus flower above him emphasize the continuation of such prosperity. Liu Hai also appears on the back flap of the child's hat in Figure 154; above him an enormous bat, symbol of *fu* (luck), has been embroidered as well. One mother made her child a pair of shoes (Fig. 166, far right) in the shape of the magical *chan*, knotting small metallic circles onto his back to resemble coins. Figure 49 is a friendly but somewhat grotesque depiction of the beast as a shadow puppet.

The three-legged toad is said to live only on the moon and is responsible for swallowing the moon at eclipses. The connection between the moon and the toad goes back probably even further than the Liu Hai legend. A robe from the Warring States period (475–221 B.C.) shows the toad next to the moon. Kan De, an astronomer from the third century B.C., mentions the three-legged toad as a symbol of the moon. The moon and all reptiles are *yin* and are therefore often pictured together.

Some versions of the Liu Hai legend hold that the toad was a greedy character that occasionally escaped down wells and that Liu Hai would be able to lure it out only with the string of coins. Other legends say that Liu Hai was a government minister during the Song dynasty. One day he came upon a begging monk who asked him for ten eggs and ten coins. The monk balanced the eggs on top of the coins. Liu Hai noted that such a trick was dangerous, since the eggs might break. The monk replied that living a luxurious life was far more complicated. Upon hearing this, Liu Hai reportedly gave up his post as minister and became a monk. Some say that practicing Taoist magic gave him the powers to ride the *chan* and distribute money to the poor. One other legend tells that the *chan* itself was originally a celestial being transformed by higher powers into a toad because of its greed for money.

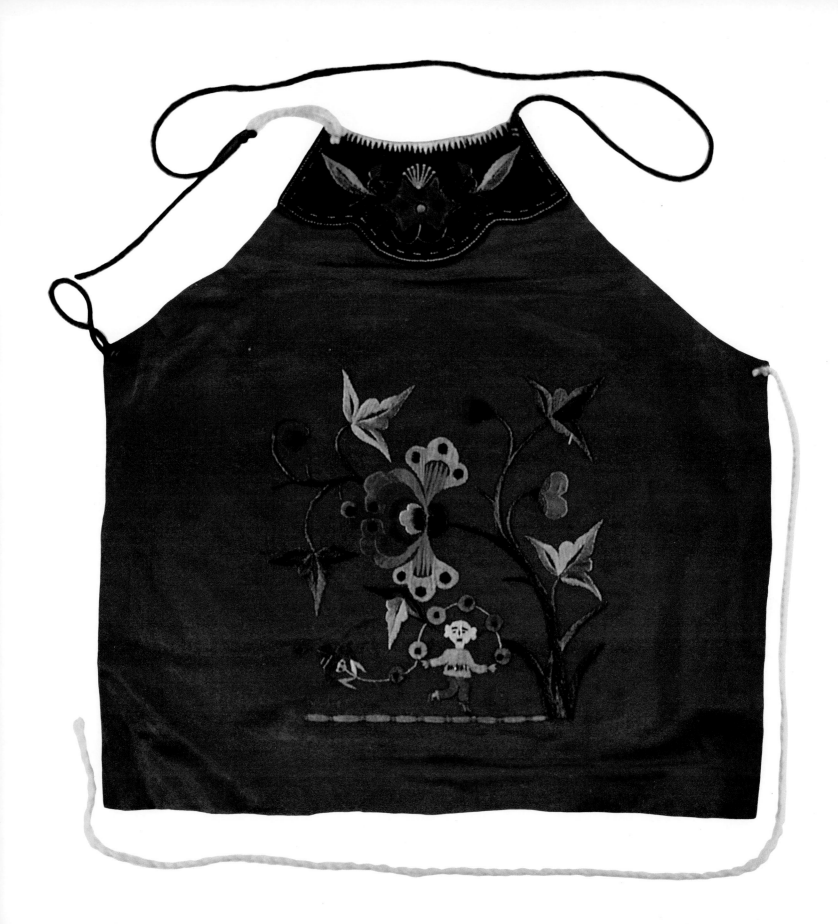

Fig. 48 (left). Child's embroidered apron. Under a flourishing lotus plant, the legendary character Liu Hai prances with his gold coins, followed by his constant companion, the three-legged toad, promising wealth to all they encounter. Hebei Province. 12″ × 12″.

Fig. 49 (top). Shadow puppet of the three-legged toad, the chan, who is said to spit gold coins and inhabit the moon. Eighteenth to nineteenth century. Shaanxi Province. 10″ long.

Fig. 50. Papercut of a child sitting on a lotus leaf and holding a musical instrument, an image representing the continual birth of noble sons. The sheng, a musical reed instrument, is here formed to look like the character shou, or long life, adding further meaning to the piece. Shaanxi Province. 3″ × 3″.

Fig. 51. Papercut of a pig carrying a basket. The lines making up this familiar household animal and character from the famous tale "Journey to the West" intersect on his forehead to form the wan character, which means "ten thousand" and implies longevity and immortality. Shandong Province. 7″ high.

Fig. 52. The fine cutting in this papercut has been patterned to form the wan *character. Gansu Province. 5" × 3½".*

Fig. 53. Appliqué pillow cover displaying a variety of symbols popular in Chinese folk design. In the center, a child rides a qilin, *representing the chance of having a male child who will rise to the rank of official. To the left of the creature is the fruit called Buddha's hand, symbolizing prosperity. Next to it, a pomegranate with its many seeds implies fertility, as does the gourd on the right side of the piece. Hebei Province. 23" diameter.*

Besides Liu Hai and the coin symbols, there are other less obvious symbols for prosperity. The carp, *li*, which is a homonym with the word for profit, is frequently depicted. Indeed, any fish, *yu*, a homonym for "abundance," is a symbol of prosperity. At New Year's, when a feast is laid as an offering before the God of Wealth, two live fish are included. After the ceremony, the pair are thrown back into the waters to live so that the *yu*, abundance, will continue. Golden fish (*jin yu man tang*) are also a symbol of wealth because, as mentioned previously, the expression is homonymic with the words "May gold and jade fill the halls."

The joys of wealth, children, and luck are amplified by a long life in which to enjoy them, making longevity, *shou*, the fourth essential ingredient of a good life. Chinese lore is full of stories about Taoist priests with recipes for immortality potions or about far-off lands where strange herbs of immortality grow. Past emperors went to great lengths to obtain such medicines. Those who did not have such luxuries used auspicious symbols, which they hoped would have the same effects. Even today, Chinese people eat long noodles on birthdays in hopes that they will ensure long life.

The Chinese language has two words that indicate longevity, *shou*, which literally means "long life," and *wan*, which means "ten thousand" but which implies ten thousand years, long life, or the concept of infinity. Both of these characters are frequently used as decorative patterns on embroideries and papercuts, and even on latticework for window and chimney openings in peasant homes. The *shou* character—壽—is often simplified to one of its forms as 寿, which is easier to work into a visual design than the more complicated form, and is also easier for a peasant woman to recall. The *wan* character—萬—is usually written as the backward form of the shape known in the West as the swastika. In Chinese it is known merely as the *wan* character, though when written out as a character it is far more complex than the swastika. In the simple papercut portrait of an immortal in Figure 92, center right, the *wan* character has been carved into the woman's stand, indicating her immortality.

The shape has appeared in artistic and religious works for thousands of years in many parts of the world and is in no way related to the Third Reich. It first appeared on funerary pots in Mesopotamia as early as 4000 B.C.[7] In China it appeared about 2000 B.C., possibly deriving from the characters for "clouds" and "to revolve," meaning rolling thunder. Some scholars say it derives from the key pattern used on the rims of Zhou dynasty bronzes.[8] One Chinese scholar, Lei Guiyuan, believes the symbol evolved from two overlapping S curves.[9] The S curve and spirals were

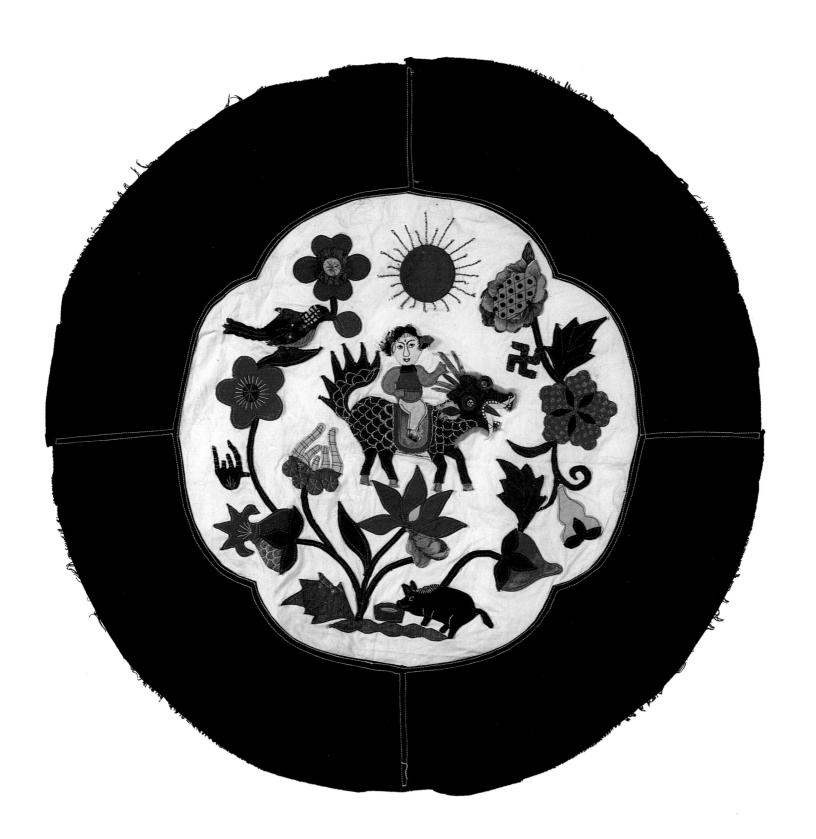

common in neolithic art, and the spinning of a spiral later came to represent infinity, as the *wan* character still does. The symbol also reemerged in China with the introduction of Buddhism. It is said to be the first of sixty-five auspicious signs on the footprint of the Buddha.[10] In Buddhist ideology it represents the ten thousand things — that is, everything — in the universe, constantly revolving and in motion but all united by the Buddha. Today in Chinese folk art, the symbol primarily stands for longevity and immortality, and few peasants consider its more esoteric origins. Like the coin symbol, the *wan* character is often used as a pattern to enliven otherwise empty spaces within a work.

Cats (*mao*) and butterflies (*die*) are also often used to imply the wish for longevity, since the words are homonyms, respectively, with the words for octogenarian and septuagenarian. The tortoise, renowned for its longevity, is also a symbol of long life, but is rarely seen in folk art today. In prerevolutionary times, the tortoise was always pictured at the base of stelae, or stone monuments. Tortoise shells were used in Shang times in divination with ancestral spirits. Bronze seals also often had images of tortoises on them and, until recently, live tortoises were buried underneath the main pillars of a house to ensure the longevity of its inhabitants. Its absence from modern folk art can be attributed to its connotations in Chinese slang: to call a man a *wangba,* "tortoise," is to say that he has been cuckolded, an extreme insult in Chinese society. Contemporary folk art works therefore rarely portray the tortoise, lest misunderstandings occur. The situation illustrates how folk art vocabulary is constantly changing, depending on the popularity of different symbols.

The peach in China has remained a symbol of long life and immortality since ancient times. It has been said that Xi Wangmu, Queen Mother of the West, a goddess in the Western Paradise and one of the most important members of the Taoist pantheon, had a great peach orchard. Here the peach blossoms flowered every three thousand years, and it took the fruit another three thousand years to mature. A bite of one of these peaches brought immediate immortality. In the woodblock print of Figure 54, the splendid annual Peach Festival, with Xi Wangmu seated in the center, is taking place.

A monkey is often pictured with a peach, an image developed only after the story "Journey to the West" ("Xi you ji") was written and became popular. This tale, which is an allegory of the striving for enlightenment as well as a description of an actual visit to India by a Chinese Buddhist monk, is one of the most popular in China, and scenes from it are often performed in opera and shadow theater. Folk art also frequently illustrates

it. The monk Xuan Zhuang made the pilgrimage from China to India during the Tang dynasty to bring some original Buddhist scriptures back to China. Several hundred years later, the author Wu Chengen wrote a novel based on this trip, incorporating the concept that anyone can become an immortal.[11] The main figure in the story is Sun Wukong, a king of the monkeys. Intent upon becoming an immortal, he managed to steal a peach from the great peach orchard feast given by Xi Wangmu, an act that created an exceptional uproar in the firmament. Sun Wukong, an irrepressibly mischievous character, had succeeded in becoming immortal only by breaking the rules. He was chastised by the goddess Guanyin, who forced him to accompany and protect the monk Xuan Zhuang on his journey to and from India. Only then would the goddess grant Sun Wukong full immortality. At the end of the trip, they were all welcomed back to heaven and granted immortality. The addition of the monkey to the peach images gives a humorous dimension to many pieces of folk art. On the embroidered pillow end of Figure 55, the whimsical monkey is holding a colorful, almost erotically shaped peach. The ear warmers in Figure 60 show the monkey in profile, precariously seated high in a spindly tree, munching on his long-awaited peach.

However, the relation of the peach to immortality began long before this tale was written and even before Xuan Zhuang went to India. The wood of the peach tree was long believed to be a powerful dispeller of evil forces. During the Qin dynasty, a piece of peach wood was put up at the gates of the Imperial Palace and of all official buildings at New Year's time to keep away evil spirits.[12] The *Li-ji* reports that shamans accompanying rulers on visits to mourning families would carry rods of peach wood to keep away evil spirits that might threaten death to the ruler.[13] In the first century, the writer Wang Cheng related that

> among mankind of most remote antiquity there were Shen Tu and Yu Lei, two brothers, endowed by nature with the power of capturing ghosts. They dwelt in the land of Tu-she in the eastern sea. Standing by a peach tree, they examined hundreds of ghosts and those which, without regard to *li* [propriety] . . . had wantonly inflicted misfortune on men, were bound with cords by the two and thrown as food to a tiger. Hence it is that district magistrates cut peach wood into human images and place them beside their door and that they paint tigers and affix them to the central gateposts.[14]

Fig. 54. Woodblock print depicting the grand
Peach Festival, presided over by the Queen
Mother of the West, Xi Wangmu, seated in the
center. Below are various auspicious characters
and symbols, including Lao Zi, the phoenix,
the monkey, and the deer. Hebei Province.
13½" × 21".

Fig. 55. Embroidered pillow end of the mis-
chievous monkey sidling up to an almost eroti-
cally shaped peach. Hebei Province.
3" × 3½".

Fig. 56. Rubbing from a Han dynasty tomb showing a hare pounding with a mortar and pestle in the second square from the top. The image is still a common one today in folk embroideries. Shaanxi Province.

It is possible that the peach was chosen as a protector against evil because the tree is an image of vitality, blooming profusely before its leaves sprout. Since it expressed the vital natural forces, which are *yang*, the tree became a repellent of evil, which is *yin*. Later, people came to believe in its power to endow longevity. In Figure 57, the papercut portrays a goddess, an immortal, seated within a peach design.

Another figure in Chinese fables, known for her attempt to achieve immortality, is Chang E, wife of Hou Yi. Her husband was a superb archer who, at a time when the earth was becoming too hot, shot down nine of the ten suns in the sky. For this great deed, Xi Wangmu presented him with an elixir of immortality. Chang E secretly drank the elixir. She intended to take only a small bit of it but swallowed it completely. Before she knew it, she had taken flight and landed in a jade palace on the moon, where she is said to be to this day. Some legends say that she became the three-legged toad when she arrived on the moon and that the hare, another resident of the moon often depicted in folk art, evolved from the elixir that Chang E coughed up when she arrived. The finely stitched pillow end of Figure 152 shows Chang E in flight to the moon. The waves of the earth below her and the wildflowers add to the sense of her uncontrollable floating away.

In ancient times, the hare was believed to live for a thousand years, and so it also became a symbol of longevity. Portrayals of it almost always picture it on the moon with a mortar and pestle, pounding the elixir of immortality under the cassia tree, as in the pillow end in Figure 59. Though the hare and the moon were related in Chinese mythology long before the Han dynasty (the hare, like the moon, is *yin*), Buddhism explains the hare's existence on the moon with a different legend. A hare in the forest came upon a starving man sitting before a fire to keep himself warm. The hare was so moved by seeing a man in such a state that he jumped into the fire to cook himself as food for the man. The man was actually a Buddha who rewarded the hare for his kindness by sending him to the moon. On Zhong Qiu Jie, the fifteenth day of the eighth month, when the moon is closest to the earth and therefore the largest, Chinese people make offerings to the evening source of light. On a table outdoors, they arrange food, incense, candles, clay statues of the hare spirit, and moon cakes that have usually been molded with pictures of the hare or of Chang E.

Fig. 57. Papercut of the Goddess of Mercy, the Boddhisattva Guan Yin, also often thought of as a goddess who brings male sons, sitting in a meditating position within a peach, a symbol of immortality. The goddess whom the locals often call Old Mother is probably a combination of Guan Yin and Xi Wangmu, a Taoist goddess who governs the great peach orchard. Shanxi Province. 6″ × 4″.

Fig. 58. Papercut of a monkey about to eat a peach. The whole image is a symbol of immortality, for it represents a scene from "Journey to the West," in which a mischievous monkey eats a magic peach and thus becomes immortal. The artist has decorated the monkey's body with wan characters — symbols of immortality — flowers, and coin symbols instead of covering the whole space with fur. Shandong Province. 5″ × 3½″.

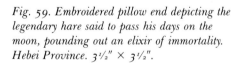

Fig. 59. Embroidered pillow end depicting the legendary hare said to pass his days on the moon, pounding out an elixir of immortality. Hebei Province. 3½″ × 3½″.

Fig. 60. Earmuffs embroidered with a simple but expressive design of the monkey consuming the enchanted peach. Shaanxi Province. 3″ × 2½″.

Fig. 61. Shadow puppet head of Lao Zi, the God of Longevity, with his characteristic high, bulging forehead and full beard. The lack of much carving wonderfully exaggerates the volume of the head. Shanxi Province. 3″ high.

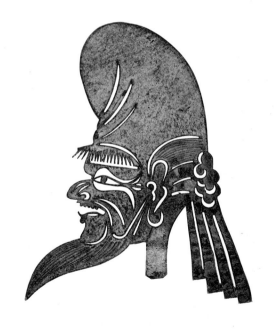

To assist other mortals who seek immortality or at least longevity, there is a God of Longevity, often called in Chinese Shou Xing (literally, the Star of Longevity) or Lao Zi, the Old and Respected One. Usually appearing as a long-bearded, aging sage with a walking stick and riding a deer, as in Figure 62, this character emerged as a legendary figure around the time of the Jin dynasty (265–420), possibly based on one of two mythical people, Peng Zu or the philosopher Lao Zi.

Lao Zi, whose real name was Li Er and whose existence has been debated, was the Taoist master who wrote the central Taoist scripture, the *Dao De Jing*. Although historical evidence places his birth around the sixth century B.C., legends hold that he was born before heaven and earth were created, lived through all the dynasties through to the Zhou, and served as minister for 276 years. Folktales say he was born with white hair, a protruding forehead, big ears, long eyebrows, a wide nose, a square mouth, big lips, wrinkles on his forehead, and three holes in his ears. He is also said to have been calm, lighthearted, passive, not worried about money, always avoiding danger, and concerned with his health—all characteristics that contributed to his long life.

Peng Zu, the mythical grandson of the ancient emperor Zhen Jian, was allegedly 767 years old at the beginning of the Shang dynasty, but he still looked young. Like Lao Zi, he was quiet and not concerned about clothes, fame, or politics. Whenever he had gold, he gave it to other people. He, too, paid attention to exercise and health. He rarely went traveling, but when he did, he walked instead of riding in a cart and never brought along food. He had forty-nine wives and fifty-four sons, but they all passed away during his lifetime. He died of grief at the age of eight hundred.

Both these men were inspirations for the God of Longevity, who is often seen in woodblock prints pasted up in homes. The Shanxi Province image labeled "Longevity as [high as] Southern Mountain" (Fig. 63) shows Shou Xing with his characteristically high protruding forehead and lengthy beard, holding a staff with a gourd attached to it in one hand and the peach of longevity in the other. His robe has been embroidered with the *shou* character, only half of which is visible because of the folds. In the papercut of Figure 62, he is shown riding a stag, as he is also commonly portrayed; according to legend, the stag is the only animal capable of finding the *lingzhi*, the fungus of immortality.

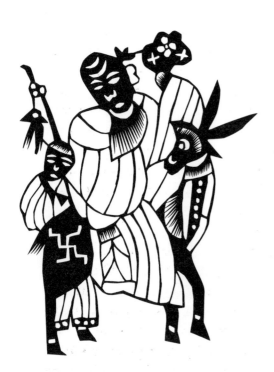

Fig. 62. Papercut of the God of Longevity. In his hand he holds a flowered lingzhi, *the fungus of immortality, and the flank of his curious stag is decorated with a vibrant* wan *character, also a symbol of immortality. Shandong Province. 5″ × 3½″.*

Though longevity is more conceivable than immortality, the latter, in the Chinese belief system, is considered a possibility for all human beings. Moreover, immortals are believed to exist in the midst of the human world, interacting with mortals—be they officials or commoners—and themselves having human characteristics. Many hundreds, if not thousands or millions, of immortals exist, but a particular eight, known as the Eight Immortals, are those most often depicted. Almost all of them were probably actual people to whom extraordinary powers were attributed after death, which is true for most gods in the Chinese pantheon. In artworks, the Eight are usually shown together, such as in a series of papercuts or as a group of silver amulets on children's caps commonly seen in southern China. Often Lao Zi accompanies them, as in Figure 64. The silver image of Li Tieguai, one of the group, attached to a child's cap from Jiangsu, illustrates the care that was given to expressing each deity's unique personality, familiar to most village folk from the many shadow plays and operas performed about them. Today, city people watch new television programs reenacting those same tales. The Eight represent all types of people in society—old and young, beautiful and ugly, male and female, rich and poor, afflicted and noble—reconfirming the belief that anyone can transcend death.

The breadth of the Eight can be imagined by reviewing the background of Lan Caihe, pictured on the cap on Lao Zi's right. She is carrying her flower basket, since she is the guardian spirit of florists. She is said to have been a street singer, always wearing tattered clothes and often singing of how quickly life and its pleasures pass, until one day (in a somewhat drunken state) she suddenly rose and drifted away on a cloud.

Often the Eight Immortals are represented not by their persons but by items. Li Tieguai is always represented by a gourd. Zhong Liquan is represented by a fan of feathers or a horsehair tassel; He Xiangu by a ladle and a basket of flowers; Zhang Guolao by a cylindrical bamboo instrument with two clappers; Lu Dongbin by a two-edged sword slung across his back; Han Xiangzi, the patron of musicians, by a flute; Cao Guojiu by a tablet allowing him imperial audience; and Lan Caihe, patron of the florists, by a basket of flowers. In the development of folk art, often a single attribute will come to stand for a much larger meaning. For example, a simple fan can symbolize revival of the dead and immortality, powers that Zhong Liquan possesses.

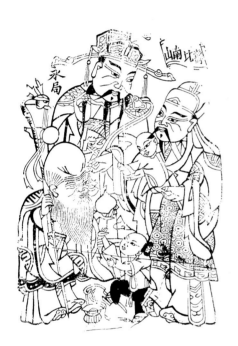

Fig. 63. One of a pair of woodblock prints to be hung on either side of doors. The spirits here are meant to bring longevity to the inhabitants of a household they guard. The God of Longevity is pictured at the bottom left. His robe is also decorated with the shou *character for longevity. Shanxi Province. 11½" × 8".*

Fig. 64. Detail of a child's cap. Nine silver amulets, representing the Eight Immortals and Lao Zi at the center, have been attached to the front of the cap; seven figures are shown here. The characteristics of each personality have been rendered by the artist. Such caps are typical of the Zhejiang and Jiangsu regions, but are rarely seen in the north or west. Zhejiang Province. Figures 1½" high.

To increase the possibilities of attaining happiness, wealth, and long life, over the centuries the Chinese belief system has developed a multitude of items and symbols that dispel evil. A glance at the architecture of the traditional Chinese home reveals this system at work. In the small villages, as well as in the cities, a wall—one side of which forms the back of the house—encloses almost all homes. Only in the front of the house are there windows onto the courtyard formed by the walls. To a person enclosed in this small fortress, everything outside appears suspicious and threatening. Various methods of protection are used to prevent anything evil from entering. First, a wall is built directly in front of the main gate, so that when one enters, one cannot see the residence. Called a spirit wall, it is meant to deflect any evil spirits that may try to come in. On the wall is usually a painted or woodblock print or an image of a tiger, one of the oldest Chinese images for warding away evil. In some regions, a small mirror is put on the doorway of the front gates so that any evil spirit contemplating entrance might glimpse himself in the mirror and be frightened away. The custom of hanging objects that protect against evil on doorways dates back to ancient China. Pasted on the doors are the door gods, who always come in pairs to fit the traditional Chinese entrance of two doors. These woodblock prints, which are renewed once a year at New

Year's time, once more protect the family from any harm wandering spirits may want to inflict upon them. The red of papercuts also warns away evil spirits. Inside, embroidered tiger collars, hats, and shoes protect the most vulnerable and treasured members of the family—infant sons.

In the Chinese belief system, most unexpected and unfortuitous occurrences are attributed to *gui,* or ghosts. Some of these are spirits who want revenge for having met unnatural deaths, or who died far from their homes and have no descendants to feed, clothe, or finance them in the afterworld. Others are merely mischievous spirits who abound in the Chinese countryside, ready to make trouble for hapless humans. The fox demon who disguises itself as a beautiful woman (Figs. 145 and 146) is one example. Peasants think it wisest to put up protection, just in case, and that protection takes many forms.

One of the most primitive and earliest methods of frightening off these *gui* is with noise. Firecrackers, which are now set off in celebration, both in China and Western countries, were invented for protective purposes. Originally made of exploding bamboo, they are set off on New Year's Eve to scare away the *gui,* and at any other festive or grave ceremony at which the *gui* might be tempted to interfere. Even laying the foundation of a home is an appropriate time for such noise making to keep the *gui* from inhabiting the new building. At eclipses, when the *tian go,* or heavenly dog, is believed to eat the sun, peasants bang on drums and make as much of a racket as possible in order to scare off the dog. Red paper with various characters is pasted up in every corner, entrance, and possible *gui* habitat.

Gui, such as those in Figure 127, work their will upon humans in many ways, or so the tragedies of life are interpreted by the Chinese peasant. *Gui* lie behind sickness, financial catastrophe, accidental death, and even emotional hysteria. In such cases, a shaman or Taoist priest may be consulted to perform an exorcism. Sometimes an unhappy *gui*—perhaps a deceased relative who feels the living are ignoring his grave, or one who wants to take revenge on those who hurt him during his lifetime—can be pacified with a series of offerings.

According to the Chinese calendar, *gui* (which are *yin*) are most troublesome during the summer, when the *yin* part of the year begins. The fifth day of the fifth month, which the Chinese call the Month of Poison, is the start of the season when disease proliferates. Many efforts are made to combat the *yin* forces, which include sickness and poisonous insects: various amulets and symbols are displayed. *Chang pu cao,* an herb with knife-shaped leaves, along with mugwort, which has an extremely offensive odor, are hung up on doorways, both sure to repulse any *gui.* Children

wear clothes such as the stuffed appliqué apron from Shaanxi Province in Figure 68. The colorful (albeit loathsome) creatures on it represent the *wu du,* the "five poisons" or poisonous insects that combat the sinister spirits. These are the snake, the centipede, the scorpion, the lizard, and the toad or spider (the specific insects vary from region to region). Today only children wear the images, but in the Ming dynasty even imperial eunuchs wore badges of these creatures on the fifth day of the fifth month.

In the Han dynasty, images of roosters were put up over the gates of the palace and all official buildings. The rooster is the symbol of the sun, since it crows when the sun rises. The sun is *yang,* and therefore so is the rooster. Being *yang,* the fowl has the power to frighten off the *gui.* Its loud crow each morning scares away all the *gui,* which particularly like to lurk about at night. Roosters also offer protection by eating insects, which can bring sickness. Following the example of the rulers, people carved roosters of wood or made painted images of them to keep away evil. Later, woodblock prints of the rooster were commonly hung up as well.

Since the Song dynasty, the custom of hanging a woodblock print of a fearsome figure named Zhong Kuei has also been popular at the start of the *yin* season. Zhong Kuei was a scholar of the Tang dynasty—a man of great intelligence but extreme ugliness. When he participated in the imperial examinations, he received the highest marks, an achievement usually rewarded by the hand of the emperor's daughter in marriage. But the emperor was so disgusted by Zhong Kuei's appearance that he canceled the marriage. Zhong Kuei, in terrible distress, killed himself. Years later, an emperor had a dream which revealed that Zhong Kuei had extraordinary powers in the underworld. The emperor had his portrait painted, and word spread that Zhong Kuei was the leader of the *gui.* During the Song dynasty, another emperor remembered his portrait and had a woodblock carved, afterward distributing the prints to his officials. So began the custom that still exists of hanging a portrait of this fierce yet brilliant scholar to frighten away evil spirits; because the *gui* revere him they will, so the legend goes, bring that home no harm. The woodblock print of Figure 199, showing the fierce Zhong Kuei accompanied by a tamer but equally serious tiger, would have been so displayed.

Door gods are also pasted on the entrance of homes, both on the front gates and the doors of the house. Chinese entrances consist of two swinging doors, and one figure is pasted on each door on New Year's Eve, when, it is said, the door gods are invited into the home. The *Zhou li (The Rites of the Zhou Dynasty)* speaks of peach branches being hung on either side of entranceways, as well as the hanging of tiger images.[15] Later the

Fig. 65. Papercut meant to frighten off evil forces; the figure is blowing on a horn and banging drums. Roosters, such as the one on his head, also scare away evil spirits with their crowing. Shanxi Province. 7½" × 4½".

Fig. 66. Woodblock prints of a pair of door gods. Pasted on the front gates of homes at New Year's time, they scare away evil spirits. Shanxi Province. 12" × 8".

tradition of figures representing door attendants appeared. Today woodblock prints—varying in size from one to three feet high, some multicolored and some only black lines—are pasted on gates to solemnly stand guard. Originally, they stood only in front of important mansions, ministries, city gates, and tombs. Later all households employed their images.

Sometimes the figures are not individualized; those holding brooms represent official greeters of dignitaries (the brooms signify that they have swept the ground in honor of the visit), while those carrying weapons are guards against evil spirits. However, various historical characters have served in this role. During the Han dynasty, Shen Tu and Yu Lei were the most common guards. The writer Wang Cheng tells us that in ancient times these two stood under a peach tree tossing evil spirits to tigers, and that by the Han dynasty their images were painted on doorways of homes to frighten off evil spirits.

After an event during the Tang dynasty, two other characters replaced Shen Tu and Yu Lei as popular guard images. The emperor Tang Taizong, legend tells, was having trouble sleeping nights and claimed that evil spirits were disturbing him. Two of his favorite ministers, Qin Shubao and Hu Jingde (also known later as Qin Qiong and Yuchi Jingde), offered to

stand guard outside his door; for the first time in a long while, the emperor slept soundly. Knowing that his best ministers could not stand outside his door night after night, the emperor commissioned portraits of these men to be painted on his door. The portraits were as effective as the men themselves. Later, door gods were printed on paper and sold inexpensively so that everyone could afford them. Peasants continue to hang images of Qin Shubao and Hu Jingde on their doors at New Year's time. Qin Shubao is depicted as a civilian dressed in long-sleeved robes with a white scholarly face, while Hu is shown in full armor with a fearsome black or red face. Later images adopted masks from the Chinese opera in illustrating these characters. Taizong's prime minister, Wei Zheng, also stood guard for him, and now, as a woodblock print, guards the rear entrance to homes. He is usually dressed in a combination of military and civil costumes with the hat of a high official.

The image of the tiger is one of the earliest to appear in China as a protector of both the living and the dead. Its ferocity and the fear it provoked in humans and other living creatures made people choose its image to frighten away threatening spirits. Tigers were plentiful in ancient China, and the animal was considered to be king of all forest life. This theory was further enforced by the *wang*, king, character, which can supposedly be seen in the stripes on its forehead. Many folk artists added this character to emphasize the beast's role, as can be seen in the tiger shoes in Figure 166.

Shang and Zhou bronzes and jades often depicted the tiger, though we are not yet sure of its significance in these pieces.[16] By the Warring States period, the image of the tiger's face was being painted, along with door attendants, at tomb entrances to keep away any forces that might want to tamper with the spirit or its property. Warriors wore helmets with images of tigers' faces on them to increase their ferocity and frighten the enemy; examples from the eleventh century were found in Henan.[17] Another tiger symbol is the shadow puppet tiger chair of Figure 148, upon which rebel generals sit to display their fierceness. Tigers, Wang Cheng noted in the first century, were being painted on the gateposts of district magistrates.[18] An impressive entrance to a fifth-century tomb, now standing in the History Museum in Beijing, shows a ferocious tiger face at the top of the rounded gateway; below him to either side are two door gods.

Fig. 67. Woodblock print of mothers and children. The children both wear tiger shoes to protect them from evil spirits. From Wu Youru hua bao.

During the Ming dynasty, the tiger was the most prominent image of the holiday on the fifth day of the fifth month, and even today pictures or woodblock prints of the tiger are hung up at that time of year, or at New Year's. Other amulets and objects ward away evil from individuals. In the Tang and Song dynasties, parts of the tiger, especially the claws, were often worn to prevent illness.[19] Tiger bones and ashes of tiger skins were used in medicines; even today, such ingredients command high prices in Hong Kong pharmacies. In the second century, Ying Shao wrote, "People who suddenly meet with ill should burn or roast a tiger skin and consume it with water; a claw of the beast if bound to the body may avert evil."[20] In *Feng su tong yi an*, written in 175, the author noted that "people being tormented by ghosts drink the soup of tiger skin for a cure."[21]

The most fragile and precious members of the family are sons, for they will be responsible for continuing the family line and caring for their elders in old age. Parents often hang a silver amulet in the shape of a lock around newborn sons' necks to lock them to life. And before even giving birth, mothers begin sewing hats, shoes, bibs, and collars, such as those in Figures 2 and 72, in the shapes of tigers to frighten off any spirit that might be tempted to harm their sons. Tiger hats (which look so similar to the eleventh-century tiger helmets), tiger collars, and tiger shoes—all with three-dimensional eyes, noses, mouths, and protruding ears—are given to boys on their one-month birthday, or one hundredth day, to protect them. The two-headed tiger cub, one head facing up and the other facing forward, is an example of such an object. While decorative and humorous, the animal also displays an open mouth full of teeth, signaling that it is bold and ready to fight.

Mothers create the tiger images in various styles. The tiger collar of Figure 72 from Shaanxi, with its purple eyes and flowered pelt, is quite a contrast to the more realistic Hebei hats, shoes, and collars, which have orange-and-black skins and include tails and all four limbs of the animal. The shoes with the side stripes fashioned into eyes assist the child in looking where he is going and keep him from tripping. Many mothers also make tiger pillows, two-headed beasts that watch out for the child's safety as he sleeps. Ge Hong, a Han dynasty writer, reported in his medical treatise that "in case of sudden nightmares, the best remedy is a pillow made of a tiger's head or resembling it."[22] Song dynasty ceramic factories also produced marvelous pillows in the shape of tigers.

Fig. 68. Appliquéd and stuffed child's apron to be worn on the fifth day of the fifth month, when evil spirits become more abundant. The five poisonous insects frighten away any threatening forces that might dare harm the child. Shaanxi Province. 11½" × 11½".

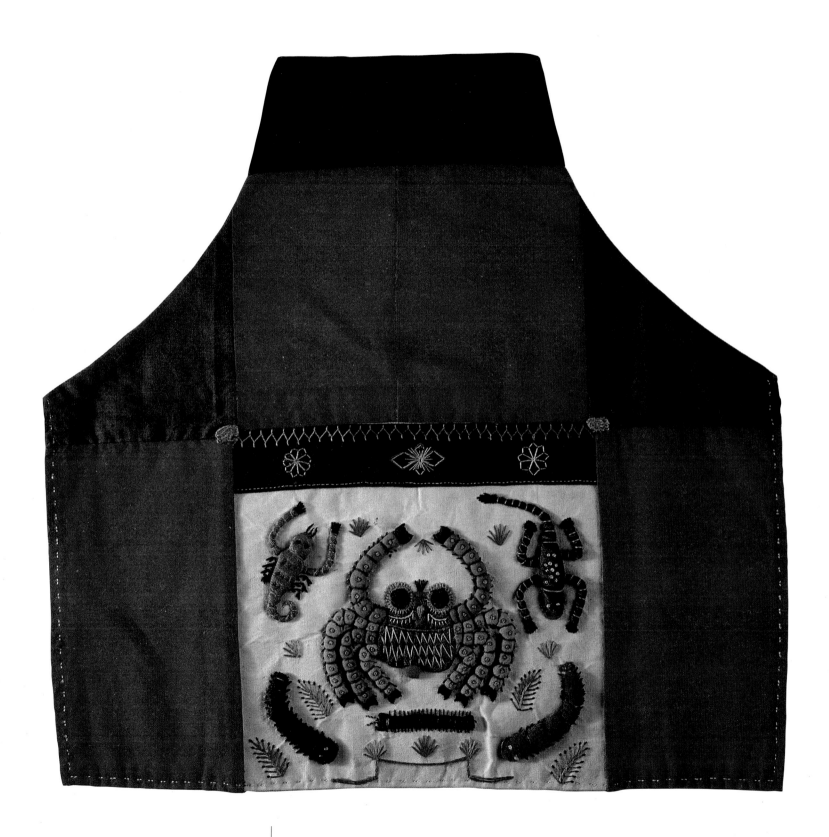

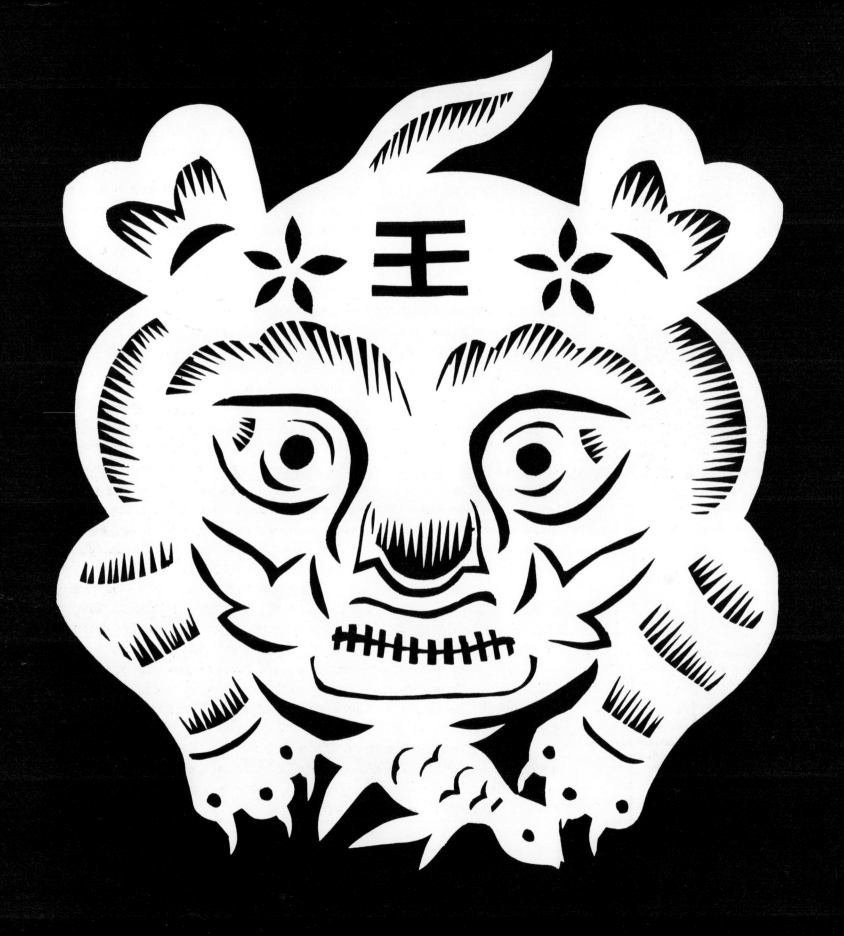

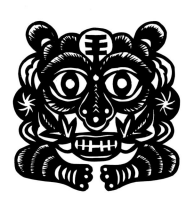

Fig. 69. *Papercut of a tiger meant to keep away evil spirits. The* wang, *or king, character on the animal's forehead notifies the spirits that he is the king of all creatures and therefore to be feared. Shanxi Province. 5" × 4½".*

Fig. 70. *Papercut of a tiger holding between his front paws a coin, symbol of prosperity. The image is very similar in construction to the tiger collar of Figure 2. Shanxi Province. 6" × 6".*

Fig. 71. *Papercut of a tiger. Shanxi Province. 5" × 5".*

Though in China the lion did not have the dominance as king of the beasts that it enjoyed in other cultures, it does play a role as a protective image, albeit less powerful than the tiger. The lion did not appear in Chinese symbolism until a comparatively late date, the Han dynasty. In fact, the lion is not native to China and had never been seen there until a foreign king had one sent in A.D. 87 as tribute to the emperor Han Zhangdi when asking for a princess's hand in marriage.[23] The lion image then came again to China with Buddhism as a religious image, representing the protector of the law. From that time on (or, as Arthur Sowerby argues, perhaps earlier), two lions sculpted of stone — one male, one female — have reposed outside all Buddhist temples in China. Later all important edifices, including imperial gates, were protected by this pair.

The development of the lion image has been quite unusual, for it moved from realism toward the fantastic. Until the Tang dynasty, the lion had been portrayed fairly realistically. But since the actual animal was rarely seen, its image changed as it came into widespread use, possibly influenced by Indian images brought by Buddhism. The lion began to look like a cute, squat pug dog. Like the *qilin* and the dragon, the lion became a legendary animal, very distinct in appearance from its real counterpart. This difference is quite obvious in folk art. Neither the papercut of Figure 78 nor the jolly stuffed hanging of Figure 73 resembles a ferocious jungle beast. The male of the species is often pictured playing with a ball, said by Buddhists to represent the wheel of the law. Some legends say that the milk of the lion — which comes from its claws — will bring immortality to those who drink it and that the ball was left out by men trying to steal this milk. In the dye-resist detail of Figure 184, the lion gleefully frolics within the circles the design has allotted him. The duty of the lion is still that of protector, though its image has become more playful than frightening, as can be seen in many examples of folk art as well as in the magnificent lion dances performed at religious and sacred festivities.

Finally, there are two other imaginary creatures of great import in Chinese cosmology, creatures invested with the highest powers and complex in their meaning: the dragon and the phoenix. These two fantastic beings symbolize neither *fu, lu,* or *shou.* When shown together, they represent the never-ending happiness of a married couple. Separately, they designate the imperial household — the emperor and the empress. Just as the appearance of a *qilin* was a heaven-sent approval of a reign, even more so was the sighting of a dragon or a phoenix.

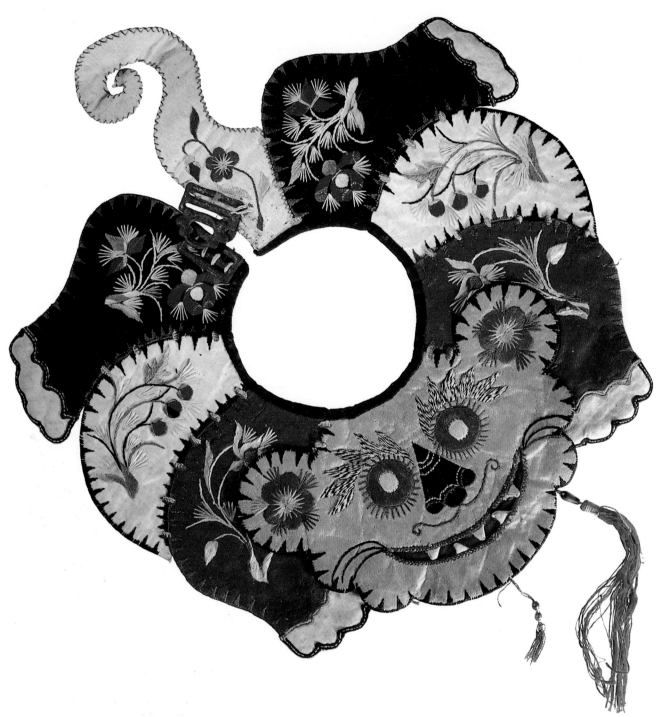

*Fig. 72. Child's tiger collar. A tiger's ferocity
scares away evil spirits, and mothers in all
parts of China adorn their children with tiger
images. With no concern for realistic portrayal,
this mother created a purple-eyed, flower-
covered fur tiger. Shaanxi Province.
13½" × 11".*

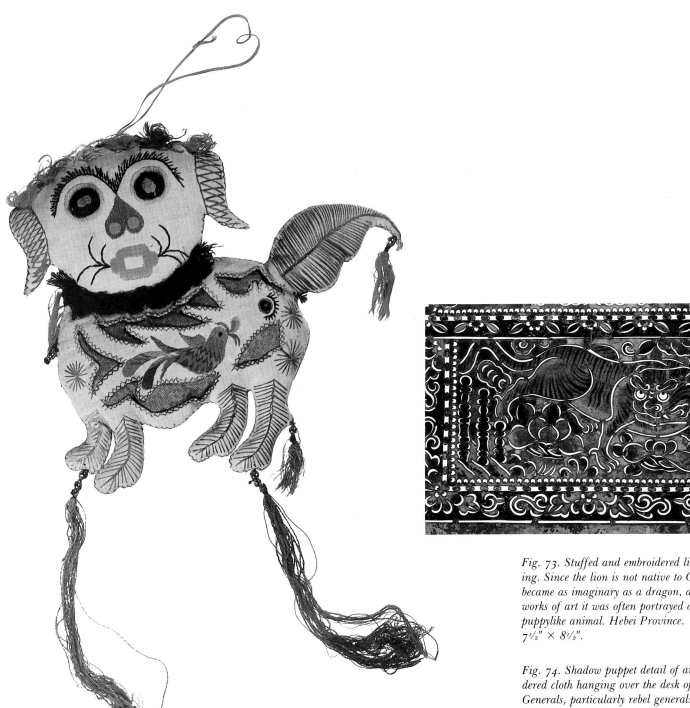

Fig. 73. Stuffed and embroidered lion hanging. Since the lion is not native to China, it became as imaginary as a dragon, and in works of art it was often portrayed as a puppylike animal. Hebei Province.
7½" × 8½".

Fig. 74. Shadow puppet detail of an embroidered cloth hanging over the desk of a general. Generals, particularly rebel generals, were often shown in opera and shadow theater with some form of tiger image to emphasize their bravery.

The dragon is said to have first appeared during the mythical reign of Fu Xi (2852–2737 B.C.).[24] It rose out of the Chai River, and on its back were engraved the symbols of the Ba Gua, symbols that held the secret to many later Taoist theories. Fu Xi then honored his officials by giving them the title of dragon, since such a great animal had presented him with these symbols.

As has been the case with other mythical creatures, descriptions of the dragon have been embellished over the years. The dragon has been variously described as having the horns of a deer, the head of a camel, the neck of a snake, the viscera of a tortoise, the claws of a hawk, the palms of a tiger, and the ears of a cow; and to hear through its horns, since its ears are deaf, and to blow clouds from its mouth. All Chinese, though, agree that the dragon, its form derived from the snake, is a benevolent being that inhabits both heaven and the ocean. It is said to ascend to the skies at the spring equinox and return to the seas at autumn. By living in both places, the dragon is able to control the rains, and it is for this power that it is most worshipped. Certainly this ability accounts for the reverence in which it was held by China's early agricultural population. In times of drought, the people prayed to the dragon for rain. Ceremonies that included music, incense, and theatricals, and at which paper and bamboo dragons were carried by eight men, would be performed. If still no rain came, the frustrated and disappointed villagers would trample on a picture of the beast.[25]

Numerous legends have developed about this wondrous creature, who is said to live in a palace at the bottom of the sea. Shadow puppet tales, employing such puppets as the friendly beast of Figure 77, would tell of virtuous men who once threw a live carp back into the ocean. Later, after capsizing at sea, they found themselves at the door of the dragon palace being invited to marry the beautiful daughter of the dragon king and live in luxury. All of this was a reward for having saved the carp, which had actually been a transformed dragon. Originally thought of as the rain giver, the dragon developed into a force that could bring riches to the kind and humble.

Beginning in the Shang dynasty, the dragon became the symbol of the imperial throne. It is displayed on Shang banners and Zhou dynasty robes, and is a frequent motif on Zhou bronze vessels. The dragon also appears on imperial furniture, architecture, and documents. The five-clawed dragon designates the emperor; according to prerevolutionary law, it could not be used on any other person's objects. The dragon robe with its many five-clawed dragons embroidered with silk and gold threads became an institution during the Qing dynasty (1644–1911).

Fig. 75. Circular papercut known as tuan-hua, *round flowers, to be hung on the ceiling, usually above the bed of a newly married couple. This work depicts a dragon and a snake, possibly the zodiac years of the two young people. Shaanxi Province. 9" diameter.*

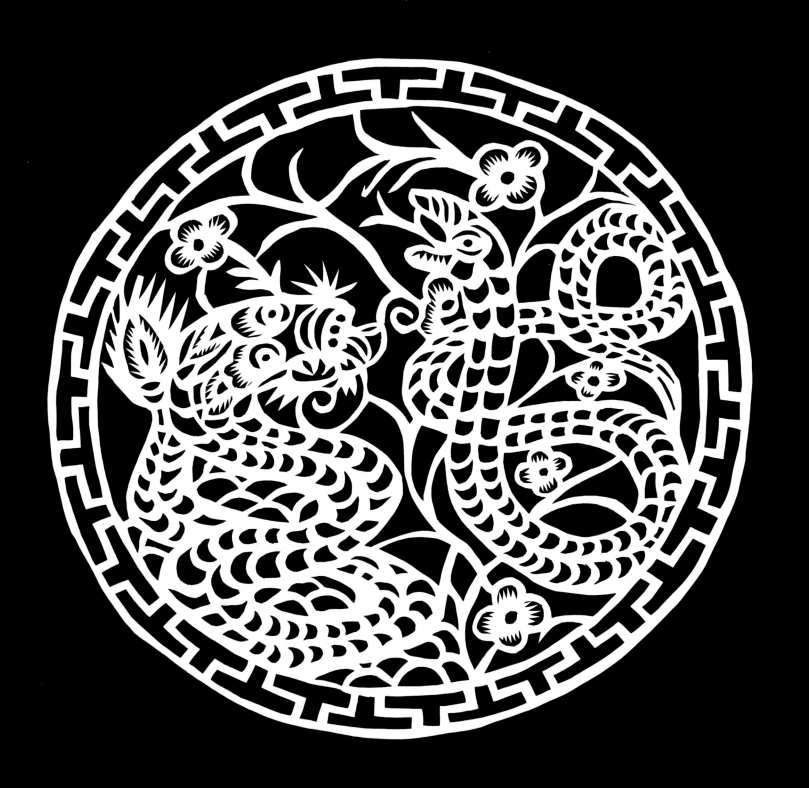

Fig. 76. Papercut, meant to be used as an embroidery stencil, portraying a dragon playing with a ball. A stencil of this shape would be laid on the front of a shoe and then stitched over completely with colored threads. Hebei Province. 5" long.

Fig. 77. Shadow puppet dragon. Nineteenth century. Shaanxi Province. 21″ long.

Fig. 78. Papercut of child drinking milk from a friendly lion. The milk of the lion was believed in some regions to bring immortality. Shandong Province. 5″ × 5″.

Fig. 79. Papercut of a water buffalo with decorative flower shapes and spirals worked into the design of the fur. Shandong Province. 5″ × 7″.

Perhaps because the image of the dragon has been so closely associated with the emperor—to the point that execution threatened those who used the symbol wrongly—it rarely appears in folk art decorating peasants' homes. Though many folk art images and crafts did descend from imperial patronage, the dragon is not one of them. It does, however, figure in folklore. A shadow theater production would certainly be considered remiss if its imperial characters did not have elaborate dragon thrones, such as the one in Figure 149, to recline upon. Dragons also appear in temple decorations to emphasize the imperial quality of the deities. In addition, many villages have their own dragon temples, which are of utmost importance, for there the people can pray for rains.

Though the phoenix, *feng huang*, is a symbol of the empress, it is still often portrayed by peasant artists. Like sightings of the dragon and the *qilin*, its appearance on earth was a signal that the current ruler was approved by heaven. It is said to have first appeared in the reign of Huang Di (2697–2597 B.C.) and then in several subsequent reigns through the Ming dynasty.[26] As seen in the dye-resist quilt cover of Figure 84, the phoenix's image was most likely inspired by the chicken, a fowl not native to China, and its appearance became elaborated. The six-foot-high bird is

said to have the head of a chicken, the eyes of a man, the neck of a serpent, the brow of a swallow, the mouth of an eagle, the back of a tortoise, the body of a mandarin duck, the feet of a crane, the wings of an eagle, and the tail of a pheasant. Its song contains five notes and its feathers five colors. Flying about the Kun Lun Mountains, it is said, it alights only on the *wu tung* tree, eats only the fruit of bamboo, and drinks only the waters of crystal streams.

Worship of this legendary fowl most likely developed out of an awe of birds in general, since birds are able to fly to the heavens and therefore can be one of man's messengers or contacts with the celestials. The *feng huang* (the male of the species is called *feng*, the female *huang*) represents the sun and therefore is *yang*. Because of its *yang* powers, as well as its later association with the female sex and beauty, the bird is believed to have much influence in pregnancy. In the center of the Figure 84 dye-resist bedspread, part of a dowry, two phoenixes circle each other, guaranteeing marital harmony. Since most folk artists are women, they certainly feel an affinity with and admiration for the phoenix, worshipping it for its fertility powers, and therefore do not hesitate to portray it despite its imperial origins. The creature fulfills their needs, just as the tiger image on their son's shoes assuages their fears for his health, the coin symbols allow them to dream of wealth, and the door gods grant them peaceful sleep.

In and about all the many symbols and images mentioned in this chapter are as many various geometric patterns: squares, circles, sometimes spirals, or even flowers, such as those carved out of the solid areas on the flank of a water buffalo (Fig. 79). The designs on the empty areas of the papercuts are similar to such designs on Shang and Zhou dynasty bronzes and to those on the Warring States period bronze pot of Figure 80. Despite their lack of symbolic significance, these designs are as essential as the other images to an artwork. The brightly colored threads, the flower patterns, the extra dots or crescent designs—the experienced artist knows when and where to place these extra decorations to enhance the meaning of her work, to celebrate that which it symbolizes. Occasionally a piece may be of only decorative value, such as the geometric, lacelike papercuts of Figure 83 from Gansu Province, or the portrayal in Figure 81 of farm work (which expresses the pride of the peasant, a status of much virtue in the Confucian hierarchy). These works enrich their surroundings because their innate beauty itself expresses the understood hopes for *fu, lu, shou,* and *xi*.

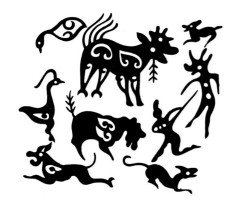

Fig. 80. Images from a Warring States period bronze vessel. The designs carved away within the animal and human figures, enhancing the decoration and avoiding large empty spaces, are similar in aesthetic concept to papercut designs. From Beijing Fangzhi Kexue Yanjiusuo, Zhongguo gudai tuan.

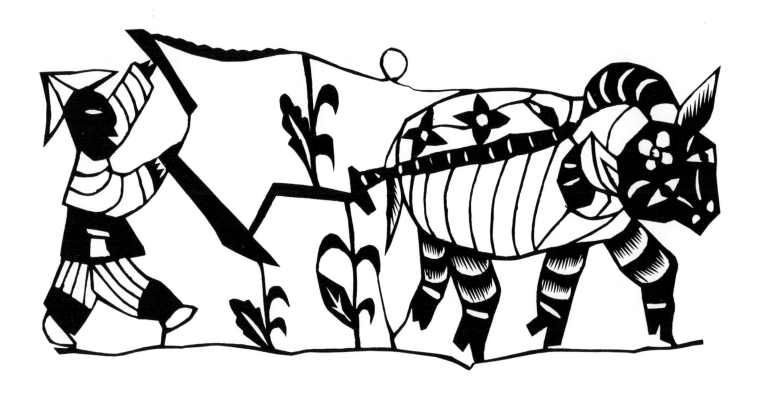

*Fig. 81. Papercut of a farmer and water buf-
falo plowing fields. The line of the whip,
twisted in the middle, and of the uneven
ground create boundaries for the image. Shan-
dong Province. 3″ × 8″.*

*Fig. 82. Papercut of a man about to shear a
sheep. The designs on the animal's body are
reminiscent of those on the Warring States pe-
riod bronze vessel. Northern Shaanxi Province.
3″ × 3½″.*

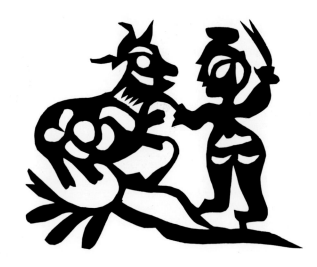

In the creation of folk art, this vocabulary of symbols and legends forms the foundation on which individuals then build, using their own creativity to elaborate on and convey them in a particular style. Comprehending these basic ideas and the values they reflect helps the observer appreciate the construction and appearance of a work, as well as the beauty it may radiate.

Fig. 83. Papercut with geometric designs forming a six-pointed star, possibly influenced by Islamic aesthetics, since there are many Muslims in Gansu, where this piece was made. 5" × 4".

Fig. 84. Dye-resist-patterned quilt cover. Phoenixes in full plumage, symbols of conjugal happiness, circle about the spread. Eighteenth to nineteenth century. Sichuan Province. 59" × 75".

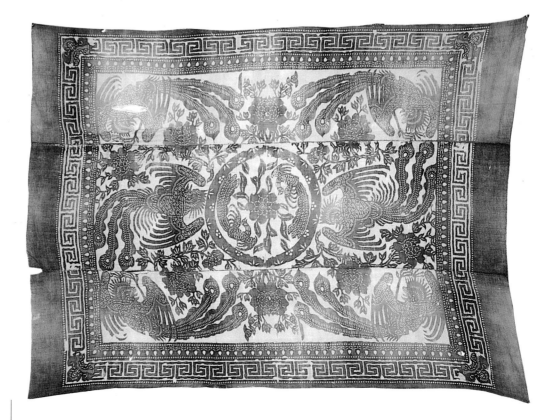

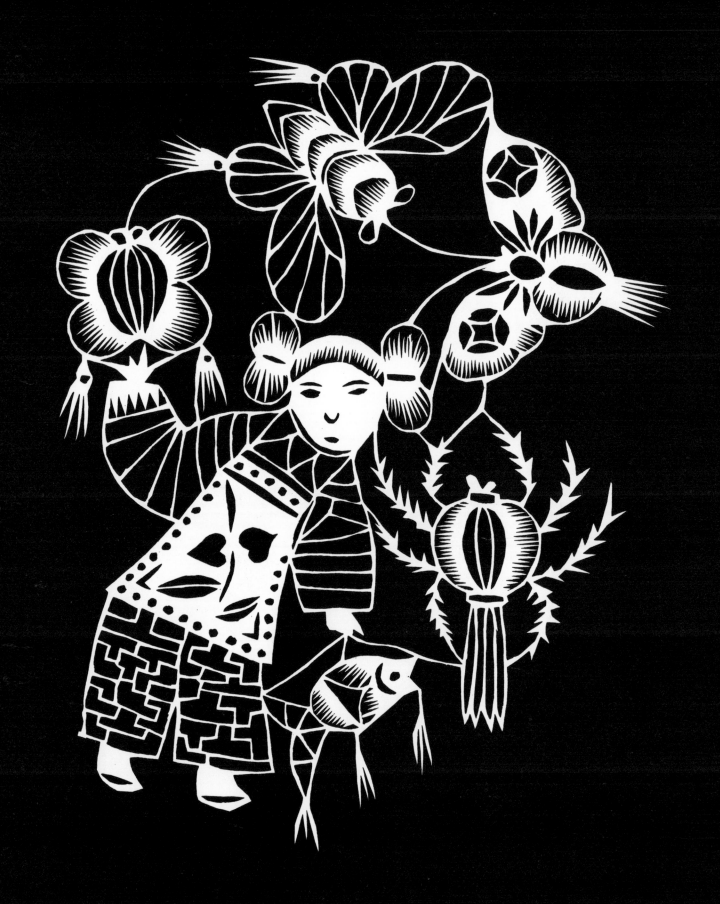

Papercuts

Smoke rises from the chimney of a small rammed-earth house. Inside a young girl is feeding dried leaves and grasses into a large stone stove, while another stirs vegetables in a pot on top of the stove. On the *kang*, the large bed connected to the stove, their grandmother sits with a knife, a wax-covered board, and colored paper, delicately carving out designs modeled after those her mother, grandmother, and all their maternal ancestors before them had made. As she finishes the papercuts, she pastes them onto the new paper windows, just glued to the lattice frames for the coming of the New Year. Visitors will notice the papercuts when they enter the house. In the evening, the oil lamp will illuminate them from within, giving the appearance of shadows of puppets thrown upon a screen. And late at night, the light from the moon will outline for those still awake the images on the windows.

Such is the scene in many villages today, and so it has been for centuries past. To decorate their homes (and occasionally even foods) for festivals and celebrations, women cut out intricate designs depicting legends, gods, and a variety of good-luck symbols. Created with the simplest of tools — a knife or scissors and paper — the papercut can be found in many Chinese rural towns, from Shandong to Shaanxi Province, and is still one of the most basic and popular arts of Chinese village people.

The great majority of contemporary papercuts are made in the home and not for sale. Unless otherwise noted, the papercuts reproduced here have been made within the past ten years. Though recently cut, they are, as is customary in the art, modeled after works passed down over generations. Therefore they can be considered traditional and, except for cases in which modern influence is remarked upon, sharp shadows of papercuts made a century or two ago.

Fig. 85. Papercut of a girl carrying an assemblage of lanterns in a variety of shapes, such as are popular at the Lantern Festival, held on the fifteenth and concluding day of the New Year's festivities. In the Tang dynasty and even through to modern times, it was common to paste papercuts within these lanterns. Shandong Province. 6½" × 4½".

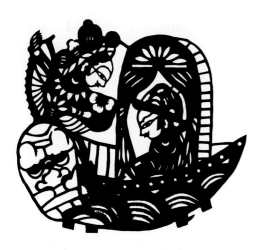

Fig. 86. Papercut of a woman and a man on a boat, a scene from a popular opera. The style of the cut's carving, particularly the face, is very similar to that used in creating shadow puppets. Shanxi Province. 4" × 4".

Fig. 87. Earliest papercut in existence, discovered at an archeological excavation in Xinjiang. The Xinjiang Provincial Museum has dated it to the Southern and Northern dynasties. (From Wenwu 6[1960], 19.)

An art form extremely reflective of personal style, the papercut has also influenced the other folk arts, many of which derive from or draw upon this medium. In embroidery, papercuts are sometimes used for stencils, in the process being completely covered by the stitching. Papercuts have also been employed as stencils for dye-resist patterning of textiles and the glazing of designs on pottery. The original shadow puppets were made of paper. And though the exact beginnings of shadow puppets are unknown, it is very likely that the custom of pasting papercut figures on lanterns inspired them.

The origins of this craft lie deep in history but clearly do not predate the invention of paper during the Han dynasty (206 B.C.–A.D. 220). Until then, scribes had carved on tortoise shells and bone and had used ink and later brushes on bamboo and silk. A sixth-century A.D. historian, Fan Ye, attributed the invention of paper to Cai Lun, a eunuch of the imperial court who died in A.D. 121. However, texts written by Cai's contemporaries do not mention such an achievement. Moreover, remnants of paper made of crude hemp—the main ingredient of the first papers—dating to 49 B.C. were found in 1957 outside of Xian. Several early texts also made note of the material.[1] A story is told in San gu shi, a Han text, of the prince of Heng (son of Han Wudi, who reigned from 140–84 B.C.), who had a very large nose.[2] When the emperor, who hated the prince's nose, took ill, the prince's tutor advised him to cover his nose with a piece of paper before entering the sick man's room. This reference in a story that predates Cai Lun by almost three hundred years argues against his being the inventor of paper. However, other texts suggest that Cai Lun's contribution may not have been the invention of the material but the refinement and organization of its production. Cai Lun's improved technique moved beyond hemp to include finely chopped rope ends and rags.[3] Later, bamboo and the bark of the mulberry tree came to play important roles in papermaking, enabling the creation of papers of high quality that in turn allowed for the development of paper arts.

Because paper is such a fragile material, few early examples of papercutting exist. Those that have survived suggest that when the art was first developed—concurrent with the invention of paper—and later, artisans often carved thin silver and leather for decorating the sides of carriages and hair ornaments, so the eventual leap to incising paper was not a great one.

In 1959, Chinese archeologists from the Xinjiang Autonomous Region Museum, excavating a tomb near Turfan, found the earliest examples of papercutting. These are five round papercuts dating from the Northern

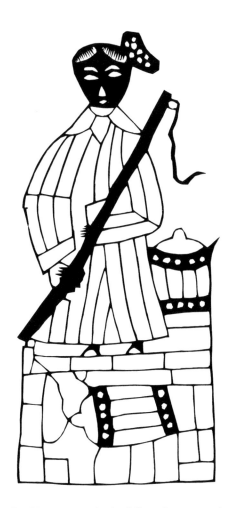

Fig. 88. Papercut in the delicate but geometric style of Gao Mi County in central Shandong Province. The contrast of the very thin lines with the few heavy ones — here almost all completely rectangular with only a few small round dots — gives the papercuts of this region their own very distinct and elegant style. A woman dips a bucket into a well; after both buckets are full, she will carry them at either end of the pole. 6½" high.

dynasties (486–581). Some have purely geometric patterns cut into them, while others are decorated with repeated animal figures. One portrays a series of deer or horses, each connected to the next by its tail; another depicts monkeys. According to Jin Zhilin, a Chinese researcher of papercut history, scholars in China have generally accepted that these were decorative objects.[4] It is also possible, however, that the Turfan papercuts were intended to represent money for the dead to spend in the underworld. They are extremely similar in appearance to the paper money used in some funeral ceremonies today in Guangdong Province.

At funerals and in daily worship of deities all over China today, mourners and devotees burn paper money. The smoke is said to carry the essence of the money to the spirits. Like the living, the spirits of the dead desire affluence; to thank those who send them riches, they assist in any worldly problems. The paper spirit money in most areas is cut from a rough, yellow, locally handmade paper, sometimes with bits of silver or gold metallic paper pasted on it or printed with simple woodblock designs. According to legend, it was also Cai Lun who first thought of employing paper for this spiritual purpose. In a scheme to popularize his invention, he and his wife pretended that she had died. Cai Lun then burned pieces of his paper and later claimed that the spirits, grateful for the gift, rewarded him by bringing his wife back to life.[5]

In general, though, spirit money is meant not to restore life but merely to make the afterlife more comfortable for the dead. No records can be found mentioning paper money for the spirits until the Jin (265–420) and Northern Wei (386–534) dynasties, casting a long shadow of doubt on the Cai Lun tale. Originally, round copper and silver coins were placed in graves, but an excess of grave robbing necessitated a better way of providing the spirit's needs. Under the Tang dynasty (618–907), a minister, Wang Yu, burnt paper money at imperial sacrifices but was fiercely opposed by more conservative officials hesitant to change customs. During the Song dynasty (960–1279), when the practice was beginning to take hold, ministers Kao Feng and Liao Yongzhong brought a petition to imperial notice announcing that "Perforating paper, so as to make it resemble money and burning it to procure happiness is an absurd and silly delusion."[6] These remarks, particularly the mention of the perforated paper being burnt for spirits, leads one to believe that the Turfan papercuts were meant to be spirit money.

The first mention of a papercutter appears in the Jin dynasty.[7] Jia Yuan, the wife of an official, lived during a time of political turmoil as well as great cultural development. Like others trying to distract themselves from the harsh realities of war, Madam Jia turned to fashion, cutting designs out of paper that she would then wear in her hair. In doing so, she began a custom whose popularity would reign for more than a thousand years, first among the wealthy and later among all classes. Hair coiffure already had a long history in China. In Shang times (16th–11th century B.C.), bones were carved into ingenious bird and animal shapes to be fitted into hairstyles. Later, ornaments of jade, gold, and silver were worn by those who could afford them. Examples of the last can be seen in the Tang dynasty murals at Dunhuang.[8] These silver pieces—delicate floral and geometric designs cut out of thin metal—suggest what their paper counterparts might have looked like.

Papercuts became associated with the New Year's festivities not long after the Jin dynasty. Dian Chengshi's text *You yang za zu* records that women during the Northern dynasties "on welcoming spring day [New Year's] would cut paper [designs] in the shapes of dragons and frogs and paste them onto little flags."[9] In the Tang dynasty, the text explains, paper was cut in the shapes of butterflies, swallows, and flowers, and stuck in

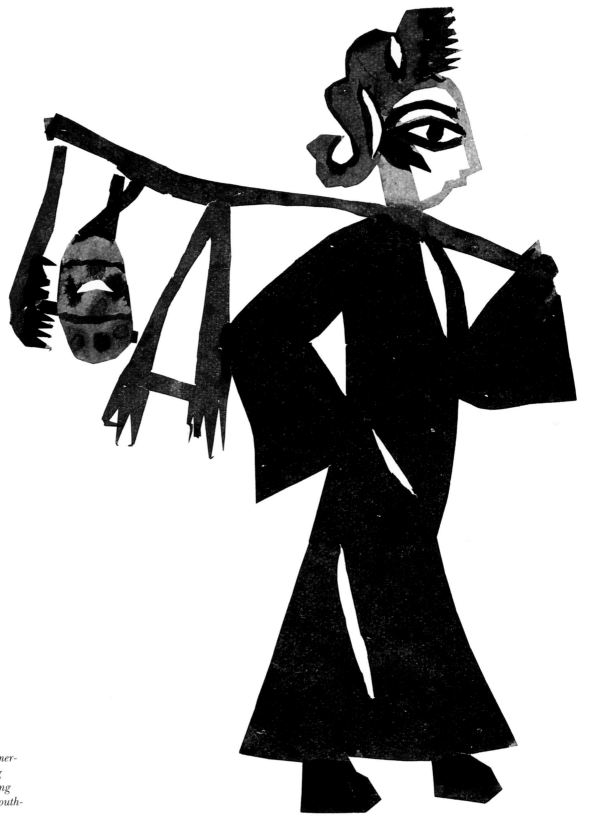

Fig. 91. Colored papercut of a traveling merchant. The simplicity in the carving, along with the bright but restrained use of coloring dyes, gives this piece a bold appearance. Southern Shaanxi Province. 3" high.

Fig. 92. Papercuts of figures in traditional, pre-twentieth-century costume. Shandong Province. 5½" high.

Fig. 93. Papercut of figures, one riding an animal below a tree from which birds and a snake look on. Northern Shaanxi Province. 6" × 6".

women's hair. Another text, *Jing chu su shi ji*, notes that it was the custom to cut out swallows and the characters *yi chun*, meaning "about to be spring," and paste them on gates.[10] And on the seventh day of the New Year, which was called the day for people (the first six days being devoted to spirits and ancestors), papercuts of human figures would be pasted on screens and in the hair. Both gold metallic paper and glossy black papers were used for these adornments.

The development in the Tang period of a range of colored and specialty papers further enhanced the papercut art. The biography of the Tang figure Wei Bu notes that he often wrote his books on paper of five different colors, while the poet Li Shangyin writes of composing a poem on paper the color of peach flowers. Another poet, Bai Juyi, mentions green and red decorative papers.

During the Tang, the proliferation of papercuts at New Year's continued with variations in color that far superseded those of the Jin period. Papercuts with silver and gold foil in flower shapes were often stuck on *dui lian*—the strips of red paper pasted on either side of a household's entrance at New Year's time with poems or season's greetings written upon them—to add an extra sparkle. When presenting the emperor with gifts, officials would place small, charming papercuts atop them as decoration. The imperial court also took up the practice, and at New Year's, the emperor Tang Zhongzong would have many colored papercuts pasted on banners and would present individual cuts to each official at New Year's feasts. The abundance of these delicate paper designs during the Tang period is evident from the many poems of that era which mention them and their relation to the New Year's festivities. "The butterfly flits about the fragrant strands and stops; / The bee goes to sip from the flower; / This year spring is early, / The [paper] cutting hurried it along," writes Song Zhiwen.[11] Poets also often refer to the papercuts of the Lantern Festival, which marks the last day of the fifteen-day New Year's celebration. The Tang poet Du Fu, one of the most acclaimed Chinese poets of all ages, mentions at least twenty times throughout his work "lantern flowers," or *denghua*, the papercuts pasted inside the paper walls of the fantastic lanterns paraded on this joyous holiday.[12] The delicately carved holes in the papercuts allowed the lanterns' light to shine out, while the bright light emphasized the graceful lines of the cut.

Besides being decoratively applied to papers and gifts or tucked into the hair, papercuts were also seen on Chong Yang Jie, the ninth day of the ninth month. Traditionally, on this day city people would go out to a rural setting, most often a mountain, to appreciate nature and would bring

Fig. 94. Papercut of a figure under a blossoming tree, atop which is perched a bird. Shanxi Province. 4" × 2".

along a special pastry. During the Tang period, people would ornament these cakes by sticking small flags bearing papercuts into them.

During the Tang dynasty, papercutting reached its full expression as an art form. A woman's skill in papercutting had already been considered a reflection of her talent and elegance, but now that skill entailed far more elaborate cuts and began to generate great admiration. Poems of the time reveal the attention being paid to these small works of art by both the creators and admirers. The Tang poet Xu Yenshou writes: "The girl sits there cutting her papercut, / Incising her new designs and colors. / In her hands the flower of spring / Is like a swallow alighting on her house to bring it beauty, / A chicken as real as it could announce the hour, / She brings it to her husband, / What part of it does not look real?"[13]

Unfortunately, because paper disintegrates so easily, papercuts are a highly transitory art form, a passing beauty. The only example still extant from which we can attempt to form a picture of Tang papercuts is in the Shoso-in, the Imperial Depository in Nara, Japan. During the ninth century, the Japanese became entranced by Chinese society and collected innumerable artworks, which they preserved for centuries in their warehouses and museums. The papercut in the Shoso-in is made of several pieces of paper. A relatively wide square border forms the frame. The images of flowers and leaves in the border were created by cutting the forms away, leaving only thin lines of white paper; the whole was then laid on a backing of metallic paper. Within the border are a human figure, a dog, and a tree, all separate from the border and all carefully painted with ink and a range of colors. The piece provides an exquisite yet playful impression of the fine papercuts being made more than a thousand years ago. It appears to be neither a hair ornament nor any other kind of simple decoration. Perhaps it was simply made by a woman to present to her lover—in a moment such as that described in Xu's poem. In fact, it was during the Tang period that the custom of cutting papercuts for weddings began, a custom that has endured to the present.

Such elegant designs in paper continued to earn the praise of poets and writers in the Song dynasty. Zhou Mi, in his text *Wulin jiu shi*, which tells of life in the capital city Wulin (present-day Hangzhou) under the Southern Song rule, speaks of cutters so skilled they could cut out characters that looked like those of famous calligraphers.[14] A Yuan dynasty (1279–1368) gazetteer from Baoding in Hebei Province remarks on a young woman so talented she could cut out images of a slender willow tree, blossoming spring flowers, and autumn chrysanthemums inside the sleeve of her robe while she was having a conversation.[15]

Fig. 95. Papercuts meant to be used as embroidery stencils. This shape would be glued on the front of a shoe and then stitched over with variously colored threads. Hebei Province. 3" × 2".

There are no records of when merchants first began selling papercuts, but their availability for sale on the streets also became common practice during the Song dynasty. During the Southern Song period, when the capital of the country had been moved south to Wulin preceding the Mongol takeover of the north, Meng Yuanlao wrote a reminiscence of life in the old capital. In his work *Dongjing meng hua lu*, as in Zhou Mi's *Wulin jiu shi*, there are descriptions of marketplaces on the eve of New Year's selling calendars, gate gods, peach amulets, tiger-head images, and papercuts.[16] Many of these papercuts were intended as stencils for embroidery. The embroiderer would lay the papercut on the fabric and stitch over it so that none of the paper was left uncovered. Some women today still employ this technique. The papercuts in Figure 95 are examples of twentieth-century stencils from Hebei Province. As has been and still is the case with most folk arts in China, including papercuts, women create art for their personal use—as hair ornaments or home decorations—and men participate in producing the objects for commercial sale. Women customarily do not leave their homes or engage in market activities. Indeed, while most of the papercuts presented here were made by women in their homes, an elderly man who learned the craft from his father carved for sale the two embroidery stencils from Hebei (Fig. 95).

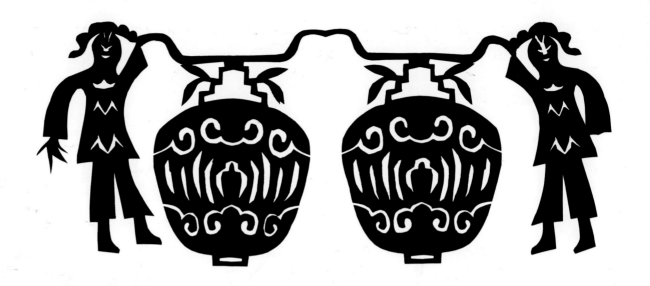

Fig. 96. *Papercut of two men carrying giant lanterns, a lighted candle within each one, for the Lantern Festival, held on the fifteenth day of the New Year. The cuts clearly evoke the scissors that carved them. The piece was made by folding a paper in half and then cutting to make a symmetrical image. Shanxi Province. 5½″ × 11½″.*

Fig. 97. *Papercut of a* qilin *carrying a child; it is accompanied by a goddess on its way to give the boy to a sonless family. They walk across delicately carved cloud images, and above them floats the moon. Hebei Province. 4½″ × 4½″.*

Traditionally, women and not men have worn papercuts in their hair, as indicated by a story told about Su Dongpo, a member of the Song literati and an official. While enjoying festivities with his nephews and their young friends, Dongpo playfully stuck a papercut ornament in his hair. The youngsters burst into laughter at the ridiculous sight of a man wearing women's coiffure. The custom of these hair papercuts was still common during the Song period. With new hairstyles of high buns, it became popular to place the papercuts, often made of glossy black paper to match the sheen of women's hair and cut in the shape of swallows and butterflies, at the peak of the bun. "Paper swallows welcome the spring flying through the hair," wrote the Song poet Wang Zhigong.[17] This lovely custom of wearing papercuts in the hair did not fade until the Ming dynasty (1368–1644).

Papercuts took on an added function during the Song era. Small, simple designs of birds or flowers were pasted onto bowls or vases before the glaze was applied. The artist would remove the cuts after glazing, leaving unglazed images. Sometimes the papercuts were laid on a base glaze, after which a second color would be applied, so that the image and background were two different colors; brown patterns surrounded by a rich red or purple are an example. This decorative ceramic method was known as

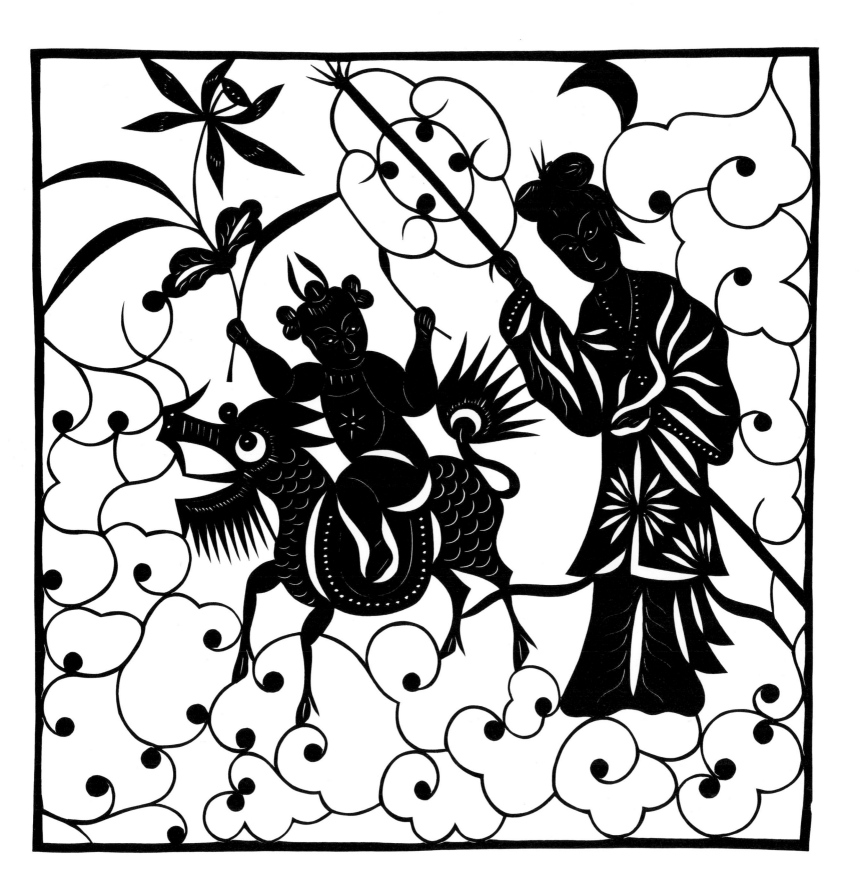

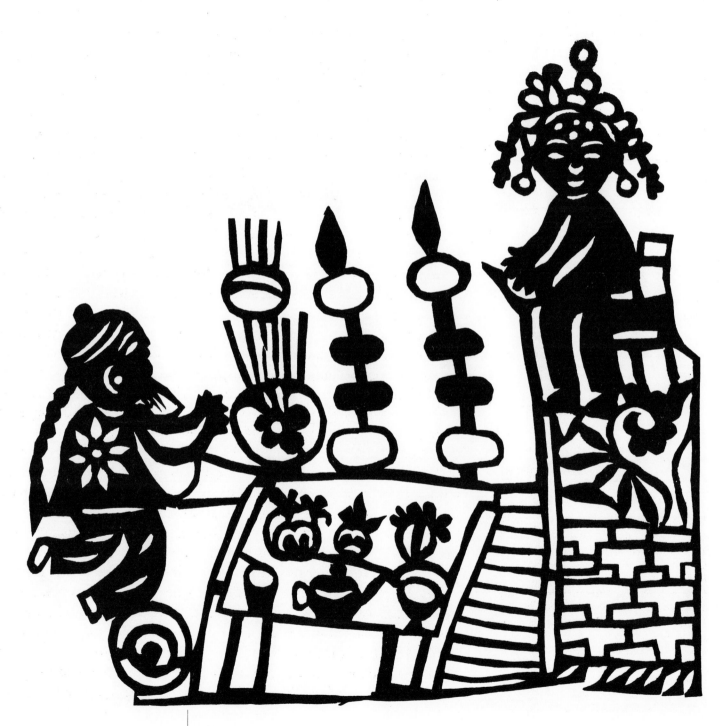

此闉閣中物也然剪除繁蕪書鬻中亦不可少此此介毛也南中用以代錢婦人以為首餘其文有黃黑點故曰貝銅楷先生有不平者用此平之書鬻九錫伶伊貝光祿

Fig. 99. Woodblock print of scissors from Ming dynasty encyclopedia San cai tu.

Fig. 98. Papercut of a man worshipping the goddess Guan Yin. This is most likely modeled after a traditional or inherited papercut, since the man is wearing a Qing dynasty cap and hairstyle (men cut off their queues after the Qing era). The artist has disregarded concepts of perspective, placing the candles and incense holder on the top edge of the table and even a second incense bowl atop the first. The man himself floats above the round cushion rather than kneeling on it. The cut expresses reverence for and faith in this very human goddess. Shaanxi Province. 7½″ × 8″.

tiehua, or "pasting flowers," and was practiced primarily at Jizhou kilns. The first-grade kilns generally abandoned the technique after the Song period, though some folk kilns continued to employ it for simple, repeating designs.

The Song dynasty, a period of flourishing culture and economy, ended with the final overthrow of the south by the Mongols, who then established the Yuan dynasty. Eighty-nine years later, native Chinese, frustrated by foreign rule, threw off the Mongol hold and founded the Ming dynasty. Once again, the Chinese culture could preside, and with it papercuts.

The relatively simple papermaking process spread to rural areas, making paper more affordable to villagers. Paper became a decidedly inexpensive way for villagers to decorate their homes and themselves. During the Ming dynasty, people in both cities and the countryside began pasting papercuts on shoes, hats, and pillows (in replacement of embroidery), as well as on windows, walls, ceilings, fans, mirrors, and screens. For the holiday Duan Wu Jie, the fifth day of the fifth month, papercuts came to serve a specific purpose. On that day, according to the Taoist calendar, evil spirits — in particular those ghosts without descendants to care for them — emerge from the underworld and harass mortals who have not taken precautions. Even to this day in some areas, people partake in the age-old customs: they hang mugwort and other pungent herbs on their doors, dress children in clothes with embroidered images of the five poisonous insects, fix yellow amulets on their gates, and wear decorative pouches filled with potent-smelling medicines to frighten away the ghosts. During the Ming dynasty, people also began to paste gourd-shaped papercuts on their doors on this day, believing that spirits inhabited gourds and that upon seeing one, they would enter it instead of the home. In some places these paper gourds were displayed on the last day of the year. Like paper money used at funerals and paper flowers, the papercut images pasted on windows became substitutes for actual objects.

During the Qing dynasty (1644–1911), a new form of papercuts developed and in many regions has become one of the most commonly seen types. Across the entranceway of their homes, people hang four, five, or six rectangular papercuts such as those seen in Figures 100 and 102. Originally, these were called guaqian, "hanging papers." At some time over the past three hundred years, the name evolved into guaqian, which sounds similar but means instead "hanging money." The change came about because many people cut out coin shapes in the guaqian, ensuring prosperity to all who inhabited the household. In some villages, it was said, the gua-

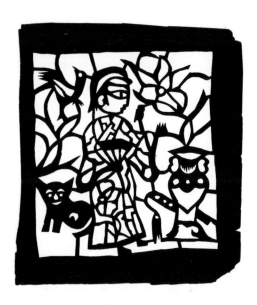

Fig. 100. Guaqian papercut, to be hung from a doorway, of a man with a cat, bird, and vase. The vase, ping, *is a homonym for "peace." Shanxi Province. 6½" × 6".*

Fig. 101. Papercut illustrating a loyal son cutting open a mountain to release his mother. Shandong Province. 7" × 5".

qian were meant to welcome the God of Wealth. The designs of the *guaqian* differ from region to region. In Yangzhou, for instance, each of the sheets may contain a character, and all characters, when read in order across the gateway, will then form a message of good luck. In Shaanxi, on the other hand, as can be seen in Figure 102, images very similar to those of window papercuts are carved within the rectangular border of the *guaqian*. In this particularly charming example, the artist has managed to combine a group of objects, all connected to ensure stability. In the cheerful design of Figure 102, the jolly child and the fish swimming beside it suggest fertility and many male descendants, for many Chinese happy thoughts that would enliven any entrance.

The fact that a large number of *guaqian* had to be produced to satisfy villager demand possibly instigated another development in the art of papercutting during the Qing dynasty. Until then, only scissors were used to carefully form the often fragile lines of papercuts. Scissors were and still are a common household utensil, since all women need them to make clothes. In the Qing period, some people began cutting their papercuts with small knives, a far less common tool. In this way several sheets of paper could be cut at once, producing identical copies. Today, *guaqian* are almost always cut with knives.

Unlike the gay *guaqian* that greet visitors to village homes at New Year's even today, most of the papercuts on these pages are meant to be pasted on the paper windows of those houses, facing into the family's rooms. Glass being too expensive, windows in many rural areas are still made of elaborate wooden lattice designs, over which white handmade paper (often locally produced) is freshly pasted at New Year's. The papercuts then stuck onto these clean backgrounds for the festival are called *chuanghua,* or "window flowers." Chinese New Year's comes in late January or February, when the days are cold, long, and dark. The time is ideal for festivals to cheer the heart and hasten spring weather. Though they are not always shaped like flowers, these papercuts that welcome the spring take the place of real blossoms, just as did the papercuts in women's hair. Bright sunlight beaming through the paper windows creates a perfect background for window flowers in the often cold and damp village home. The abundant decorative shapes cut away on the papercut design conveniently let more light into the home, just as they allow more light out when the papercuts are pasted on lanterns.

Papercuts are also pasted on the walls at New Year's time, particularly around the *kang,* the oven-bed where families, especially in the north, spend most of their time during the winter months. The window flowers

Fig. 102. Papercut, to be hung in a series from doorways at New Year's time, of a child with a fish, symbol of the desire to have many male descendants because of the many eggs it lays at one time. Shaanxi Province. 10″ × 6″.

must be small enough to fit in between the wooden lattice slats of the windows, but the papercuts decorating the walls are restricted only by the size of the wall. In the kitchen area, papercuts are hung between shelves, both playing a decorative role and protecting food from soot and dust.

All of these papercuts are freshly made and pasted up in the few bustling days before New Year's. By the last day of the year the home, with its cheerful papercuts and woodblock prints, has been transformed from a dark and dusty room into a place of celebration. In the following months, the papercuts fade and peel away, the *guaqian* are torn by the blowing wind, and the house will not be as welcoming again until the next year.

In most villages today, weddings are the only other occasion when papercuts appear in the home. Called *xihua,* or "joyous flowers," they are pasted on the windows, the walls around the newlywed couple's bed or *kang,* on the doorways to announce the happiness to the public, and on the ceiling above the nuptial bed. Ceiling papercuts are termed *tuanhua* or *yun,* "circular flowers" or "clouds," since they are almost always round. The subjects of *xihua* always relate to marriage. Some are simply fanciful ways of writing the character *xi,* "joy" or "happiness." In Figure 16, the bride and the groom stand to either side of the *xi* characters. More often than not, two *xi* characters are combined in a figure called double happiness, representing the bride and the groom. Four shadow puppets in Figure 14 carry a traditional bridal sedan decorated with *xi* characters. Even in modern cities where papercuts and other folk arts have all but died out, double happiness papercuts or signs with the double happiness characters are hung up outside the home of a newlywed couple.

Other *xihua* reflect the hope for many children, such as the bulging pomegranate of Figure 30 and the teapots of Figures 31 and 32. The teapot is a symbol of fertility because of its shape as well as because the word for teapot, *hu,* is a homonym with the word for gourd, whose many seeds represent multitudes of children. In Figure 32 the artist has, with very fine lines, created a bulbous teapot decorated with two figures, a man and a woman, both in the shape of gourds. The hope is also that children will succeed and become officials; to that end, papercuts of *qilin,* the magical animal said to bring sons destined to be officials, also abound at weddings.

Most village women make their papercuts with scissors, large or small. Grasping the paper in their left hand and the scissors in their right, they weave the tool around and about the paper, snipping away until an image evolves. The best cutters are able to create elaborate designs from imagination without drawing sketches on the paper or even looking at other pieces for inspiration. Some girls copy exactly their mother's cuts. Others simply cut away and color woodblock printed images. Most, though, after years of watching mothers and grandmothers cutting, are able to improvise on the models handed down to them. For those without enough courage, there is the possibility of copying friends' or relatives' cuts with a knife.

The technique of papercutting with a knife is very different. Because a small knife is rare in village homes and considered a luxury, the first step for most women is to make their own. After acquiring a small metal blade, they fit it into the end of a bamboo or wood stick. Material is wound around the blade to hold it more firmly in place and to improve the grasp on the bamboo handle. The sheets of paper to be cut — usually numbering from eight to ten — are placed in a pile on a board or pan filled with about half an inch of wax or animal fat mixed with powdered charcoal. Flour is sprinkled between the sheets so they will be easier to separate. The flour is kept in a small bag so it can be applied onto the paper through the pores of the cotton. The artist pierces through the layers of paper with a pin in several places, making holes through which small pieces of paper, rolled up to make a thin string, are then threaded to hold the papers together during the cutting. She then moistens the paper by putting a damp cloth over the whole stack for about a half hour. The topmost layer is either a sketch, usually made with the burnt end of an incense stick, or an image of a previously made papercut. Artists tend to choose the knife method when they wish to make several papercuts at one time. And it is primarily professional cutters, who sell their cuts as embroi-

Fig. 103. Colored guaqian *showing flowers in a vase design. Shanxi Province. 8″ high.*

Fig. 104. Papercuts meant to be pasted in the corners of windows; their designs depict the pomegranate, a symbol of bearing many male children. Shanxi Province. 5″ × 5″.

一一三　113

Fig. 105. A marriage papercut depicting the bride and the groom in their new home decorated with lanterns and flowers. Shandong Province. 5½" × 5".

Fig. 106. Papercut. Two door gods stand guard at the front entrance to a home. Above the house two horses — their bodies decorated with coins, symbols of prosperity — stand. On their backs are gold ingots and more coins. It is common in some regions to arrange tiles in the middle of a rooftop in the shape of the coin as seen here. Hebei Province. 11½" × 7½".

dery stencils, who use this technique.

Copy-images are made by placing a papercut, moistened so that it will adhere, onto a white piece of paper and holding it over an oil lamp. The lampblack then covers the blank paper, creating a perfect negative image of the papercut. This is a common method for preserving designs and handing them down to younger generations. The clever cut of a girl in profile as she looks in the mirror, where we can see her full face, was copied in this manner (Fig. 108). In Figure 107, of a bird in a tree, the copier had already attached her model to the clean papers and begun carving new copies.

When cutting, the artist holds the knife in the right hand in a position similar to the way the brush is grasped when doing calligraphy. The hand must have utmost control over the knife's movements, keeping it vertical as much of the time as possible. The left hand holds the paper close to the area being incised. The artist works from the center outward, cutting the most outward-lying areas and the border last. If the outline is cut first, the pins cannot hold the layers together; moreover, the area will be too small for the left hand to hold steady.

With a variety of cutting techniques, papercutters have been able to create a broad range of textures and sensations. In Figure 112, the artist has patiently snipped hair after hair to create an extremely furry goat. In Figure 97, thin lines and dots give scales to a *qilin*; and in Figure 1, sweeping cuts carve out clouds on which the cowherd walks on his way to visit his wife, the weaving maiden.

Not tied to the precepts of realistic art, folk artists experiment, often successfully, with portraying the legends, spirits, and daily life of their world, sometimes exaggerating or stylizing certain areas for desired effects. Figure 115 from Hebei Province shows a fantastically colored landscape. Though the scene is reminiscent of traditional Chinese landscape painting, a proper brush artist would never dare to apply such brilliant colors to his mountains. The papercut artist attains a wonderful roundness to the hills in the distance, which contrast with the spindly branches and leaves of the trees. Another example of such exciting artistry is the Shandong papercut of the girl or goddess in the clouds (Fig. 111). The shapes of her draping robe and of the billowing clouds about her have almost meshed into one flamboyant mass of movement. With heavier lines, the equally tumultuous cutaway shapes of Figure 8 can be seen to outline a mother and child, their clothes and the chair decorated with flowers.

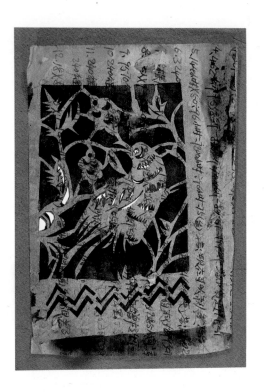

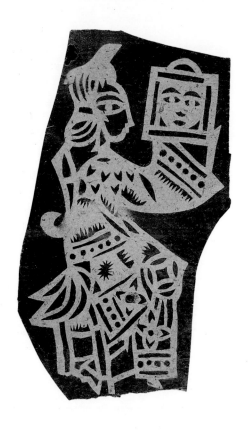

In comparing Figures 31 and 32, both of teapots, or Figures 27 and 30, both of pomegranates, it is clear that styles of papercuts vary greatly from county to county as well as from artist to artist. Some generalizations have recently been made about provincial papercut styles, including the observation that Shaanxi papercuts are monochrome, heavy, and rather crude in appearance, while Shandong papercuts are finer and Hebei multicolored.[18] While these descriptions hold true for certain villages in these provinces, they do not stand up when making a thorough inspection of works from a variety of counties within each province. Figure 116, for example, is a magnificently colored piece from Shaanxi Province depicting an acrobat in a scene from a local opera. Despite the dangers of generalizations, it is still possible to identify the range of styles for which regions, though not necessarily provinces, are known.

In parts of Hebei Province, notably the county of Yuxian, papercutters dab onto their white papercuts a variety of bright colors, rather than making solidly colored pieces. Several papercuts can be colored at once, since the paper is so thin. Piled together and moistened with wine or water, up to ten layers can absorb one dot of color, and colors bleed together. This method of dyeing papercuts was said to have been invented by a young boy, Wang Laoshan, at the end of the nineteenth century. After seeing an

*Figs. 109 and 110. Papercuts made by folding
the paper a quarter of an inch at a time, cut-
ting out the shapes, and then cutting again
until the full design is completed. The geomet-
ric pattern was possibly influenced by the Hui
or Muslim peoples, many of whom inhabit
Gansu Province and whose religion forbids
them to create human images. Both from
Gansu Province. Left, 4¼" × 4½"; right,
5" × 4".*

Fig. 111. Papercut of a female spirit riding the clouds. Gao Mi County, Shandong Province. 4¹/₂″ × 2″.

Fig. 112. Papercut of a goat. The artist has successfully varied the treatment of different sections of the goat's body. Some areas have been left blank, others filled with sawtooth cuts to represent the animal's fur. The fur projects from the line on the left side of the work, but not on the top or back. Shaanxi Province. 3″ × 2¹/₂″.

opera, he was inspired to make papercuts that would look like the elaborate masks of the actors he had just seen on stage. Wang Laoshan grew up to be one of the most famous papercutters of his time, his works detailing the fantastic costumes and masks of the popular operas.[19] Figure 115, from a county neighboring Yuxian, displays this technique with a different type of imagery. In southern Shaanxi, women in some villages also color their papercuts but often draw designs with ink first and then paint on each piece individually. The cut of Figure 118 from a scene in a local opera about a female military hero is a superb example of such individually applied colors working to create a wonderfully expressive character. The artist is able to bring out the volume of the horse and the confidence of its rider with ink outlines and colors.

In Jiangsu and southern Shandong, papercutters create color in their work by piecing together papers of various colors, cut to fit together like pieces in a puzzle. Several sheets of paper, each of a different color, are put in a pile and cut, with a knife, in a pattern. Certain areas are purposely cut so they will separate from the main mass or border of the piece. When the cutting is finished, the pieces are separated and then combined with other pieces of the pattern to make a series of multicolored *guaqian*, each one unique. The different colors are held together by pasting small pieces of scrap paper on the back of the papercut, so small that they do not interfere with the holes of the design.

In most of the country, however, solid red is the most common color for papercuts, since the Chinese associate this color with happiness and luck. Because white is the color of mourning, only embroidery stencils take this color, never decorations. The bright red marriage and New Year's papercuts — such as the carefree character at work in Figure 114 and the hanging papercut of Figure 102, pasted to a window or an entranceway — make their strongest impression in this of all colors.

Even among these solid-color works, there is a great range of styles. In northern Shaanxi, where women often use scissors to cut out their designs, the papercuts are extremely rounded, often symmetrical, and leave large areas of space unperforated. It has been hypothesized by Jin Zhilin, a modern scholar of the area, that this distinctive style stems from Mongol influence.[20] Figure 89, showing a barefoot girl, is typical of the papercuts from this harsh, isolated region.

Many papercuts are made by first folding the paper in half and then incising the design, creating a symmetrical work, such as Figure 113. The artist who long ago cut the Turfan papercuts also used this method but folded the paper several times before cutting. In Figures 109 and 110,

Fig. 113. Papercut done with a scissors after having first folded the paper so that the image would be symmetrical. Two women, perhaps goddesses, hold a baby boy in an image evoking hopes for fertility. Shaanxi Province. 6″ × 7″.

from an area of Gansu Province bordering on northern Shaanxi, the artist folded the paper once for every horizontal line, making very small but definite cuts, and then folding again until she had created a fine geometrical design. The heavy appearance of the northern Shaanxi papercuts has been created by the artists' cutting away only small shapes in the mass of the papercut and leaving broad areas of paper uncut. In contrast, in the papercuts from Gao Mi County, in central Shandong Province—such as Figure 88 of a woman drawing water from a well—the women cut away large areas of the paper, so that only thin lines remain to delineate the images. While the Shandong artists prefer rectangular blocks in creating their compositions, the northern Shaanxi papercutters tend to dot their solid areas with cuts of crescent shapes and circles. Sometimes the shapes suggest parts of the image represented, such as the face or body of the horse in Figure 121. Other times they are mere decoration to fill a space, such as on the woman's body in Figure 120. The way the figure's arm has been depicted in this example, by cutting away the space around it, is also a distinctly northern Shaanxi technique. The Shandong papercuts are similar to the Shaanxi in their disinterest in realistic portrayal but show greater fascination with the relations of lines rather than merely leaving space, imparting a delicate and naive appearance.

The rendering of faces also distinguishes various styles. In Shaanxi, the head is usually shown in profile, the eye extending from the top of the nose to the back of the head with a large pupil in its center looking out. An equally long eyebrow may be carved out above it. The treatment is similar to that given to shadow puppets. In some cases the eye and eyebrow are negative space; that is, they have been cut away; other times, such as in Figure 119, they are positive. In Figure 120, the artist has cleverly thought to put the face both in profile and, adding an extra eye, looking straight at the viewer. In Shandong, papercuts generally show the face facing forward, a solid area with simple lines for the eyes, eyebrows, and mouth, and a ∪ shape for the nose, as can be seen in Figure 122. Each style has its own balance of positive and negative areas and juxtaposition of shapes and proportions, and thus a unique flavor. Each style has developed its own technique for depicting perspective and mass; some do it with color, others with shapes, and still others ignore the problem altogether, concentrating on forms.

Fig. 114. Papercut of a man with a rake, his face simply indicated by a diamond for the eye, a crescent for the eyebrow, a tear-shaped cut for the jaw, and a slight bump for the nose. Northern Shaanxi Province. 6″ × 4½″.

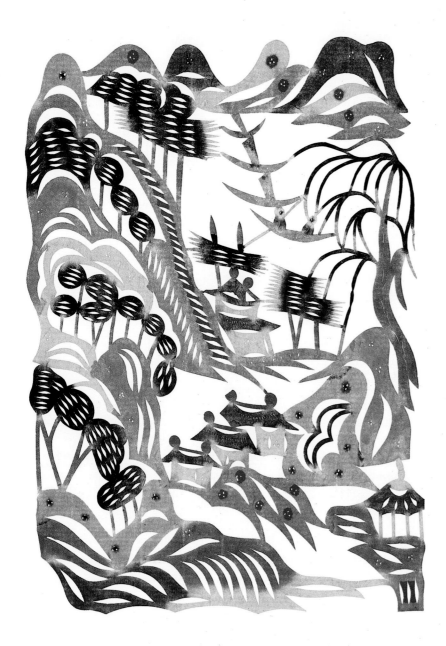

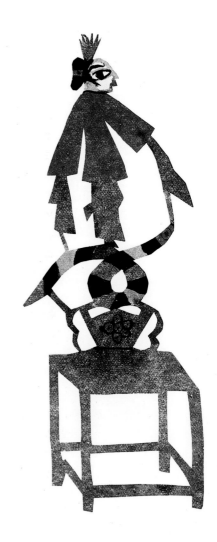

Fig. 115. Colored landscape papercut. The
brightly colored mountains and rhythmically
delineated forms contrast with the traditional
subject. Hebei Province. 5″ × 3″.

Fig. 116. Papercut of an acrobat dancing on
a multicolored scarf. Southern Shaanxi Prov-
ince. 6″ high.

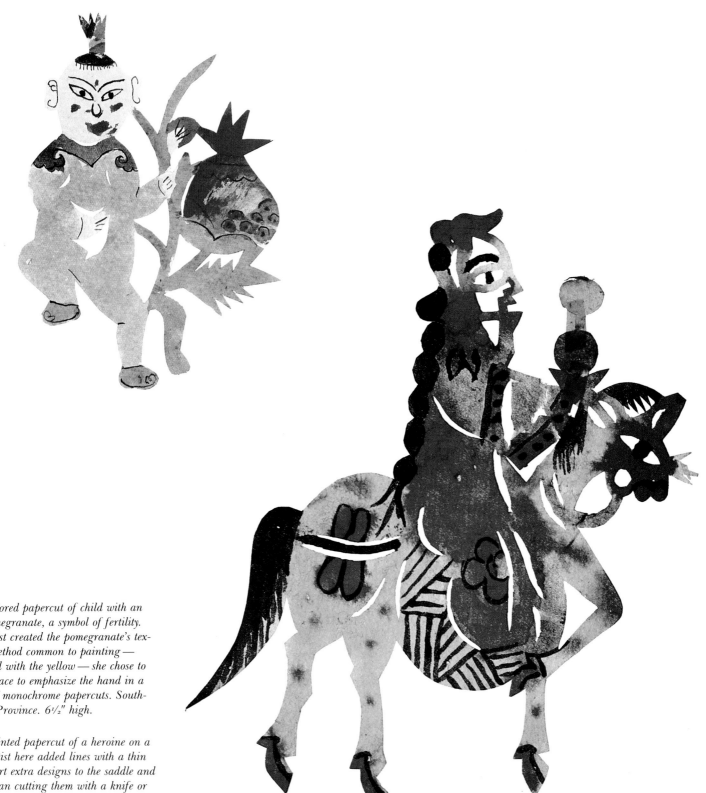

Fig. 117. Colored papercut of child with an enormous pomegranate, a symbol of fertility. While the artist created the pomegranate's texture with a method common to painting—mixing the red with the yellow—she chose to cut away a space to emphasize the hand in a way typical of monochrome papercuts. Southern Shaanxi Province. 6½" high.

Fig. 118. Painted papercut of a heroine on a horse. The artist here added lines with a thin brush to impart extra designs to the saddle and robe rather than cutting them with a knife or scissors. Shanxi Province. 4½" high.

Fig. 119. Papercut of a man, with Qing dynasty–style cap, in a tree. Unlike the case in most other styles of papercuts, the artist here has cut away only the outlines of the nose and eyes, leaving those parts of the face positive rather than negative space. Shanxi Province. 6″ high.

Fig. 120. Papercut of a woman holding a fan, smoking a pipe, and holding a tobacco pouch, a New Year's custom in northern Shaanxi. The artist has cleverly put the head in profile, but two eyes look out at the viewer. Northern Shaanxi Province. 7½″ × 2½″.

Relying mostly on monochrome and restricted by the need to have all parts connected, the papercut medium developed its own distinct aesthetic language. Like those of all arts, this language is constantly evolving. Styles and themes handed down from generation to generation are adjusted and elaborated upon by the hands through which they pass. A young woman feels no constraints about modifying her grandmother's lampblack copies of papercuts to suit her own tastes. The line between tradition and personal inspiration cannot always be drawn when looking at a work; the papercut often represents an expression of both the collective and the individual.

Fig. 121. Papercut of a man with his horse. Here the horse's head is depicted in profile and only one eye is seen, in contrast to Figure 122. The treatment of the area within the animal and the man is also very different from that in Figure 122. Northern Shaanxi Province. 2½″ × 3″.

Fig. 122. Papercut of an acrobat riding a horse while standing on his hands. Though the horse is shown in profile, both eyes face the viewer. Shandong Province. 5½″ × 3″.

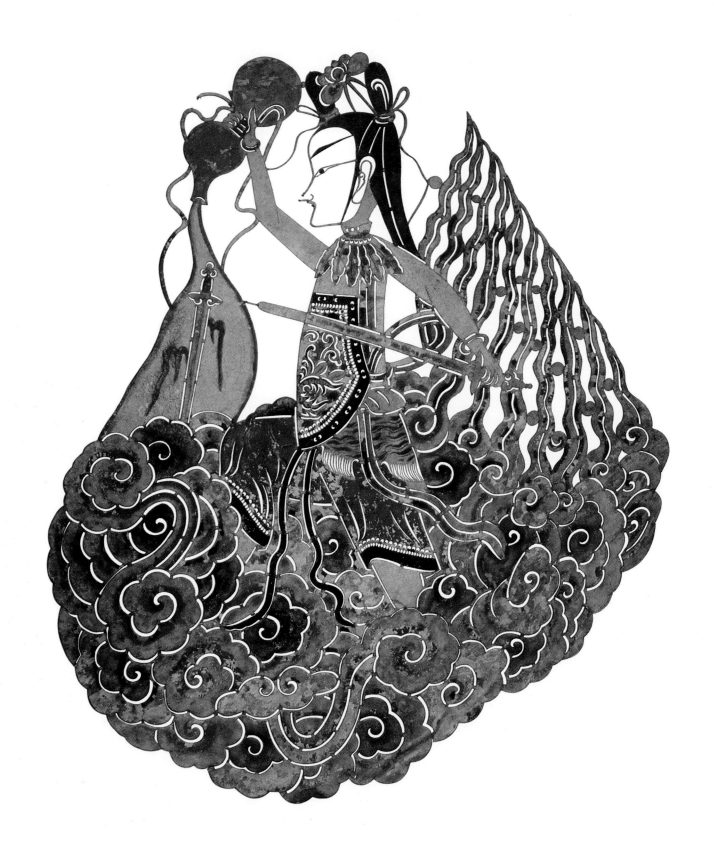

Shadow Puppets

Cymbals clash, drums beat, a light appears behind the white cloth stretched between bamboo poles. An elaborately carved table and chair are already on the stage. With another clash of the cymbals, an elegantly clad official enters. The audience, so involved with the tale and acting, quickly forgets that the actors and the furniture are only one-foot-high pieces of carved and painted leather being maneuvered about on sticks behind the screen. "A thousand autumns' events wielded under a lantern, ten thousand years of ancient heroes held in one hand," a Chinese saying describes the shadow theater. "The laughter all depends on ten fingers," reminds another, lest one forget that the characters on stage are only shadows of leather.

Shadow puppets, flat pieces of leather or paper carved into shapes of human figures and scenery, are designed to be manipulated in front of a lamp, thereby projecting images on a screen. Every color, every detail of clothing and expression can be seen by the audience, since the puppets are held very close to the thin screen. When combined with narration and music, these puppets create spectacular performances of ancient legends. Adored by young and old, the shadow theater has existed side by side with the living theater for centuries in China without suffering from the competition. Hand puppets, rod puppets, opera, dramas, and storytellers have abounded without diminishing people's fascination with the minutely carved leather characters. Since its beginnings, this drama form has been as much a craft as it has been theater.

In technique and origin, shadow puppets are closely related to papercuts. By the Tang dynasty (618–907), papercuts were already being pasted on lanterns, screens, and possibly windows. Light illuminating papercuts from behind creates magical images similar to shadow puppets and may

Fig. 123. This shadow puppet is a deity described as a mythical child with supernatural capabilities, riding fantastically carved clouds while pouring swords from his magical gourd. Being an upright and noble character, his face is delineated by an outline only. Leather. Nineteenth century. Shaanxi Province. 16" high.

have inspired them. In fact, the earliest Chinese shadow puppets—those from the Song dynasty (960–1279)—were made of paper. Later, leather replaced paper because of its durability. (Paper puppets, however, continued to be made until the beginning of this century in poorer communities or for amateur home use. In comparing the paper puppet of Figure 139 with the leather puppets, it is apparent that leather allows for greater detail in carving.) The Song dynasty text *Du cheng ji sheng* records that "the shadow theater people of the capital first used plain paper carved out and later used colors on leather to make them."[1] In southern China today, some villagers still call the art form "paper shadows," though in the northern part of the country the puppets are referred to as *piying*, "leather shadows" or "leather dolls," or just "shadow theater," a term from the Song era.

Like papercuts, shadow puppets are flat, two-dimensional objects meant to depict three dimensions. In both media, designs are created by cutting away either the form or its outline, leaving a balance of positive and negative shapes for both aesthetics and stability. In papercuts pasted on windows, these intricately carved-away shapes allow light into the home; when pasted on lanterns, they allow the light to shine out. Likewise, these negative areas in shadow puppets let the light from behind come forward, brightening the screen and giving depth to the figures. Many of the motifs and symbols employed in papercuts, such as the coin and the long-life symbols, are also worked into the designs of shadow puppets.

The same legends also appear in both art forms, but in shadow theater they can be performed in their entirety. Indeed, characters and images of the shadow theater have in turn now influenced the shapes and aesthetics of some papercuts, confirming and extending the intimate relationship between the two.

The puppet theater's endurance and unique appeal to audiences can perhaps be explained by its unusual flexibility. Many more legends can be performed in shadow theater than in either opera or wooden puppetry, its two closest rivals. Like movies (which the Chinese call "electric shadows," a name obviously derived from "leather shadows"), shadow puppets can evoke magical animation. Hidden behind a screen and discernible only when close to it, the puppets can undergo fantastic transformations: they can fly, decapitate each other and be decapitated, and perform the supernatural phenomena that often take place in Chinese legends but are impossible to produce on the stark stage of the Chinese opera. For instance, in a shadow theater performance of the story of "The White Serpent," Bai Suzhen can actually be transformed into a snake right before the viewers'

Fig. 124. Papercut, meant to hang from top of a doorway, of a woman with a bird in a tree. The way the figure is portrayed, with all four limbs included but the face presented in profile, resembles the technique of shadow puppet construction. The challenge of creating such an image with complex cut-out designs covering the character's costume is also common in shadow theater. Shanxi Province. 6" × 5".

Fig. 125. Papercut. The cutting technique, particularly in the construction of the head and eyes, resembles that used in making shadow puppets. Shanxi Province. 3″ high.

Fig. 126. Woodblock print of a wooden puppet theater stage set up in a private home. The puppeteers peek out from behind the set. From San cai tu, a Ming dynasty encyclopedia.

eyes. The wondrous deity of Figure 123 can whirl off on his cloud. Some shadow puppets, like that of Figures 145 and 146, have two heads; in this example, a beautiful woman can turn into a goblin.

Unlike the Chinese stage theater and wooden puppetry, the shadow theater incorporates elaborate props, furniture, and scenery. Chairs, trees, hills, and clouds are all part of a prop repertoire that is used to create wonderful compositions on the screen; horses and even elephants may gallop by steep mountains on the shadow stage. In contrast, when an official mounts his horse in Chinese opera, no horse exists; the actor simply makes a certain gesture to suggest the action of mounting and carries a whip for emphasis. Though lacking the three-dimensional aspect of reality, the shadow theater is also able to depict dragons, any kind of monster, and flying immortals, if necessary, as well as fires and bloody deaths.

Shadow theater enthusiasts and scholars, such as Berthold Laufer and Genevieve Wimsatt, often point to a tale from the Han dynasty (206 B.C.–A.D. 220) as the origin of the shadow puppet concept.[2] According to this legend, in the year 121 B.C. the emperor Han Wudi's favorite concubine, the beauty Li Furen, died. The bereaved ruler was immersed in grief. The court shaman, Shao Weng, promised the emperor that he would retrieve Li Furen's soul. Soon afterward her soul appeared on a screen in the emperor's bedroom, but when he reached out to grasp his beloved, the fragile shadow disappeared beyond the curtain. Despite the charm of the tale, it is unlikely that its subject inspired shadow theater, since the puppets were not to become popular for a thousand years after the Han era. But the legend does illustrate the power the shadow on the screen may have over its audience, as well as the ability of such an image to capture the human spirit. Berthold Laufer uses this example to claim that "the shadow figurines indeed were the shadows or souls of the departed, summoned back into the world by the art of the professional magicians."[3] Such a concept is reinforced by the fact that mourners invite shadow troupes to perform at funerals.

Figs. 127 and 128. Two gui *that lurked in shadow theater scenes. Door gods and other amulets prevent such creatures from intruding on mortals' lives. The difference in the carving techniques of these two puppets illustrates the great variety of effects that can be obtained. Both cowhide and both from Shaanxi Province. Left puppet 17" high, right puppet 17" high.*

Fig. 129. Set background for shadow drama of a pavilion, under which the puppet characters will perform, surrounded by trees. The piece is complete in details, including animals frolicking in the trees. Made from several sheets of leather attached by leather strings, the massive piece can fold up and be as mobile as the puppets. Shaanxi Province. 43" × 70".

Most historians now trace the origins of shadow puppetry in China to the Song dynasty, when it first became popular. In the Song book *Shi wu ji yuan (The Origin of Objects)*, author Gao Cheng states that it began in the Song reign of Ren Zong.[4] A Chinese scholar working during this century, Sun Kaidi, has suggested that the origins of shadow puppetry lie in southern China, where Tang records describe Buddhist monks reciting sutras with illustrations or images lit by lanterns.[5] Several points do link the shadow theater with Buddhism: for instance, shadow theater's lyrics have the same seven- and five-word lines and rhyming schemes similar to those of sutras discovered at Dunhuang. Shadow puppeteers today, as in the past, often ask each other, "What scroll are you spreading?" rather than "What play are you performing?"—a wording indicative of Buddhist missionary influence. However, shadow plays in the Song dynasty (at least as far as can be determined from the existing records) were primarily secular. In a list of miscellaneous opera and other theater titles, a Song text notes tales about prostitutes, Taoist spirits and ghosts, and historical legends.[6] These titles undermine the argument that Buddhist sutra ritual was a forerunner of shadow puppetry, and instead suggest that it developed independently of the Buddhist spreading of scrolls.

The Song dynasty was a time of great wealth and tranquillity, a fertile time for advancement in all the arts, from brush painting to ceramics and literature. The folk arts were no exception. With urbanization and the subsequent growth of the marketplace and a middle class, public entertainment increased. Jugglers and acrobats who once performed only in the homes of the wealthy could be seen in the markets; as the common man's prosperity grew, performers could earn a living from his goodwill.

Shadow theater probably originated among the lower and middle classes rather than first finding an audience among the elite. From the Song period a wealth of records detailing these leather shadows survives. *Dongjing meng hua lu*, written in 1147 by Meng Yuanlao, tells of the former life in Kaifeng, once the Chinese capital. Meng talks of shadow theater tents at street corners where children would sit and watch legends while adults enjoyed the festivities and markets of the Lantern Festival. It mentions "The Tale of the Three Kingdoms," a historical drama—then commonly performed as it is today.[7] Zhou Mi, in his records of a slightly later period, notes the custom of inviting a shadow troupe to perform at birthday celebrations of newly born sons or of elderly men, a custom practiced in Beijing until the beginning of this century and still found today in the villages. Genevieve Wimsatt, an American living in China during the early twentieth century and author of one of the few books about shadow pup-

Fig. 130. Background scenery for a shadow play of a house upon a mountain. Although the carving in this piece is simpler than in many others and the leather thicker, the singular dashed lines describing the hill and the placement of the bird, tree, and house upon it were done by a hand sensitive to visual images. Eighteenth century. Cowhide. Shaanxi Province. 14" high.

petry, notes that when she lived in Beijing in the 1930s, the drama about the Queen Mother of the West's Peach Festival was often performed at birthday parties for old people, because peaches—particularly those grown in the Queen Mother's orchard—were symbols of longevity. When Wulin became the capital of the country during the Southern Song dynasty, great pleasure grounds were erected where marionettes, acrobats, comedians, actors in Big Shadow Theater (children or adults who replaced puppets behind the screens), storytellers, and shadow puppeteers performed. Tales of ghosts, crime, history, and romance were related in undoubtedly captivating performances. Shadow theater appears to have been even more popular than regular puppets: *Wulin jiu shi* reports that at one time there were only ten puppet troupes as compared with twenty-two shadow puppet troupes.[8]

In *Ming dao za zhe*, also written during the Song, by the writer Zhang Lei, the author relates a story that demonstrates how involving the shadow theater could be for some.[9] In Kaifeng, there lived a young but wealthy orphan who loved the shadow theater. He became the target of a group of street urchins who were anxious to take advantage of him and his riches. Every time the boy saw a performance of "The Tale of the Three Kingdoms," he was so moved that he would cry and plead with the puppeteer not to kill Guan Yu, the great and loyal general. One day, the puppeteer called back to the boy: "Today we must slay generals, but you can still sacrifice to them." At this suggestion, the young orphan brought out large quantities of silver ingots, wine, and food to offer to the spirit of the general—all of which the hooligans immediately stole away.

By the end of the Northern Song period, the shadow theater was already well developed; writers from both this period and from the Southern Song speak of individual shadow puppeteers who had achieved fame. Among the troupe members noted by Zhou Mi in *Wulin jiu shi* are several women, including Li the Second Girl and Black Mama.[10] This mention of women as performers indicates both the openness of Song society and the possible development of the art from papercuts, a craft practiced largely by women. By the Ming dynasty (1368–1644), the status of women had fallen; home became the only province for proper women. Names like Black Mama disappeared from the ranks, and the profession of the shadow theater became an all-male one, as it still is today.[11]

The popularity of the shadow theater did not fade when the Mongols took over China and established the Yuan dynasty (1279–1368); on the contrary, the Mongols assisted in the expansion of the drama form. Those puppeteers who did not escape to the south would have been forced to

perform for the foreign rulers, as was the lot of many other artisans. During the Mongol reign, shadow puppet troupes were sent to entertain armies in distant parts of China and even farther, accompanying the military to Persia, Arabia, Turkey, and Egypt. Shadow puppetry in these countries may have developed from the Chinese influence;[12] Persian historian Rashid-eddin (who died in 1318) mentions shadow plays being performed in the courts of his country, then under Mongol rule. Shadow puppets were a favorite pastime at the Egyptian court of the fifteenth century, and they appeared in Turkey during the seventeenth century.[13]

Within the boundaries of China, the art also spread and developed over the following centuries, leaving behind its status as street entertainment, and assuming an important role along with the other drama media. An early Ming poet, Tian Nucheng, wrote in his excitement over a new shadow theater being built: "In Nan Wa has newly opened a shadow theater house; / The hall's bright lamps shine on the rise and fall of nations; / Watching them play up to the Wu Jiang Ferry [where the Chu king committed suicide], / Again using the hero to tell the tale of the [Chu] leader."[14] Tian is referring to a popular historical drama about the wars at the end of the Qin dynasty (221–206 B.C.).

During the Ming dynasty, several distinct schools of shadow puppetry emerged. The Luanzhou school, established by Huang Suzhi during the reign of Wan Li, evolved in northeast China and eventually, with the rule of the Manchus, centered in Beijing. Originally located in Hebei Province, this school was reputed to produce the most finely crafted shadow puppets. Genevieve Wimsatt notes that saying your shadow puppets came from Luanzhou was like "boasting an all star cast from Broadway."[15] The school was divided into eastern and western styles. The latter, popular in Hebei and Shanxi provinces, featured puppets made of cowhide, whose thickness did not allow for fine cutting. There was little scenery, and western scripts were never written down, no doubt a factor in the disappearance of the school during the eighteenth century. The eastern school was far more refined in its carving techniques and used the thinner and more translucent hide of the donkey to construct its puppets. Donkey skin continues to be considered the best material for puppet making; it does not warp or crumble over time, it takes clean line cuts, and it absorbs pigments well. The skin from the donkey's belly is the finest of all. These eastern puppets were half as large as those of the western school, but the carving was far more elaborate.

OMBRES CHINOISES

Fig. 131. French illustration of the shadow theater, which was popular beginning in the eighteenth century in Paris, where they called the show "Chinese shadows." Reprinted in Bordat, Les theatres d'ombres.

Equally detailed were the puppets of the Shaanxi and Shanxi schools, which emerged separately from the Luanzhou style. According to Lian Zhenghua, one of China's foremost scholars in shadow puppetry, Chinese shadow puppetry originally developed in these regions. It was during the Qing dynasty (1644–1911), Lian claims, that puppet makers there began working with punching tools of various shapes, instead of just knives, to create more complicated designs.

Figures 130 and 133 reveal the effect of different materials and tools. The background landscape prop of the bird and house on the mountain (Fig. 130) was done simply with a knife on a rather thick hide—probably goat or cowhide. Though this primitive method has its own distinct charming effect, it is altogether different from the carved, punched, and delicately incised female character of Figure 133, created from donkey skin.

During the Yuan dynasty, the opera had a definite impact on shadow puppetry. Its influence was twofold: the shadow puppet makers adapted masks as well as costumes from the opera, and began to incorporate the stylized movements of the opera into the shadow theater. Figure 135—the face of a martial character—wears the same mask that this character would have had painted on his face in opera. The same mask also occurs in the depiction of the woodblock print door gods of Figure 206, indicating that another medium was influenced by the aesthetics of the opera. Such masks allowed the viewer, familiar with the meanings of each color and form, to easily decipher the personalities of the characters in a drama.

Like opera, shadow puppet plays are both spoken and sung, with the background music an integral part of the performance. Originally, only a wooden drum in the shape of a fish, known in China simply as a fish drum, kept the beat for the narrator; later, other instruments such as flutes, gongs, horns, and string instruments joined the accompaniment. During the Qing dynasty, the Luanzhou school of shadow puppetry borrowed music from *kunqu,* a southern opera school, bringing the shadow theater to its mature form.

The popularity of shadow puppets continued under the Manchus, who were so fond of them that officials often brought their own puppet troupes along when they were assigned to provincial posts. In this way, the shadow theater spread even more deeply through the whole of China. At the same time Europe, through commercial and missionary links with China, became intrigued with the shadow theater as well. Missionaries back from China introduced the idea in France, and entertainers there first performed with shadow puppets in 1767. By 1784 they were extremely popular; the shadow dramas produced by François Dominique

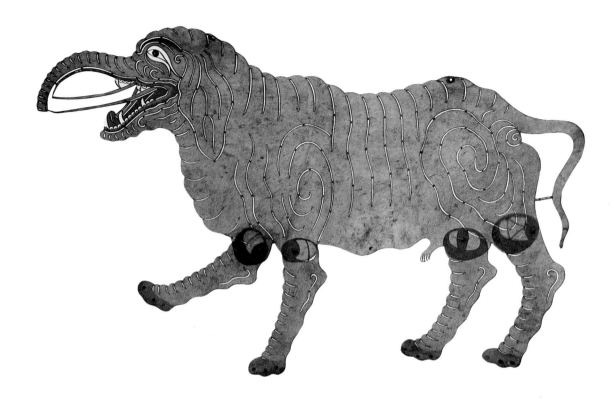

Fig. 132. Elephant shadow puppet. Made of thin donkey skin, this puppet is more translucent than others. The fantastic, complex lines carved away create a wonderful wrinkled texture for the animal's skin. Shaanxi Province. 12" × 20".

Seraphin at the Palais Royale didn't close until 1870. In Paris, this theater was known as *ombres chinoises*. Called "Chinese shades" in London, the puppets were a common sight on the streets by the nineteenth century, having been inspired by the tales of sailors who had been to China. The Europeans published and produced their own shadow plays.[16] "Minerva's Birth, Life and Deeds" was performed in London in the early part of the nineteenth century. Later, European culture was to influence the Chinese theater.

In our century, especially between 1920 and 1970, shadow puppetry has gone through drastic transformations. In state-organized troupes, established after the 1949 revolution, plastic sheets replaced the fine leather puppets, and synthetic colors the natural dyes. Combined with cruder cutting techniques, the effect was cheap and represented a sad departure from the tradition of the elegant, older shadow puppets. Even more striking have been the changes in subject matter. Some were minor; as the art form caught up to the times, bicycles and airplanes appeared on the shadow screen. But then the very essence of the plays changed. In 1938, dramas such as "David and Goliath," "Sodom and Gomorrah," and "The Exodus" were being performed at shadow theaters in Beijing. In the 1940s, Communist art groups in Yan'an, the northwestern Communist

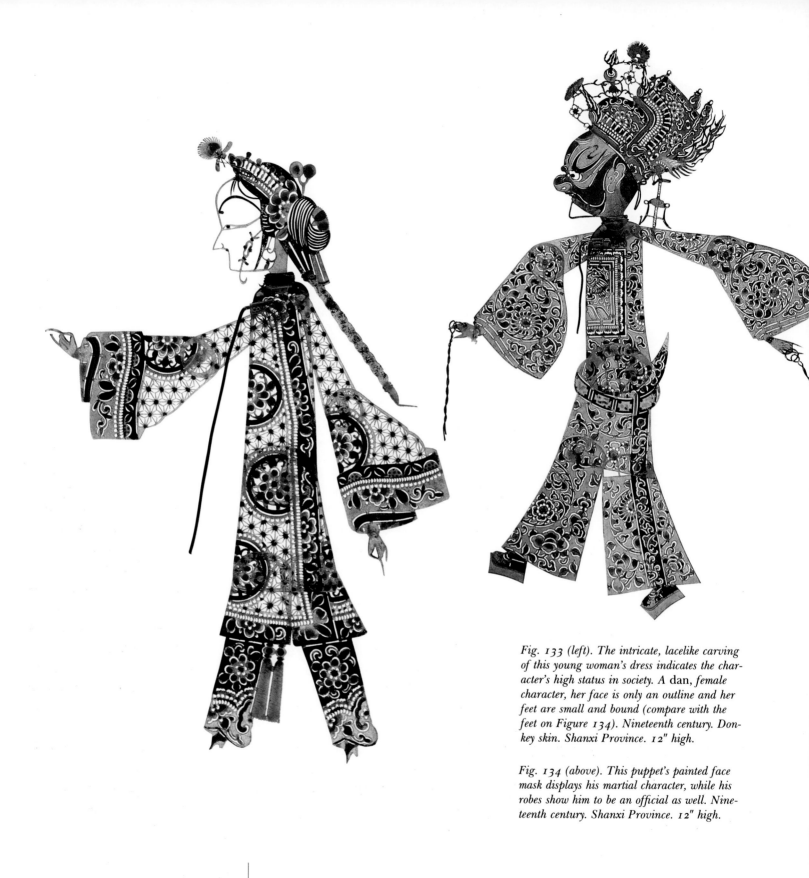

Fig. 133 (left). The intricate, lacelike carving of this young woman's dress indicates the character's high status in society. A dan, female character, her face is only an outline and her feet are small and bound (compare with the feet on Figure 134). Nineteenth century. Donkey skin. Shanxi Province. 12" high.

Fig. 134 (above). This puppet's painted face mask displays his martial character, while his robes show him to be an official as well. Nineteenth century. Shanxi Province. 12" high.

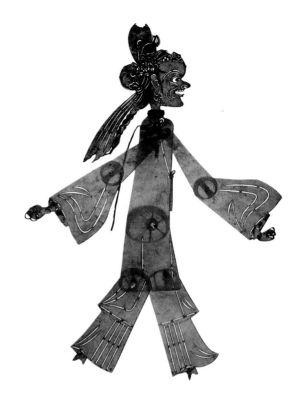

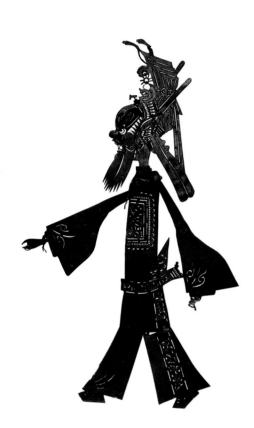

Fig. 135 (above). The elaborate headdress, mask, and the imitation embroidery on the chest communicate the role and personality of this puppet general. Eighteenth century. Cowhide. Shaanxi Province. 14" high.

Fig. 136. This puppet is an older woman with a simple costume unadorned by embroidery; she might play the role of a maidservant. Her face, which is not seen in outline, and her open mouth also reveal her lower position in society. The puppet's wheel-like joints can be seen at the waist and elbows. Donkey skin. Shaanxi Province. 12" high.

base, took to propagandizing their cause through all forms of folk art and folk drama, so that audiences would watch tales of peasants oppressed by landlords. The puppet in Figure 217 is an early Communist or Guomindang revolutionary worker; it was probably made in the thirties. After 1949, Communist ideology continued as an increasingly dominant theme in shadow puppetry. The People's Liberation Army formed its own shadow troupes. These toured the country and entertained the soldiers in Korea during the Korean conflict. One shadow drama called "Battles Against American Imperialism," which criticized the American role in this war, actually portrayed Eisenhower. Much of the passion for shadow puppetry—as well as for other folk art forms—among the Chinese people stems from their love of the historical legends that figure so largely in their lives. Without these rich tales of morality, lechery, heroism, and evil deeds, the shadow theater lost a great deal of its original spirit.

Now that the Cultural Revolution (1966–76) has ended and small private enterprise is allowed, village troupes have taken their puppets out of their cases and begun performing the old dramas once again. The extreme changes in both technique and content have been reversed.

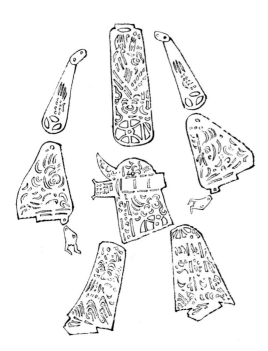

Fig. 137. The ten separate pieces that constitute the body of a shadow puppet. In the areas that will overlap—such as at the elbows and the trunk—the carver cuts away most of the leather, leaving only spokelike strips so that the overlap will not create an imposing shadow. The pieces are held together by leather string and, where that has deteriorated, by wire. Drawing by Zeng Xiaojun.

Most modern puppeteers use puppets that are one hundred to two hundred years old, but a few have started making new ones along the old guidelines. Construction of a shadow puppet is a long and complicated process. The hide must be taken from a freshly slaughtered animal—usually a sheep, donkey, cow, or ox, depending on what animals are prevalent in the region. (In Gansu, shadow puppets are called *niu pi wa wa*, ox-hide dolls.) First the puppet maker soaks the hide in water for a few days and then stretches it on a frame. While it is wet, he rubs and scrapes it, first with a stone and then with bamboo, until the hide becomes so thin that it will become transparent when rubbed with tung or paulownia oil.

The puppets depicting human figures are made up of eleven separate parts: the head, the two upper arms, the two lower arms, the two hands, the upper torso, the lower torso, and the two legs. In the less important figures, the legs and the torso and even the head may all be one solid piece of hide; since these characters are not required to express individual personalities, they do not need to make many complex movements. For each part, the puppet maker pins a pattern onto the hide and then marks its outlines. A good puppet maker knows how to make different parts of the shadow puppet's body from different sections of the hide: thicker sections are more appropriate for the feet, legs, and torso, because the thickness keeps the puppet balanced and stable. Thinner, lighter sections are used for the arms and head. All the sections must be cut parallel to the grain of the hide so that the puppet, when put together, will lie flat and not warp.

Before the puppet maker cuts out the pieces, he begins carving the details and patterns of the character's costume and face, those lines, dots, and other shapes that allow light to pass through and that are so essential to the overall impression created by the figure. As in papercutting, he starts from the center and works out. The leather is then laid on a waxed board to be cut, again similar to papercutting. But unlike the papercut, which soon after it is made is pasted onto a window that will support its delicate strips of paper, the shadow puppet cannot have any fragile pieces of leather connecting decorative spaces, since they would fall apart during performances. (Often the puppeteer slams the puppet against the screen during the course of a play.) At the same time, the puppeteer also wants to make his designs as delicate and intricate as possible; it is a challenge to carve out both a fantastic and stable puppet. The wonderful lacelike quality of the costume in Figure 133 has successfully accomplished this.

The puppetmaker also knows to form the ends of the puppet's legs and arms that meet the torso into shapes like spoked wheels. When two

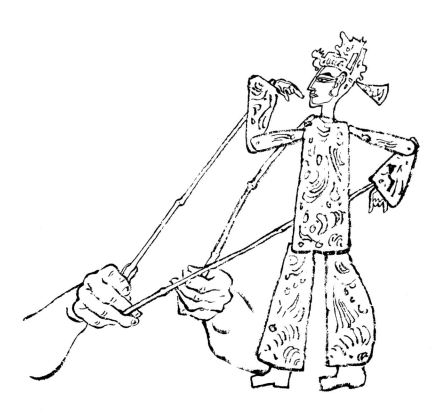

Fig. 138. A puppeteer's agile hands manipu-
late the three rods of a shadow puppet. His
hand movements control the gait, the jumping
and twirling movements, and magical trans-
formations of the many different personalities
on the screen. Drawing by Zeng Xiaojun.

such ends are overlapped, the radial cuts prevent a large, dark spot from
appearing on the screen. In Figure 136, these wheel-like connections are
clearly visible. Strings of leather or silk hold pieces of the puppet together.
Occasionally, metal wire is used to reinforce broken parts. Only the head is
not attached permanently. Instead, the puppet maker puts a strip of
parchment around the puppet's neck, making a collar for the head to fit
into. This socket allows characters to "change costumes" in the middle of a
performance or to be decapitated. The last step in creating the puppet is
attaching three wires—one to the parchment at the neck of the torso and
one to each of the hands. The wires are then fitted into bamboo rods, with
which the puppeteer manipulates the puppet.

The shadow puppet figure must be flexible enough to walk, run, turn
somersaults, hold teapots, be decapitated, jump on a horse and engage in
swordplay, perform acrobatics, sit politely on a chair, and otherwise go
about daily life. For a good puppeteer, all this is possible. The puppeteer
holds the rod attached to the neck in one hand, and the two rods attached
to the hands of the puppet in his other hand. When the puppet is held up
against the screen, the audience barely sees the shadow of the rod or the
puppeteer's hands. No rods are attached to the puppet's feet, so they dan-
gle as the body moves. A skilled puppeteer can control their movement as

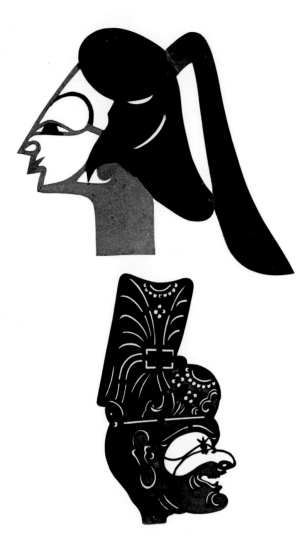

he sways the torso and thus give each character its own manner of walking. One can imagine, for instance, the difference between the gait of the sweet woman of Figure 133 and the swagger of the general in Figure 135. To evoke both personalities simultaneously is certainly a challenge for a puppeteer.

The intricate facial designs of the puppets communicate to the audience each individual character's disposition. A Song dynasty text—*Meng liang lu* by Wu Zimu—says of shadow puppets that "loyal characters are carved with a proper appearance and evil people with an ugly look."[17] Though it took centuries to develop the minute details of masks representing different personality traits, the tradition might have begun with shadow puppets.[18] As in Chinese opera, the characters today are divided into four major groups: the *sheng*, usually scholars or officials, are male characters and can be old or young; the *jing*, also men, are military figures whose painted faces symbolize their personality traits; the *dan* are all the women, be they militaristic, educated, or servants; and the *chou* are the comic actors. Immortals can take any of these roles.

From the shadow puppets' heads, these roles and personalities can be immediately distinguished. Except for an occasional *gui*, or monster, almost all the faces of the shadow puppets are in profile. Noble gentlemen, the *sheng*, and all women always have faces completely cut away except for the graceful outlines of their eyebrows, eyes, lips, and nose in profile. The men's foreheads are flat and the women's rounded; otherwise only earrings and hairstyles distinguish the two sexes.

Figures 133 and 139, a *dan* and a *sheng*, are fine examples of the artistic work devoted to portraying these character types. The *dan* and the *sheng* always have closed lips, while the *chou* and *jing* may have parted lips, sometimes even baring their teeth to give a coarser appearance. The latter two classes of characters also usually have solid faces with rounded foreheads, protruding noses and eyes larger than those found in the *dan* and the *sheng*. The evil monster of Figure 141 and the pathetic spirit he is punishing in hell are both portrayed naked and with their tongues out, as well as with all the flesh of their faces visible, in itself a shameful feature. To a regular viewer of the shadow theater, they are obviously repulsive and lowly characters. Again imitating the live theater, the *jing* characters' faces are painted in intricate designs. The puppet maker also incises lines in the face, allowing light through to emphasize the mask's expression. The various colors used and their arrangement on the face indicate personality. In Figure 135, a fierce general wears a red-and-black mask; the red designates strength, and the black, loyalty. Different types of mous-

Figs. 139 and 140. Two shadow puppet heads. Top: the graceful lines delineating only the profile and the handsome, arched eyebrow show this sheng *character to be an aristocratic and righteous individual. Though the material used here is only paper, an elegant effect is still possible. Nineteenth century. Hebei Province. 2½" high. Bottom: the open area around the eye, creating the effect of a white patch, along with the open-mouthed grin revealing teeth, indicates that this is a* chou, *or clown, character. Leather. Shaanxi Province. 3" high.*

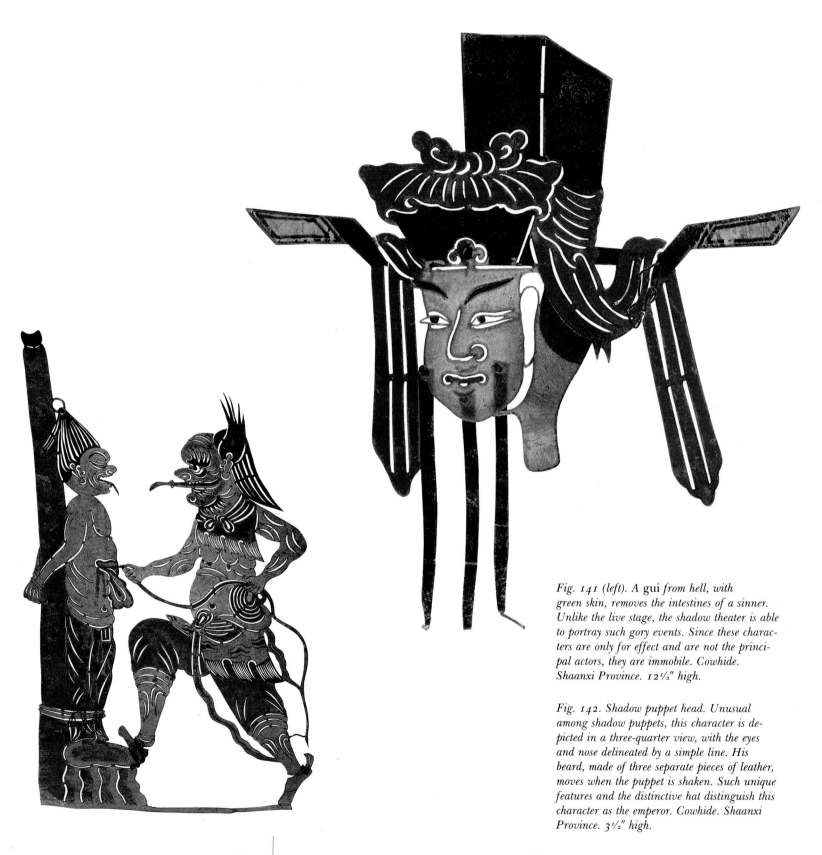

Fig. 141 (left). A gui from hell, with green skin, removes the intestines of a sinner. Unlike the live stage, the shadow theater is able to portray such gory events. Since these characters are only for effect and are not the principal actors, they are immobile. Cowhide. Shaanxi Province. 12½" high.

Fig. 142. Shadow puppet head. Unusual among shadow puppets, this character is depicted in a three-quarter view, with the eyes and nose delineated by a simple line. His beard, made of three separate pieces of leather, moves when the puppet is shaken. Such unique features and the distinctive hat distinguish this character as the emperor. Cowhide. Shaanxi Province. 3½" high.

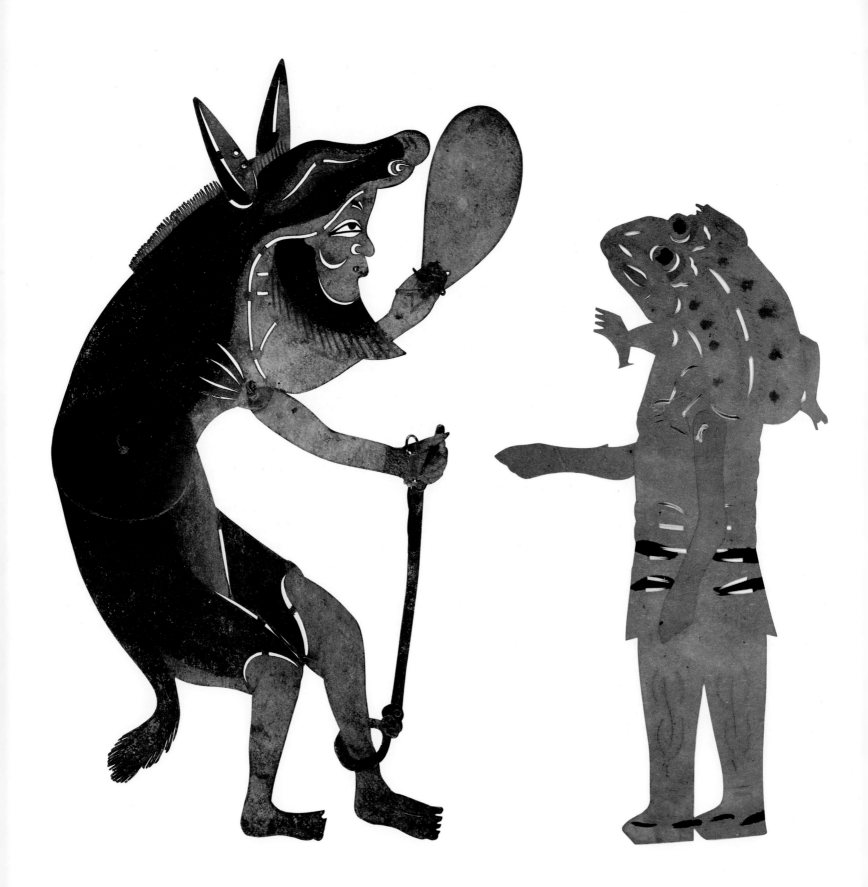

Figs. 143 and 144 (left). Two creatures from the shadow theater. At left: a man dressed in a wolf's clothing. Leather. Shanxi Province. 11½" high. At right: a frog character depicted with a human body, as animals are in some regions. Paper. Hebei Province. 9" high.

Figs. 145 and 146. This shadow puppet head serves as both a charming woman and the goblin into which she, a fox spirit, can be transformed. The goblin's horrid tongue becomes a braid when the human character reappears. The goblin face is attached by leather strings to the puppet's head and can be flipped out of the way until needed. The large size of this puppet head and the thickness of its leather differentiate it from more frequently seen styles. Here the distinction between the depiction of a gui (shown with open mouth, teeth, and flesh-colored face) and an upright human being (with an outlined face) is apparent. Cowhide. Province unknown. Collection of Louise and Peter Rosenberg. 5½" × 4½".

taches also give clues to a figure's character. A finely combed beard is appropriate for an upright gentleman, while a meaner fellow would wear a fuller beard. *Chou* characters often have an area of white surrounding their eyes cut away, as in Figure 140, to simulate a patch of white powder smeared on their faces. Hats similarly indicate social standing: the simplest ones are worn by the lower characters, and more elaborate ones by those with more prominent roles. Officials of different ranks wear different hats, and even eunuchs have their own specific hat. By such distinctions the audience is kept completely aware of the hierarchy of the actors on stage at all times.

Costumes further convey rank; the more detailed the carving, the more important the person. Old servants are depicted wearing very plain, unembroidered, and therefore uncarved garments with perhaps only incised lines to suggest folds in the cloth, as in Figure 136. The costumes of officials and generals are elaborately carved and painted to represent the lavish embroidery that covered the clothing of such men in ancient China and that certainly impressed the common people. Other clues to identification are symbols on clothing. Dragon motifs and bright yellow colors are worn only by imperial characters. Only females of imperial rank can wear a phoenix motif, and a jade belt is worn only by officials. When a woman wears red, she is attending her marriage ceremony. Figure 21 shows a young lady in a wedding gown richly decorated with the double happiness characters, *xi xi*, symbols of marriage.

Most troupes possess between 100 and 150 bodies and around 1,000 heads, for the subtle differences in personalities are usually reflected by the heads (and of course by the puppeteer's performance), while the costumes can be used interchangeably by a number of characters. In a set used by a puppeteer today, the puppets may not all be of one style or even carved during the same period. Puppets fall apart and are repaired or, if possible, replaced, creating sometimes jumbled sets with a variety of styles of puppets.

Much of the appeal of the shadow theater — and what distinguishes it from other Chinese drama forms — is its combination of fantastic scenery, characters, and special effects, referred to earlier in the chapter. In the late eighteenth century, the English traveler John Barrow attended a shadow performance at the Imperial Yuan Ming Gardens in Beijing. He praised it as "a first-rate effort of invention and ingenuity," and described the multitude of creatures,

> dragons, and elephants, and tygers, and eagles, and ostriches, oaks and pines, and other trees of different kinds. The ocean was not behind hand, but poured [forth] on the stage the wealth of its dominions, under the figures of whales and dolphins, porpesses and leviathans, and other sea monsters, besides ships, rocks, shells, spunges, and corals, all performed by concealed actors, who were quite perfect in their parts and performed their characters to admiration.

Later in the performance, the whale "taking his station exactly opposite to the Emperor's box, spouted out of his mouth into the pit several tons of water. . . . This ejaculation was received with the highest applause."[19]

Besides such a range of fabulous animal life, a shadow theater set also includes a number of trick props, such as a mirror in which the figure's "reflection" appears when she or he looks into it (a leather head in the proper perspective is hidden behind the mirror and flipped against the screen at the appropriate moment). In the world of Chinese legends and myths, where fantastic spirits and common mortals often mingle, it is not unusual for monkeys to fly, for beautiful women to turn into frightful demons, or for the petals of a lotus blossom to open and reveal an immortal. The shadow puppet theater has created brilliant props to accommodate such extraordinary occurrences. Figure 145 is a charming woman who can become, with a simple adjustment, a goblin (Fig. 146). Figure 147 is another woman who, after being struck on the head, will turn a blood-spattered face to the audience. In both cases, two heads are attached to one neck and can be switched by a quick touch in the midst of an action-filled scene. Shadow puppeteers through the centuries have ingeniously invented such simple mechanisms to convey the exotic world of their legends, and in so doing have been able to capture an audience already intrigued by that world.

Fig. 147. Trick head of a beautiful young woman who will become spattered with blood after being hit on the head. In the middle of the action, the puppeteer simply turns the head, and the awful face appears. Unlike the construction in Figures 143 and 144, the two heads here are made of one piece of leather connected by leather strings to the hair piece. Cowhide. Shaanxi Province. 2½" high excluding hair piece.

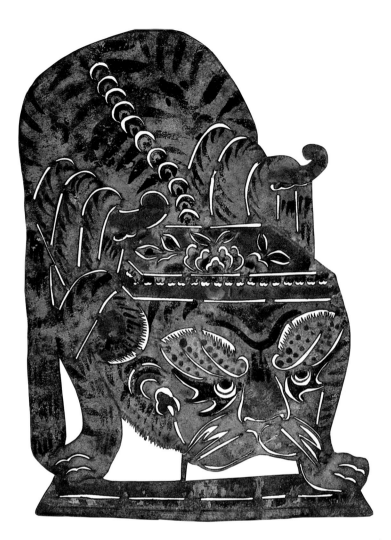

Fig. 148. Tiger chair, a shadow theater prop,
used by generals and leaders of rebel armies.
The questioning eyes of the tiger, emphasized by
the lines about his eyebrows, give extra strength
to this piece and to the character who will sit
upon it. Cowhide. Shaanxi Province.
8½" high.

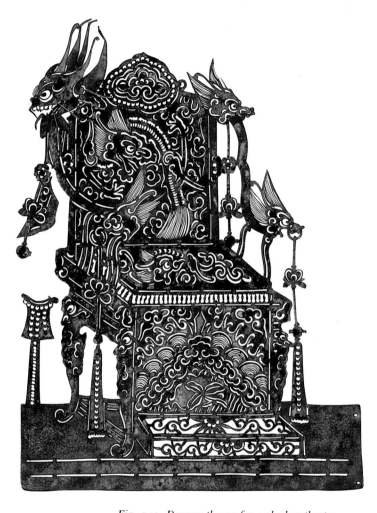

Fig. 149. Dragon throne for a shadow theater
emperor; the dragon is the symbol of the impe-
rial family. Details of embroidery and wood
carving have been crafted into the leather to
create a heavily decorated seat worthy only of
the emperor. Compare with the carving applied
to the tiger chair of Figure 148. The larger
dragon on the top of the chair is a replace-
ment; the original having fallen off, the pup-
peteer made do with whatever dragonlike char-
acter was available, a common practice in
repairing old puppets. A pomegranate, symbol
of fertility, decorates the lower part of the em-
broidery on the throne. Cowhide or goatskin.
Shaanxi Province. 9½" high.

The furniture of the shadow stage, arranged in most cases to represent the rooms and halls of China's aristocrats, is designed according to hierarchical details almost as specific as those governing the characters. A general of a rebel group sits only in a chair covered with a tiger's skin, like that in Figure 148. The emperor sits only on his dragon throne, such as the richly carved seat of Figure 149. An official's desk can be recognized by the objects on it: the seal of office, brushes, brush rests, and *lingjian*, the long strips of bamboo or wood in a pot that officials would hand aides when giving orders. Each piece of furniture has a small hole at the top through which a pin is stuck to attach it directly to the screen of the theater. Though the human and animal figures of the shadow theater are almost always shown in flattened profile, the furniture is all depicted in two-dimensional perspective, giving the setting a great sense of depth. Such pieces add another dimension of reality to any scene.

Imparting life to the fabulous scenes are the members of the shadow puppet troupe, who never come out from behind the screen. A troupe usually consists of five to eight people (though Song records speak of troupes with up to twenty-two people),[20] most of whom are musicians. Every participant has more than one responsibility, especially when assembling the stage. The screen is a five-foot-by-three-foot white cloth or a sheet of white paper stretched between two bamboo poles. If paper is used, it is used for only two or three performances and then replaced by a new sheet. On either side of the screen are hung embroidered curtains and beyond them black curtains to hide the activity behind the screen from the audience. The musicians sit behind the puppeteer, playing cymbals, the *erhu* (a Chinese stringed instrument played with a bow but shaped like a small, barreled banjo), flutes, gongs, drums, and horns. They also speak and sing for the minor characters. One singer may be responsible for all of the women's parts if he is adept at the falsetto that must be used. The chief puppeteer may take care of the rest of the speaking while also managing all of the puppets' movements. Should Guanyin, the Goddess of Mercy and also the patron goddess of all shadow puppeteers, appear in a drama, only the best performer of the troupe is allowed to operate her puppet and speak her part, because she is so highly regarded. Puppets not involved in the action but still on stage are leaned against the screen. A rough mat on the stage keeps them from slipping. The puppeteer occasionally nudges them to make them appear alive.

As suggested earlier, a skilled puppeteer's handling of the puppets is as essential as the costumes and the details etched into the faces in revealing the personality of the character. The smallest gestures can convince the

audience that they are watching shadows of human beings rather than just leather. Movements created by a good puppeteer will reveal emotional as well as moral qualities of the character. The silly *chou* figure, for instance, would certainly walk differently than the serious scholarly gentleman, and a genteel woman will move her hands daintily. A skilled puppeteer can handle up to four or five puppets on stage at one time, and masters, it is said, control eight puppets simultaneously.

The shadow plays themselves can be divided into several categories — civil, martial, romantic, burlesques, comedies, and Buddhist stories — which are sometimes combined into one play. Most of these plays, like all folk art, are by anonymous writers. Audiences are usually familiar with the whole repertoire but enjoy seeing their favorites over and over, for each puppeteer adds his own flavor by dropping in jokes and improvising. "Journey to the West" is a particular favorite because the antics and acrobatics of the monkey character Song Wukong make the shadow theater an ideal medium for the story. "The White Serpent," "The Tale of the Three Kingdoms," and the comedy "The Beating of the Flour Barrel" are all popular.

In the past, puppeteers were often scholars who had failed the exam to become an official. With their vast knowledge of history and literature, they were perfect for the puppeteer or storytelling profession. Sometimes the puppeteers were retired actors who were familiar with the tales from their years of performing. In rural areas, they might also have been farmers whose family puppets had been passed down for years and who in winter, when there was little farm work, would perform in the villages to earn a bit of extra money. Indeed, that is the situation in many cases today. The scripts puppeteers carry around with them have traditionally been merely rough scenarios of the stories; the individual tale-teller must elaborate and entertain in a manner appropriate to a given audience, be it lewd or proper.

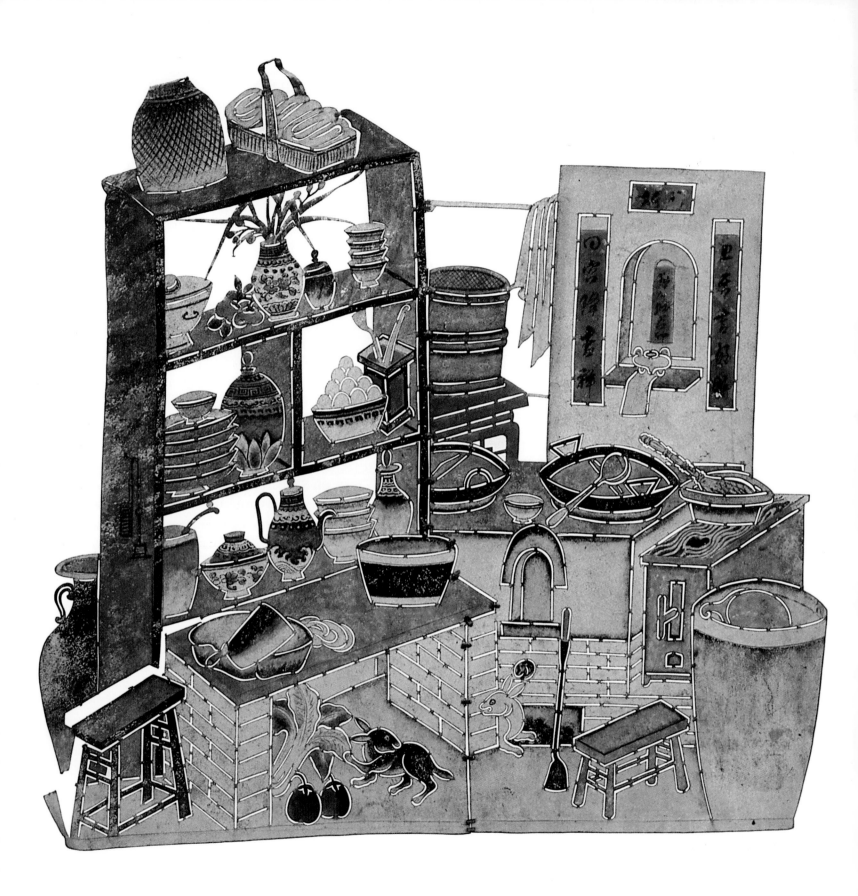

Fig. 150. Shadow theater scene of an average household kitchen. Above the stove is an alcove for the Kitchen God; calligraphy denotes his presence. On the shelves are eggs, bowls, steamers, and various cooking necessities. Below the table, a hare munches on what may be his last meal, giving the scene even more vitality. Donkey skin or goatskin. Shaanxi Province. 17" × 16".

Fig. 151. Screen with a table upon which are a fan and vase. This prop would be used in a set for a scholar's home; the couplet of calligraphy on the screen reads "Books, [one need] not read those after Han and Qin; the mind [should] often be in nature." The table and screen are one object and not detachable. Cowhide. Shaanxi Province. 18" high.

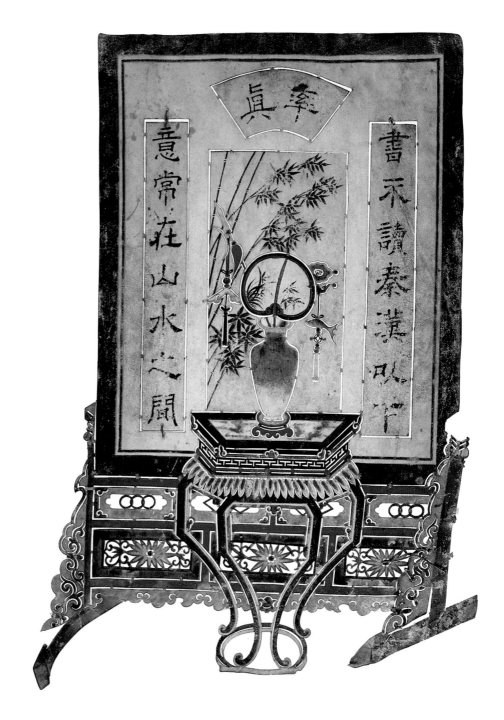

Up until the late Qing dynasty, puppet troupes were still common in the cities. Wealthy families would invite them in when celebrating the birth of a son, a wedding, or the birthday of a grandfather. Today they are rarely seen in the city but are still popular in the countryside. "I hired a troupe for two days for my grandmother's funeral," a young Hebei Province man boasted recently.[21] Births, weddings, funerals, gods' birthdays, and New Year's festivities are still lavishly celebrated among the rural population. Recent reforms have allowed villagers to earn more money, and often they choose to spend that money in celebrating and watching over and over the tales that bring them joy and hope.

Whether future generations will continue to be enchanted by the fantastic world behind the shadow screen, preferring it to the "electric shadows," is difficult to judge. At least today, when there is still little television in the countryside, the shadow theater still holds its ancient magic. Particularly at funerals, when the mood of the guests calls for entertainment, hiring a shadow troupe — called the "small opera" — is still popular. But with recent affluence in the villages, the more impressive "big opera," live stage opera, is becoming more accessible and encroaching on the smaller version's market. Fifty years ago some people were already prophesying that the shadow theater would quickly fade. As yet their words have not been realized, yet they stand as a warning. In the 1930s, when Genevieve Wimsatt interviewed a Beijing puppeteer, he bemoaned the fact that

> young people, children, even women are now going out to the theaters and motion pictures. They are no longer inviting the shadows into their halls and courts to celebrate a grandmother's birthday, a betrothal or a naming of a son. . . . I have no pupils to continue the old traditions, to make my shadows dance when I am gone. I do not know who then will love my little players and cherish them . . . shadows pass.[22]

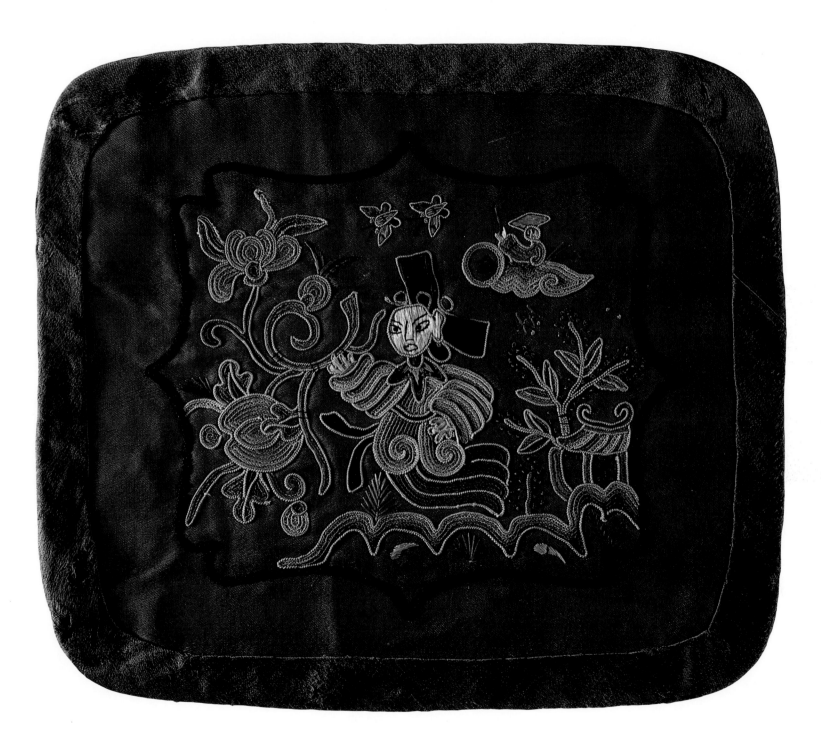

Embroidery

Women in traditional China, whether they were from families that tilled the land or those that ruled it, were judged not by their beauty but by their embroidery skills, abilities believed to express the fine qualities of their inner natures. Women of wealthy families stayed behind the walls of their homes, in the women's quarters known as the embroidery rooms, concealed until the day of their marriage. When a matchmaker went to speak with a potential groom's family, she often brought with her a sample of the young woman's embroidery. A girl would have started embroidering the goods that would constitute her dowry long before her match was confirmed: gifts for her new in-laws and her wedding dress, which she would display only once, for the ceremony, and then fold away in storage.

Embroidery, the stitched decoration on clothing and other textiles, is one of the oldest forms of artistic and decorative effort in China, if not the oldest. In making clothes, a job that has fallen mainly to women, the instinct to add a bit of decoration while the needle is still in hand has come almost naturally, particularly when making a garment for a loved one. Elaborately embroidered textiles made with the finest of silks were luxuries only for the wealthy, who could afford to hire embroiderers. But the less well-to-do also put their whole hearts into embellishing clothes and mementoes when they could steal the time, using whatever materials they could find. Some techniques they developed themselves, and these are almost exclusive to folk works; others they shared with the wealthy classes, for whom they often worked.

Fig. 152. Pillow end, primarily employing the suo *stitch, portraying the legendary character Chang E on her flight to the moon. Silk thread on silk background. Hebei Province. 7″ × 8″.*

Looking into the past, we see how embroidery early on became a basic celebratory act, growing almost into a full-scale industry to serve society's elite. It in turn encouraged and allowed the lower classes to create their own form of embroidery. In Xinjiang, archeologists have found beads, flattened on one side, dating from at least twenty-five thousand years ago, which Youngyang Chung, a scholar of Asian embroidery, believes were sewn into animal-skin clothing worn at that time.[1] In that primitive society, the luxury of embroidery had already begun. Needles made of bone have been found dating from Upper Paleolithic times, indicating that sewing and thread making had been a part of early human activity. As human beings advanced and left the nomadic life-style to settle in agricultural villages, they became less dependent on hunting for food and also created weaving, which ended the practice of wearing animal skins. The invention of the loom was the initial, essential step toward the development of embroidery as we know it today. It has so far been impossible to determine exactly when the loom came into use in China. Weaving had certainly existed during the Yangshao culture (5000-2500 B.C.); the pottery of that time, samples of which were discovered at Banpo, in Shaanxi Province, reveals impressions made by woven textiles, mats, and baskets.[2]

Sericulture — the raising of silkworms and the production of silk fabric — may also have emerged during the Yangshao. With the discovery of this elegant filament, the art of fine embroidery could develop. The effects created with this magnificent material were impossible to attain with any other thread. A silk cocoon discovered at Shaanxi appears to have been artificially cut open, corroborating the Yangshao connection, for in silk production the cocoon must be forced open before it is mature. Chinese legends say that the sericulture process was invented by the wife of the Yellow Emperor during the Xia dynasty, whose existence has yet to be proven but which is believed by some to date from the twenty-first to the sixteenth century B.C., making it almost contemporary with the Yangshao culture. As far as records indicate, the silk industry since then has been largely conducted by women, with men responsible for the heavier farm work. According to Herrlee Creel in *The Birth of China,* from as early as the Shang dynasty (16th–11th century B.C.), most of embroidery was also done by women, perhaps as a logical extension of their year-round work.[3]

Silk production begins with the care of silkworm eggs, which need to be kept warm all winter. Upon hatching, the larvae eat only leaves from the mulberry tree. The silkworm raiser must not only care for the worms but must also have a continuous and sufficient supply of this fresh feed.

The worms eat, growing larger and larger, until they begin spinning their cocoons. From their mouths come fine, continuous strands of silk that form the cocoon. After a certain number of days, the cocoon must be carefully opened and the silk unwound. This must be done before the worm begins to secrete a substance that would result in an inferior silk. The most common way to remove the silk is to place the cocoons in boiling water, unravel the silk filaments, and then spin them into threads. These can then be woven into fabric. The number of worms needed to create a single bolt of silk is astronomical, for although each cocoon yields up to three thousand feet of filament, large amounts of it are necessary because of its fineness. In areas where the climate is appropriate, people throughout China and especially those in the rural areas have participated in raising the silkworms.[4]

The organization and manpower necessary for the production and trading of silk were present during the Shang dynasty, a time of great cultural advances. The characters signifying silk and silkworms appear often on bronzes from this period. The Shang emperors and their extended families lived in many-roomed, luxurious mansions. Vast numbers of artisans in their employ crafted clothes, vessels, and decorative articles.

Fig. 153. Papercut of a girl feeding mulberry leaves to silkworms. The worms, which consume great quantities of these leaves before they begin building their cocoons, are shown here in both their smaller state, in the lower left-hand corner, and in the larger size to which they rapidly grow. Here the adult size is obviously exaggerated. Northern Shaanxi Province.
7″ × 9″.

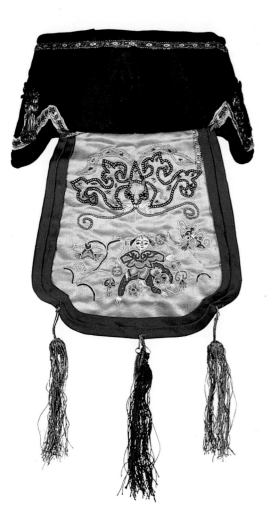

Fig. 154. Back view of child's cap. The flap is embroidered with a gay image of Liu Hai and his three-legged toad, who bring good fortune. Above them flies a bat, fu. The Liu Hai figure was created with the seed stitch, while the bat was delineated by stitching a thin strip of material onto the background. Silk thread on silk background. Hebei Province. 8½" × 10".

Woven fabrics, embroidery, carved mother-of-pearl, wood carvings, bronzes, musical instruments, jade ornaments, marble sculpture, carved turquoise, lacquered walls, and pottery embellished the sophisticated world of the aristocracy.[5] Sericulture was a central part of this highly developed civilization. The imperial wealth that gave rise to such lavish artworks was at least partially drawn from proficient, established silk trading. The powerful Shang government was able to enforce a system incorporating the farmers and those within the palace to generate large quantities of silk to glimmer alongside their fantastic bronzes. These luxurious cloths were doubtless embellished by embroidery. Though no actual pieces of embroidery still exist from the Shang era, some evidence of it has been found. Shang tomb sculptures of human figures found at Houjiazhuang are dressed in robes and skirts, the hems and cuffs of which are heavily decorated in a manner suggesting embroidery.[6]

Although the Zhou nation (11th century–256 B.C.) was originally not as advanced as the Shang, it adopted many of the Shang art forms when it conquered that civilization; under the Zhou dynasty, the number of embroiderers under government control increased greatly. According to Chung, "hundreds, perhaps thousands" of government-sponsored workshops were organized to produce elaborate costumes, screens, and wall hangings for the palace and nobility, as well as for trade.[7] Most likely, women from the countryside were employed or enslaved to do embroidery work. The patterned silks and embroideries discovered in tombs in Changsha—embroideries that used the chain stitch—are examples of the fine work already being done.[8] That the rural areas were so involved in silk production is evidenced by the Qin dynasty (221–206 B.C.) tax laws, which required from each family "three piculs of grain, one bolt of silk, three ounces of silk floss or fifty feet of hemp cloth."[9]

Specimens found at Dunhuang and elsewhere reveal that by the Han dynasty (206 B.C.–A.D. 220) eight different kinds of stitches were being employed: the chain (*suo*, or lock) stitch, the couched (*ding*, or nail) stitch, the seed (*da zi*) knot stitch, the satin (*ping*, or flat) stitch, the *xian wen*, or stem stitch, appliqué, and the buttonhole and quilting stitches. Even today, these eight stitches are used in China. According to Chung, no new stitches were employed until the Ming dynasty (1368–1644), when the canvas, Florentine, and petit point stitches came into vogue.[10] However, Chung does not discuss the advent of the cross-stitch, seen primarily in folk embroideries, or the Pekinese *wan* (or roll) stitch, which came into use much later.

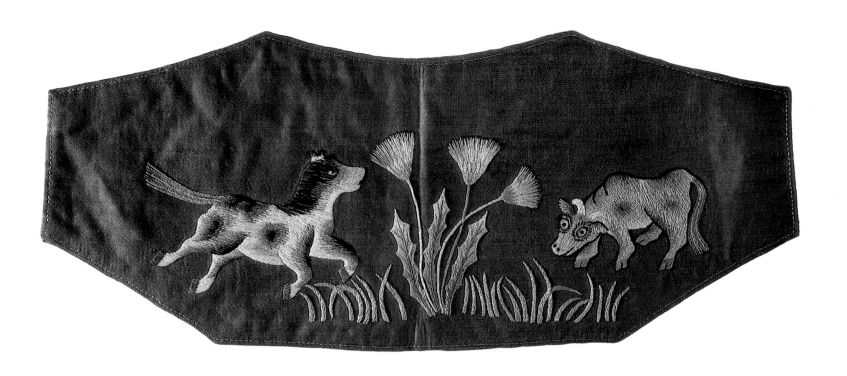

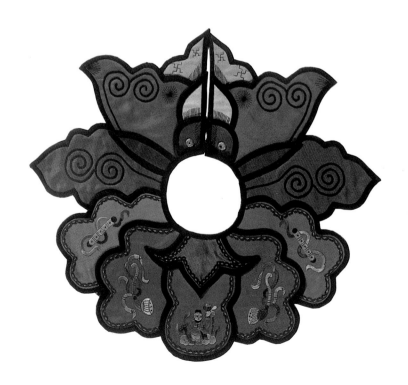

Fig. 155. Stomach apron and pocket depicting two cows grazing contentedly. Silk thread on silk background. Shaanxi Province. 5″ × 13″.

Fig. 156. Child's collar. By incorporating a variety of differently shaped petals to form the collar, the artist has cleverly created illusions of other images. The lower five petals are a pomegranate, symbol of fertility; the top two petals form a bat shape, another good-luck symbol. Silk thread on silk background. Hebei Province. 9½″ × 10″.

Fig. 157. Ming dynasty woodblock print illustrating a scene from The Water Margin *of a woman sewing her husband's costume. From* Ming Chen Hongshou shui hu ye zi.

The emperor Han Wudi expanded China's borders and opened up the famed silk route. By way of trade roads, Chinese silks and embroideries reached Syria, Parthia, India, Chaldea, Central Asia, Siberia, and also Rome, where, by the first century, they were the rage, to say the least. For many years, the secret of the silkworm was a mystery to the West, allowing the Chinese a monopoly on the textile.

The 1972 discovery of a well preserved tomb dating back twenty-one hundred years demonstrated to modern researchers the degree of sophistication achieved by the artisans of the Han era. In this tomb, Lady Cheng, wife of the marquis of Tai, was buried, accompanied by embroidered mittens, shoes, robes, and fifty works of embroidered silk and brocades, all done in a grand variety of colors and designs. Exquisitely intertwined bird figures cover one whole cloth. Sculptures also in the tomb depict musicians and attendants wearing embroidered costumes, revealing that embroidered clothes were not limited to the nobility but were worn by a large percentage of the populace.[11] In post-Han times—with the introduction and expansion of Buddhism—the demand for embroidery widened to include embellishment of scrolls, tapestries, and banners expressing devotion to the Sakyamuni Buddha.

The palace from the Tang dynasty (618–907) in Chang An employed a record number of thousands of seamstresses and embroiderers. The country's capital, Chang An had become an international trade center; markets displaying more than two hundred different crafts crowded the city streets.[12] All across the country, textile production increased to fill the demand. Large centers evolved not only in the capital but in other commercial cities across the country.[13] Again, peasant wives were doing much of the work, in both producing the silk and embroidery, to bring in extra income for their families. The Tang poet Du Fu writes about them with sympathy: "The silk divided in the Vermillion Hall was woven, / By the hands of the poor women; / Women whose men were whipped in their homes, / By tax collectors who took the silk to court."[14] The Vermillion Hall was the imperial palace where officials would divide silks collected in lieu of taxes, probably unaware of the toil involved in creating such pieces. Perhaps Du is referring to families who had expected to earn extra money by selling the silk but instead had it taken away from them by unmerciful tax collectors.

The clothing of the upper classes became more and more elaborate during the Song dynasty (960–1279) and the embroidery even more fanciful than in previous times. Stitching decorated everything from silk para-

Fig. 158. Woodblock print pattern from a book dating from between the early twentieth and late nineteenth century. This pattern is to be used for making children's tiger shoes, as seen in Figure 166.

sols to silk fans. As interior decorating flourished, embroidery became an increasingly important component—bed covers, wall hangings, and screens added to the magnificence of the homes of the wealthy. The art of embroidering paintings evolved into a respected art form in itself, particularly among the daughters of the affluent.

When the Mongols invaded the Song empire, giving rise to the Yuan dynasty (1279–1368) they enslaved many silk workers and embroiderers, along with other craftspeople, and brought them to the capital to continue producing these much-admired goods. With the return of Chinese rule some ninety years later in the Ming dynasty, the genius of the Chinese people for textiles was again emphasized by the government. Imperial orders forced farmers to step up production of those crops essential to the making of textiles, such as mulberry, cotton, and hemp. During the Ming period, the custom of wearing the imperial square—an embroidered badge on the front and back of officials' robes—was developed, and the square became a wonderful focus for fine embroidery. Each rank of official was assigned an animal symbol, ranging from cranes to dragons, to be embroidered on their badge, and they could not change symbols unless promoted. The shadow puppet official of Figure 135 wears such a badge.

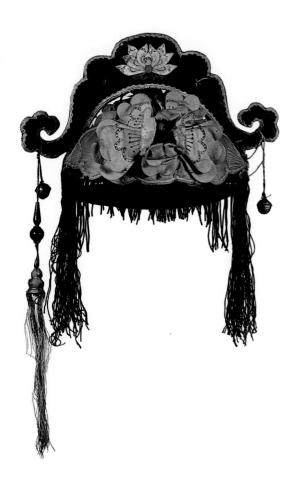

These embroidered silken goods, which were so much part of the aristocrats' world, were still in large part produced by the lower classes. Some daughters of the wealthy in their leisure time embroidered paintings based on contemporary paintings of flowers and birds, but most hired skilled peasants to embroider their elaborate clothes and various articles such as pillow covers, quilts, and purses. Poor women could supplement their family incomes by embroidering for the wealthy. However, although there are few records of early peasant life, we can assume that embroidery in some form was practiced by these lower segments of society for their own homes. This involvement and skill in the art form would allow the peasants to enrich their own surroundings. Impoverished as they might be, people of the villages were still interested in beautifying their dwellings — at least for auspicious and celebratory occasions. Records from the Song dynasty underscore the involvement of the common people in the art of embroidery for their own use. Zhou Mi, a writer and historian of that time, mentions that papercuts were sold in shops side by side with needles and thread.[15] Most likely, these papercuts served as stencils to assist women with their embroidery. Later, books were printed that included both clothes patterns and embroidery ideas. Figure 158 is a page from a book of this type that appeared late in the Qing dynasty (1644–1911). Here the design is for a child's tiger shoe like that in Figure 166. The smaller designs of the dragonfly and cicada could be used on other pieces. The image would have been cut out, pasted onto the material, and then stitched over until eventually none of the paper would show (designs sold in the shops during the Song era were already cut out). Many women, though, far from urban centers, relied not on these patterns but on their mothers' and grandmothers' embroideries for inspiration. In this way another art form passed from the upper classes to the lower, where it eventually developed unique styles that distanced it from its aristocratic origins.

Embroidery has traditionally been one of the few ways a peasant woman could express and display her skills, her agility, her sense of beauty. Today a woman's life before her marriage (with the exception of domestic work) is directed toward her marriage, and one of the tasks that fills her free time is embroidering objects that will one day form her dowry. Her wedding day is the one day in her life when she will resemble in some small degree a person of noble rank, both in dress and in the way she is treated. She will spend many hours designing, sewing, and then lavishly embroidering her wedding clothes. Obviously, much time was devoted to the lotus-shaped collar in Figure 33, worn at a wedding and symbolizing the bride's fertility.

Fig. 159. Child's hat in the shape of an official's hat. Attached to the front of the hat is a lotus flower, implying the saying lian sheng gui zi, *"continually giving birth to noble sons." Silk with painted designs. Shanxi Province. 6" × 7½" diameter.*

Fig. 160. Child's two-faced tiger hat. One face looks upward, the other forward for extra protection in frightening off malicious spirits. Silk and cotton. Hebei Province. 11" × 8½" diameter.

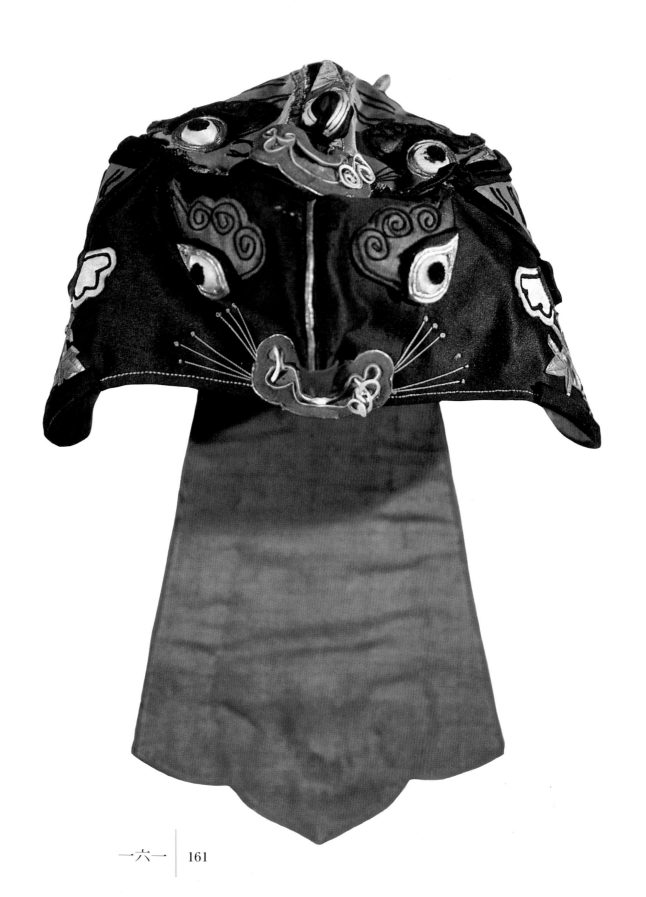

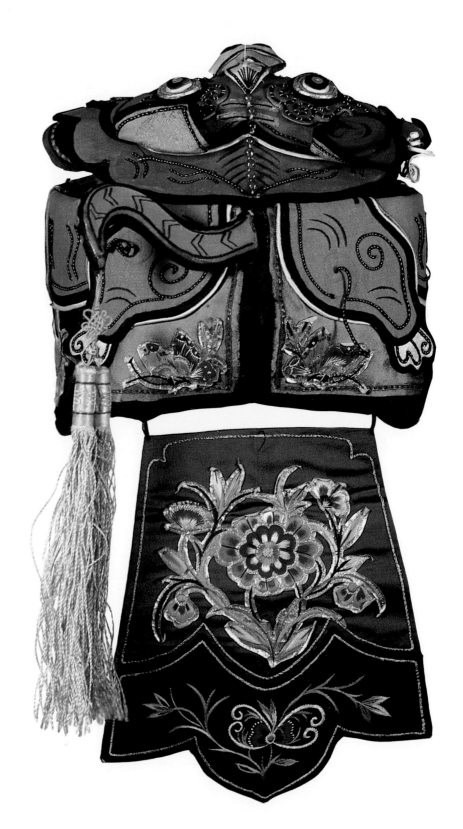

Fig. 161. Back view of the two-faced tiger hat, showing tail and decorated flap that keep the wind off the child's neck.

Fig. 162. Child's collar in the shape of a two-faced pig. Like the tiger, this animal protects the child, but in this case it does so by fooling the evil spirits into thinking that the infant is only a pig, not a human, and therefore not worth harming. The embroiderer has used small beads to illuminate the pig's pupils and metallic paper to brighten the outlines of its ears. Silk thread on cotton background. 13½" × 10".

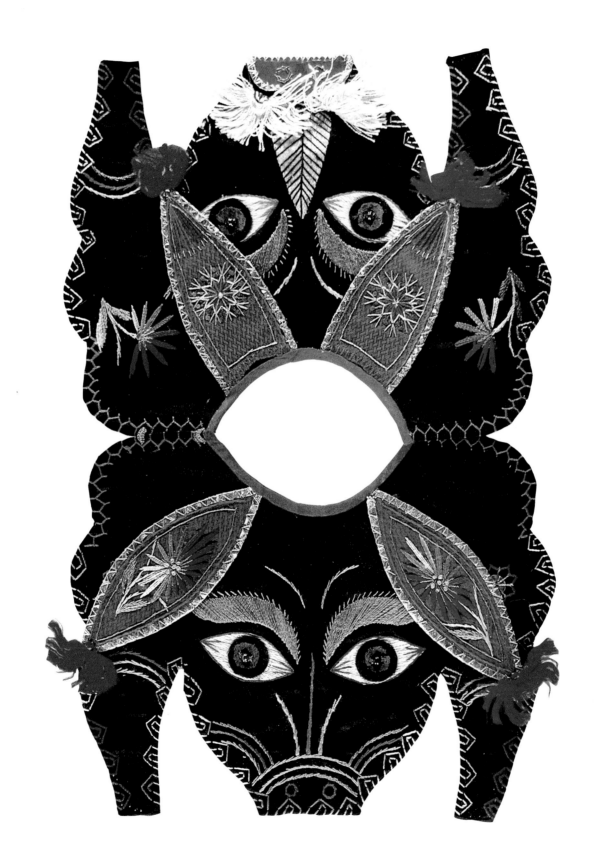

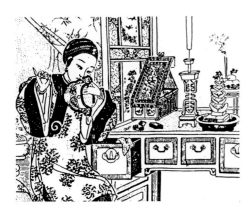

Fig. 163. Detail from a woodblock print showing a mother sewing a cap for her child. The cap is in the shape of an official's hat, similar to the one in Figure 159, meant to inspire the child to become an official, and to bring him luck in that endeavor. From Wu Youru hua bao.

Fig. 164. Pillow end depicting a young girl standing beside a cornstalk. Using the simple satin stitch and brightly colored threads, the artist has created an unrefined yet charming image. Silk thread on cotton. Shanxi Province. 5″ × 5″.

Some of the most enchanting folk art to be found in China is not wedding embroideries, however, but the work a woman does after entering her husband's home. Then she begins to embroider for her sons, who, as the Chinese say, are her treasures. Sons represent the future of a family and will ultimately bear responsibility for their elders and the ancestral spirits. Giving birth to sons confers status upon a woman in her husband's family, for without them she would be considered merely a financial burden. Hence the embroidery devoted to them receives a woman's deepest care and attention.

The embroidered clothes made for little boys are not simply decorative; they play a special role in protecting these precious sons. Certain embroideries are worn on important days when the young ones are more vulnerable to the vengeance of evil spirits. When a boy is one month old, his mother or grandmother makes a tiger hat, tiger pillow, tiger collar, and tiger shoes, which are both shields and decoration. Tigers are the chosen motif because they are not believed to be terribly antagonistic toward human beings yet are ferocious enough to frighten away malicious spirits. The child wears the tiger hat, collar, and shoes, and sleeps on the pillow on anniversaries of his birth and during other festivities, such as New Year's. All this paraphernalia makes him the center of attention; such a sight may not scare away any ghosts but should certainly charm them. For the next four or five years, the mother will continue to make larger hats as the child grows through the ages in which he would be most susceptible to disease.

Figure 165 is a typical Hebei tiger hat, orange with black stripes; its eyes have been stuffed with cotton until they bulge, and its tiny cotton teeth and curling fangs look ready to sink into any threatening spirit. In its ears, little children rest—demonstrating that, though he is fierce, the tiger is also protective.

The tigers found on Shaanxi hats are even more abstract. On one Shaanxi tiger, crisscross stitching draws attention to the eyes, emphasizing their seriousness. Again, a child on its head shows its protective qualities, though the creature barely resembles that which it is meant to represent. In the collar in Figure 162, a two-headed pig has taken over the protective role. His large embroidered eyes, furry snout, and pointed hooves are meant to daunt the potential evildoer, while the metallic-paper ear decorations and colored flowers on its haunches add a touch of friendliness. In the southern provinces, tiger caps are less popular. Instead, women attach

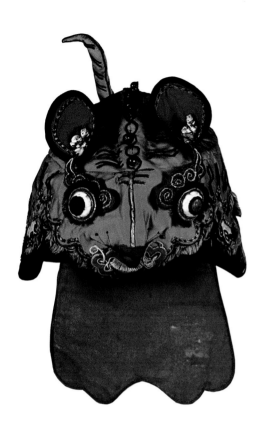

silver amulets to caps, often denoting the Eight Immortals and immortality itself to help protect their sons. The characters in Figure 64 were added to such a hat from Zhenjiang, Jiangsu Province.

Mothers and grandmothers also create shoes and embellish them with enchanting embroideries of animals such as rabbits, pigs, and frogs, as well as tigers. The tiger shoes of Figure 166 are of the more realistic Hebei style but have eyes worked into stripe designs. Mothers today explain that these eyes help the child to see where he is going. The collar of Figure 168 does not so much protect the infant as it illustrates the fat, healthy, and well-dressed child a mother obviously hopes the baby will become. Using a variety of stitches, the artist has created an image of a little boy wearing heavily embroidered clothes and shoes. The face, which was painted on, would have hung on the child's chest.

The *doudou* apron, a typical child's outfit (in fact, many children wear nothing in the summer but this simple piece of clothing), also serves as a background on which women can create decorations that prevent evil, encourage fertility, or instruct in morality. In stressing fertility, one mother formed a wonderful collar into the shape of a lotus flower; pale green leaves form the back, and pink flowers with the many-seeded yellow pod the front. The lotus's seeds symbolize the many children and descendants who will honor the family. Beyond its symbolic value, the piece evokes the care its maker took to produce a simple but elegant work, suitable both to decorate a beloved child and to be appreciated by adult viewers.

In reviewing these many works, we see that the forms of collars, shoes, and hats have become formats challenging the folk artist's creativity. Staying within the restrictions of the shapes and symbols, each woman creates a different exciting shape, style, and image. As we see in the examples of the hats, individual women working in the same medium, the same shape, and with the same theme create very distinctive objects. A woman may simply follow her mother or grandmother's method in solving the problem, for example, of how to create a tiger's face on a shoe, or she might resolve the empty space according to her own fancy, recombining or adding to images from her visual vocabulary.

The striking cotton *doudou* of Figure 68 with its loathsome, appliquéd insects frightens away evil spirits. In the more delicate silk *doudou* of the frontispiece, the artist has illustrated the tale of "The Third Wife Teaches the Son." The fine stitching and the attention given to the figures' expression is evidence of the embroiderer's commitment.

Fig. 165. Child's tiger hat. The tiger's bulging cotton eyes underline their size and likewise their power to protect a child from any evil spirit. Silk and cotton. Hebei Province. 11" × 9" diameter.

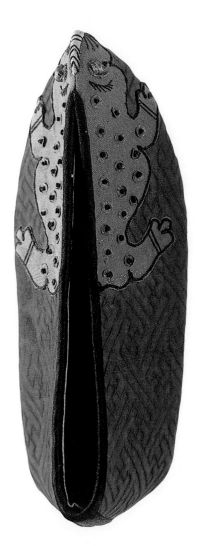

Fig. 166. Children's shoes. To frighten off evil spirits, mothers make shoes in the shape of tigers and other creatures for their children. The eyes on the tiger shoes further assist the child in keeping him from tripping as he first learns how to walk. From left: silk thread on cotton background; cotton thread on silk; cotton on silk. Hebei Province. Left to right: 5½", 6", 6¼" long.

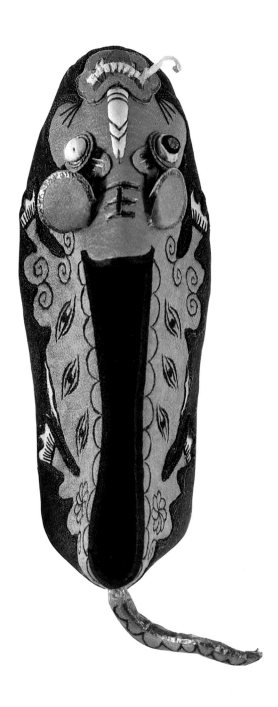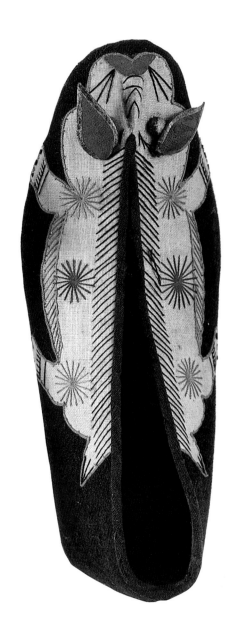

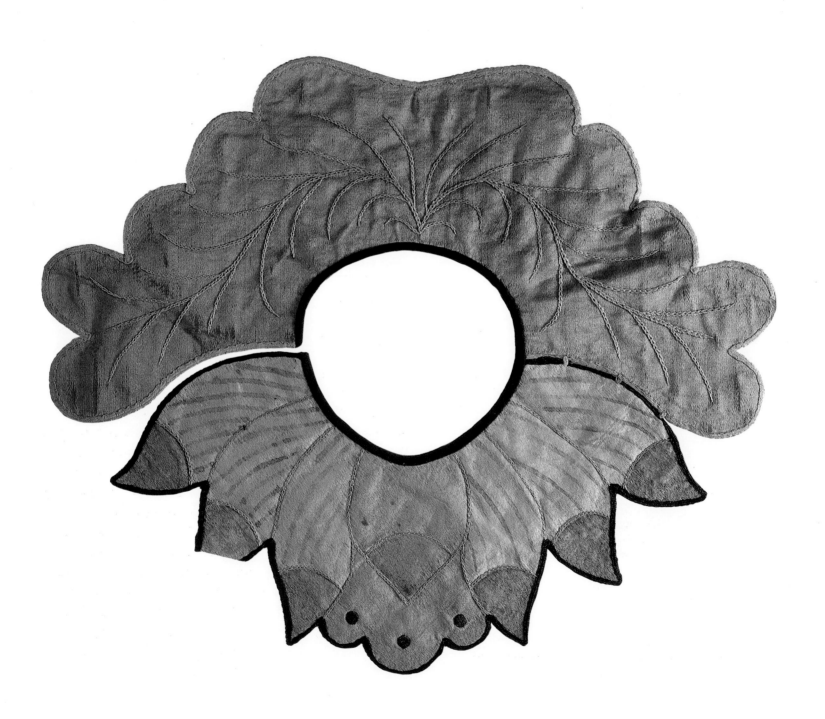

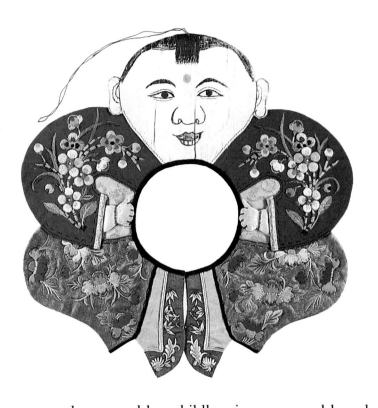

Fig. 167 (left). Child's collar in the form of a lotus leaf and flowers, symbolizing continual fertility. The artist has embroidered the veins of the leaf with white thread but delineated the flower and the seeds of the pod with colors and a brush. Cotton thread on silk background. Shaanxi Province. 9½" × 12½".

Fig. 168. Child's collar. Embroidered and painted on silk, this collar has been made in the shape of a child. The feet are not connected to each other, so the collar can be slipped around the child's neck, leaving the face hanging upside down from the infant's perspective. 9½" × 9½". Hebei Province.

When a woman has passed her childbearing years and has already taught her daughters the skills of womanhood, she embarks on her last embroidery project: burial clothes for herself and her husband. For the Chinese, this preparation is not a somber or morbid affair. Many buy their coffins years before they expect to die so that they can enjoy their days knowing that their entry into the next world has been well prepared for. They envision the afterworld as similar to the one mortals inhabit and into which one must bring clothes, housing, food, and spending money. At funeral services today, families burn paper models of mansions, cars, servants, refrigerators, and other appliances so the dead will live in more comfort than they did on earth. In elegant burial clothes, they can also be assured of appearing more refined than they did during most of their lives as peasants. Though there are no examples available of recent burial clothes, because they have all since been buried with their creators, tombs of pre-Qing dynasties have all revealed elaborately embroidered robes and textiles.

To fully appreciate this art form on any object, it is necessary to understand the many types of often complex stitches that compose it. In making their embroideries, peasant women, like their predecessors, must employ a variety of stitches—twisting, knotting, pulling, and even weaving the threads to create a diverse range of textures and patterns.[16] As mentioned earlier, there are eight basic stitches, the oldest as well as the simplest of which is the satin stitch (known in Chinese as the *ping*, or flat, stitch). This well-known stitch appears as a straight, continuous line on the material. Simple as it is, embroiderers are able to create innumerable effects by experimenting with its placement or by working with two or more colors. When satin stitches are placed next to each other, the result is a glossy area. In Figure 162, for instance, the pig's eyes and eyebrows stand out due to the satin stitch. The young artist of Figure 164 has used the same stitch to create bold areas of color on the girl's body and the healthy cornstalk. By overlapping such stitches, the embroiderer of Figure 171 created quite an unusual effect of the deer's fur and the crane's body.

Similar is the *xian wen* stitch (also known as the thread-line or stem stitch), in which the needle enters the fabric and reemerges on the same side at the middle of the last stitch, creating a solid line made up of short diagonal stitches. In a somewhat more complicated version of this stitch, a second thread is wound around the simple stem stitch, adding extra volume and texture, as shown in Figure 169. Occasionally peasant women will use two differently colored threads to striking effect. In portraying the eyebrows of the tiger in Figure 72, the artist used yellow and black threads. The wonderfully colored tree in Figure 173 was made in this same fashion. By layering the stitches and sparingly adding extra shades of color, the artist of Figure 155 was able to subtly shade the two cows grazing.

To outline important figures or objects in an embroidery, the artist often employs the couching, or *ding*, nail stitch, as in the frontispiece, which shows a scene from "The Third Wife Teaches the Son." First, she lays thread flat upon the surface of the material. Then she uses a second thread stitched at intervals around the first to attach it to the material. This method was often used for silver and gold threads; because such thread was expensive, the embroiderer wanted to show as much of it as possible on the right side of the material rather than wasting it on the reverse.

Fig. 169. From top to bottom: the ping, *or flat, stitch; the* ding, *or couching, stitch; the* wan, *or roll, stitch; the* suo, *or lock, stitch; the* da zi, *or seed, stitch.*

Fig. 170. Child's tiger collar. This beaming-eyed creature is worn by a child on special occasions such as New Year's and his first birthday. Cotton thread on silk background. Hebei Province. 10" × 11½".

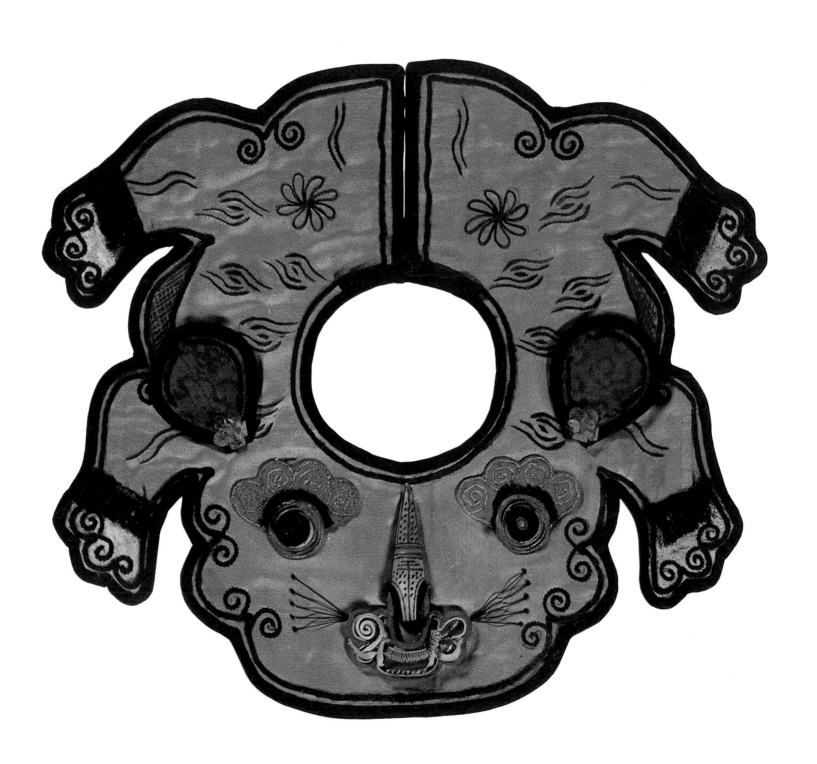

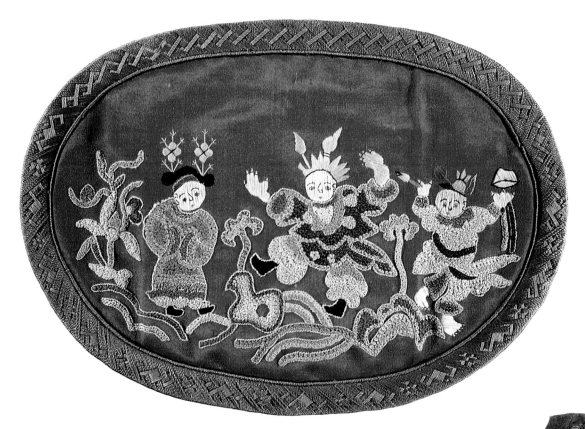

Fig. 171 (left). Pillow end decorated with an embroidered deer, noted by its antlers; flying above it is a crane, symbol of longevity. Together they traditionally symbolize the joy of marriage. Cotton thread on silk background. Sichuan Province. 5" × 6".

Fig. 172 (top). Embroidered pillow end showing three immortals, one of whom has deer antlers and is possibly a shaman. Except for the faces, hands, and bare feet of one of the men, which are done in the satin stitch, the rest of the work is a series of finely produced and knotted seed stitches outlined by couching. By using two different shades of the same color on, for instance, the blue water and the orange robes, the artist has achieved a sense of volume. Silk thread on silk background. Hebei Province. 4" × 6".

Fig. 173. Pillow end showing a child emerging from a pomegranate, a symbol of fertility because of its many seeds, zi, a pun for the Chinese word for sons. The work is done entirely in the da zi stitch, possibly intended as a double pun. Silk thread on silk background. Hebei Province. 4½" × 4½".

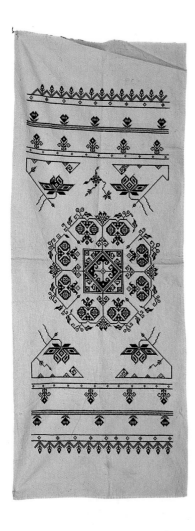

Fig. 174. Cover for cylindrical pillow embroidered with geometric cross-stitch design of flowers and pomegranates. Cotton thread on cotton material. Sichuan Province. 38″ × 15″.

Fig. 175. Innersoles embroidered with a geometric cross-stitch design by a woman for her husband-to-be to wear on special occasions. The cross-stitch, which prompts geometric designs, is popular in northern Sichuan and southern Shaanxi provinces, where people often cannot afford to embroider on silk. Cotton thread on cotton background. Sichuan Province. 10″ long.

The *na,* or patch, stitch (which is not as commonly used as the eight basic stitches), in which threads are woven together in a variety of manners, such as on the bat's body at the top of the pillow end in Figure 10, gives a decorative surface volume rather than just a handsome line. The *suo,* or lock, stitch, also known as the chain, shares with the satin stitch the distinction of being one of the oldest stitches; textiles from western Zhou tomb excavations display its refined look. The *suo* stitch is excellent for straight or curving lines. This graceful stitch is created by making a tiny loop, which then connects to the next stitch or loop, effectively locking into it. Used in the designs on the leaf of the collar in Figure 167, the stitch appears of much more substance than the simple satin stitch, and gives an extra elegance to a piece. The Pekinese *wan,* or roll, stitch goes even further. In it, two threads loop around each other and make for a consistently gentle, rounded appearance. A great part of Figure 152, illustrating Chang E's flight to the moon, is composed of this stitch. It has a flat, nonshiny surface, but its texture is still very neat and refined. The fine stitching combined with the folk composition and perspective makes this a superb work of art.

Finally, there is the well-known seed, or *zi,* knot stitch, also termed the forbidden stitch by some foreigners who reported that it had been outlawed because sewing it hurt women's eyes. The seed stitch is actually a type of knot that is then stitched onto the fabric. Usually areas of an embroidery—such as the petals of a flower or the dress of a noble character—are filled with these tight knots. The resulting texture is unlike any other stitched areas; full, it gives great depth to an object. A fine example of this stitch is in Figure 172, in which three immortals meander about a landscape. All the figures, the trees, and the ground are constructed of the seed stitch, imparting a wonderful rich matte texture and tone to the composition. In a technique also known as couching, the artist has added with black, red, and pink threads the eyes, noses, and mouths on top of the satin stitch. Couching serves both to tighten the first layer of threads and to add depth and color to a design; the technique is common in peasant embroideries. In Figure 72, the couching stitches on the tiger's nose give it a certain volume. In yellow threads, the artist has also stitched on the character *wang*— 王 —or "king," to ensure that the viewer knows that this bizarre beast is a tiger, king of the animals.

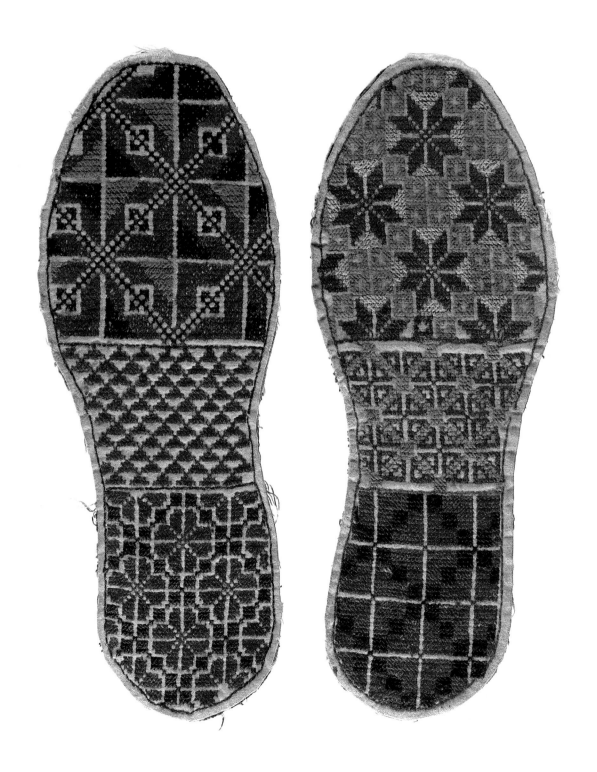

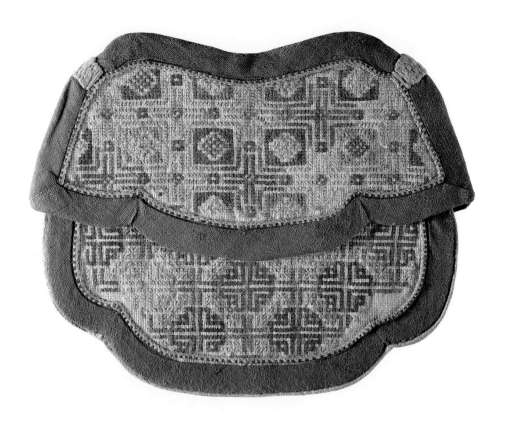

Fig. 176. Purse embroidered with colorful cross-stitch embroidery. Cotton thread on cotton background. Hebei Province. 4½" × 5".

Fig. 177. Pillow end. In this embroidered and appliquéd design, a child wears an apron, such as that seen in the frontispiece, and around his neck a lock necklace, which parents give their children to wear so they will be locked to life until they are older and less vulnerable to evil influences. Cotton thread on cotton background. Shaanxi Province. 5½" × 5½".

All of the above stitches are most effective when executed using silk threads on fine silk material. Silk, however, was not always available to the poorer classes of society. Though the peasant women were and still are an important link in the silk industry—raising the worms, spinning the thread, and even weaving the material—they would have to give it up in taxes or sell most of it for family income. Occasionally, they might be able to afford to keep some for wedding clothes or children's festival outfits. But in areas too poor to allow even that hope, embroidery on cottons developed. Cotton, which was introduced into China in the first century, did not become common until the Song dynasty, when production methods were refined. Only then did cotton supersede hemp as the peasants' basic fabric. When cotton became widely available, embroidery stitches were developed that were much more appropriate to its texture. These stitches, in turn, inspired an aesthetic very distinct from that of the silk embroideries.

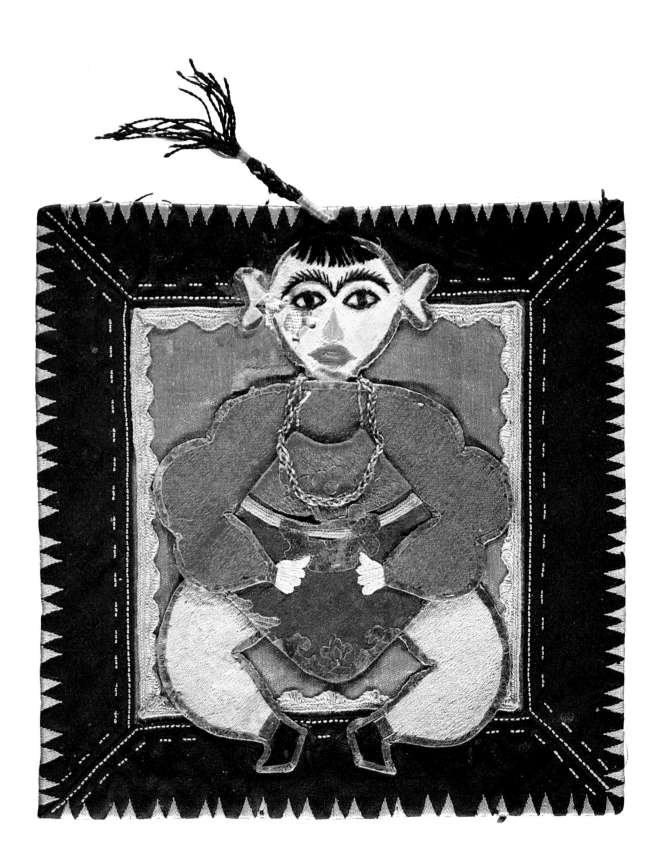

Because of its weave, the cross-stitch is most suitable to cotton, while stitches used in silk embroidery generally are not. The cross-stitch has influenced resulting visual images: designs in cross-stitch must be formed from little squares, which give a rougher look than those found on silk embroideries, and which encourage patterning based on geometric shapes. Cross-stitch embroidery is mostly confined to two areas of China—the northern Sichuan and southern Shaanxi region, and Hebei Province. One researcher, C. Schuster, proposed in 1936 that the style prevailing in the Sichuan area was actually a remainder of ancient Persian influences in the area.[17] But Lu Xinghua, a modern student of embroideries, who grew up in southern Shaanxi and who now is deputy director of the Shaanxi Provincial Arts and Crafts Association, believes that the cross-stitch was adopted by the Chinese from minorities living in southern Sichuan.[18]

Like women in other parts of the country, the women in Sichuan use embroidery to decorate objects for their sons, their husbands, and their in-laws. On the innersoles (each made for a different pair of shoes) in Figure 175, which a young woman embroidered for her fiancé to wear on their wedding day and other special occasions, colored threads are stitched to construct an overall pattern. In these pieces, several different patterns have been combined, all using the same simple blue, red, and black lines, each a distinct assemblage of diamonds, squares, and triangles, forcing the eye to jump happily from space to space. The use of simple black or indigo threads on the raw, undyed, or bleached cotton is the most commonly seen form of embroidery in this area, and Figure 174 with its blocklike flowers is typical of the local designs.

The cross-stitch work of Hebei seems not to have been directly influenced by that of Sichuan. Geometric patterns have likewise been inspired by cross-stitching, but Hebei artists, using many differently colored threads, have created images made of squares and diamonds, such as in Figure 176, resulting in a unique style.

Appliqué is another folk method of decorating textiles. Sewing small and large pieces of colored material onto larger backgrounds makes for bright and bold designs. On the pillow end of Figure 177, the artist first glued somewhat metallic paper to the edges of the shaped cloth before pasting it to the background, a technique that brings out the forms. Using scraps of material most likely left over from clothes making, she has created a charming image of a bright-eyed peasant child, punctuated by his red lips and the braid of hair cleverly extending beyond the frame of the work. In the cotton pillow cover from Hebei Province (Fig. 53), the artist

has cut out shapes of pomegranates and gourds (both fertility symbols), Buddha hand flowers (representing prosperity), a *wan* character (for longevity or immortality), a child riding a *qilin* (symbolizing the hope of becoming an official), and a small, humble black pig on the ground from which all else has blossomed. She has even occasionally made use of some printed cloth to add an extra dimension of texture to the images. On top of the *qilin*, she has embroidered using metal threads to give more texture and opulence to the creature. On the apron of Figure 68, a mother first stuffed the cotton insects before attaching them to the ground material, infusing them with a lifelike, three-dimensional quality.

Unable to afford fine silks, these peasants have still been able to create exquisite and exciting images. In fact, cotton aids in promoting the bold appearance desired by many folk artists, since they are announcing their hopes for good fortune; more subtle designs have been reserved primarily for the embroidery of the wealthy. Using their own concepts of design and the materials at hand, villagers were able to develop from an art once restricted to the elite an art form distinct from and independent of its origins. And while city dwellers have all but ceased to embroider in their leisure time, country women still take the time to create special clothes and ornaments for those they hold dear.

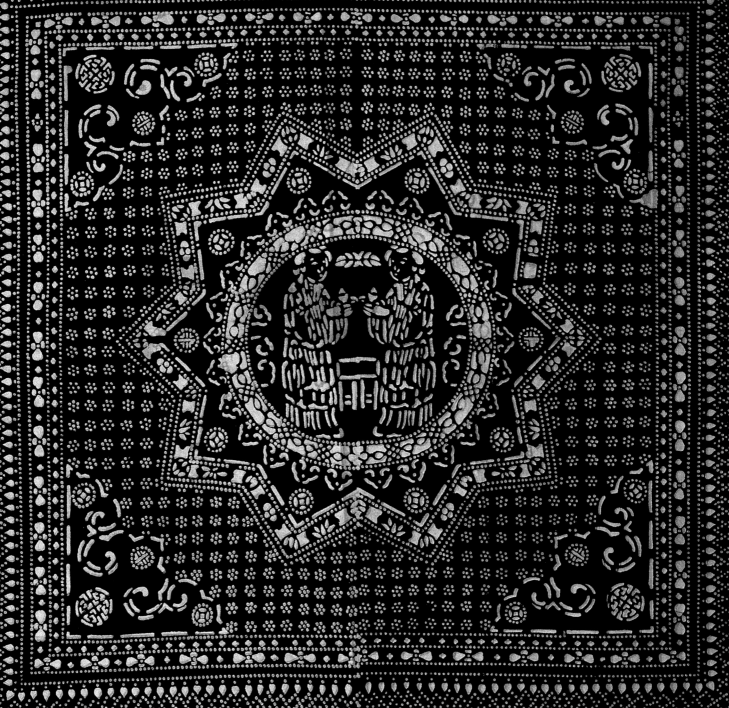

Dye-Resist Printed Fabrics

Luxurious silk is often associated with China, but for the farmer working in the fields, the material is impractical and unaffordable. For centuries the people have worn plain cotton clothing; before cotton became popular, they wore hemp. Class designations were so strict before the Han dynasty (206 B.C.–A.D. 220) that the nonelite—that is, those who were not officials or their relatives—were barred from wearing all but the least refined type of silk and even colorful dyed clothing. Although these regulations were relaxed to some extent in later Han times, silks remained too expensive for villagers. Instead, they turned to simple decoration of their rough fabrics. After years of developing techniques and with the expansion of the economy, the dye-resist method of adorning cotton became the main type of decoration in many rural areas by the Ming dynasty (1368–1644). Until the beginning of this century, clothes, quilt covers, door curtains, and cloth wrappers were embellished with various indigo-blue-and-white designs, giving rural homes a distinctive color scheme.

The dye-resist method, often called batik in the West (a Malay word) and common throughout Southeast Asia and Africa, is the process by which a water-repellent substance—such as wax, bean paste, or even a tightly knotted rope—is applied to a piece of cloth in a preconceived design. After the fabric is dyed, the substance is removed, either by boiling or washing, leaving white those areas that the dye could not penetrate.

The oldest surviving piece of dye-resist in the world was discovered in 1959 in Xinjiang Province, outside of Turfan in tombs at Yutian, south of the Tarim Basin, at an excavation by the Xinjiang Autonomous Region Museum.[1] The wool fragment dates from 519, the Southern and Northern dynasties (420–581), and is indigo blue with white flower patterns, strikingly similar to the patterns and colors of nineteenth- and twentieth-cen-

Fig. 178. A dye-resist-patterned bao fu *textile for wrapping and carrying packages. The plum-blossom pattern of the background (see detail in Figure 180) resembles textiles also done with dye-resist excavated from sixth-century tombs. A series of square, octagon, star-shaped, and circular concentric borders, with harmonizing backgrounds, surrounds two men formally greeting each other. Nineteenth to early twentieth century. Cotton. Sichuan Province. 36" × 32".*

tury folk pieces. According to museum researchers, the patterning was most likely done with a hard board or thick paper stencil.[2] The design, made up of dots, was cut out of the board, and a paste made of beans and zinc powder mixture was pressed through the stencil onto the material to resist the dye. After the color set and the material dried, the paste was scraped off, leaving a white design. The stencil allowed the same design to be repeated with the bean paste across the length of the material. This stencil method of dye-resist was employed until recently in villages in Sichuan, Hunan, and Jiangsu provinces.

Though the scraps from Xinjiang and the early twentieth-century dye-resists shown here bear much in common, and while records state that blue-and-white printed materials were favored by all the classes during the Southern and Northern dynasties, it is also true that blue-and-white designs are only a small part of dye-resist's highly developed and colorful history. The use of bright red, brown, and a variety of other dyes on silk —sometimes in combination—was very fashionable among the upper classes through to the ninth century.[3] Later these dyes lost their appeal, and dye-resist became, as it is today, a folk method employing only the readily available indigo.

Various factors led to and allowed the development of the dye-resist method. The process necessitated dyes, dye-resisting substances (bean paste and wax), and fabrics. First hemp, silk, wool, and a limited amount of cotton were used. Much later, after the Song dynasty (960–1279), new cultivating techniques for cotton brought about increased production of that textile, which in turn stimulated the rejuvenation of dye-resist among the common people and enabled it to mature to its most popular form. By the Warring States period (475–221 B.C.), the Chinese were employing both mineral and vegetable dyes to color their fabrics. Dye specialists during the Han dynasty had created more than twenty different hues,[4] and by the Qing (1644–1911) that number would increase to more than seven hundred;[5] of this total, indigo blue is one of the most durable.[6] In 1972, the Western Han archeological excavation at Mawangdui in Hunan Province uncovered a number of pieces of blue fabric about two thousand years old, the color still bright. Scientific analysis proved that the dye was indeed indigo. The Han agricultural book *Ji min yao shu* explains in detail the complicated techniques entailed in dyeing with indigo.[7] The plant coloring was also used at the time for eyebrow makeup, as it later was in Persia and Japan. By the Tang dynasty (618–907), there were workshops that specialized in indigo dyeing alone. And almost every county had its own indigo dye shop by the Ming dynasty.

The most common textiles in China during the years when dye-resist was first gaining its popularity were silk, wool, and hemp. The official and noble classes wore primarily silk, while the rest of society was restricted to hemp and wool. Cotton was introduced from India during the Han dynasty,[8] but only in Xinjiang, Fujian, and Guangdong was it used to any extent at that time. And from Xinjiang, where the dry air and the sands have preserved antiquities, there are early examples of dye-resist on cotton, silk, hemp, and even wool exhibiting both the bean-paste and wax methods of dye resist.

The wax method, involving either beeswax or pine resin, was most likely learned by the Chinese from the minorities living in the southwest border region.[9] The Miao people in China still employ this technique today, but it faded almost completely among the Han Chinese centuries ago. Because a warm dye bath would melt the wax, cold water was used in this method, and indigo, which is effective when cold, therefore was ideal. In 1959, in Xinjiang's Minfeng County, an Eastern Han dynasty cloth decorated with dye-resist was found. The corner of the material still extant depicts a Buddha or deity figure, the tail of a dragon, and a checkered border pattern.[10] These images, whose white areas flow together, could only have been done with wax, since it would be impossible to create a stencil for the checkerboard pattern or even the Buddha figure that would not collapse. The Shoso-in in Japan possesses an intriguing Tang dynasty example of wax dye-resist, a piece of decorated silk that was used as a screen. The extant panels each display large, intricate trees in full bloom. A ram stands beneath one and an elephant beneath the other, again designs so complex and painterlylike that they could not have been made with a stencil or therefore the bean-paste method.

Fig. 179. Dye-resist design on wool excavated from Northern dynasties tomb in Xinjiang Province. From Chen, Zhongguo fangzhi kexue jishushi; *reprinted with permission from Kexue Chubanshe.*

Fig. 180. Detail from Figure 179.

Fig. 181 (left). Detail from a dye-resist quilt cover. Nineteenth to early twentieth century. Cotton. Jiangsu Province.

Fig. 182. Eastern Han dynasty dye-resist textile excavated in Xinjiang Province and made with the wax method. It shows a Buddha figure and the tail of a dragon. Cotton. From Chen, Zhongguo fangzhi kexue jishushi; reprinted with permission from Kexue Chubanshe.

Fig. 183. Tang dynasty tie-dye. From Chen, Zhongguo fangzhi kexue jishushi; reprinted with permission from Kexue Chubanshe.

According to the Song dynasty text *Shi wu ji yuan,* the bean-paste-and-stencil method, described earlier in this chapter, had already existed in the Han dynasty. Certainly by the Tang period it was being practiced, since historical records (*Tang yu lin* by Wang Dang) mention that a woman named only as the sister of Liu Jianhao created such designs and that they then became popular.[11] The *History of the Tang* notes that women's clothing of that era was often a dark blue-green with small white flowers, most probably made by such dye-resist techniques.[12] On three-colored glaze Tang ceramics of horses and human figures, these textiles are often portrayed.[13] The advantage of the stencil method over the wax was that a design could be repeated over and over quickly by merely moving the stencil down the fabric, creating great lengths of printed material. Producing a design with wax meant applying every detail of the image by hand, a much slower process.

Besides these methods, tie-dyeing was also a simple and popular decorating technique, in use by the fourth century. Tying strings around parts of the gathered cloth and then dyeing the material creates round, flower-like designs. A 1962 archeological expedition excavated a specimen dating from 344.[14] Records cited by Shen Congwen, a writer and costume researcher at the National History Museum in Beijing, describe tie-dye cloths

worn by women of the Northern and Southern dynasties that sported fish, flower, and butterfly designs, demonstrating their superb techniques in controlling the patterns with the strings. Indigo dye was not the only color used: yellows, browns, and a particularly favored red made from safflower and produced only in Sichuan during the Tang dynasty also colored the materials.[15]

The fantastic array of dye-resist and tie-dye materials that had been created during the Tang dynasty were suppressed during the Northern Song period. Because the imperial army of the Song dynasty during the reign of Zhen Zong dressed in dye-resist-patterned uniforms, the common people, according to the *History of the Song*, were prohibited from wearing black or brown-and-white stenciled dye-resist materials or tie-dyes with blue, purple, or yellow backgrounds. Buying and selling stencils for making dye-resists was a crime as well.[16] Some techniques disappeared entirely as a result of these laws. With the fall of the Northern Song empire to the Mongols, and the reestablishment of the Song court in Hangzhou, in the south, the regulations were abandoned. Tie-dye never regained its popularity, though examples of it could still be seen here and there at the early part of this century. Dye-resist with stencils and bean paste did revive, however. The popularity of cotton (particularly preferred by peasants over hemp) and the development of cotton cultivation in the years after the Song fell gave further stimulus to the dye-resist art.

Before the Song dynasty, the techniques for producing cotton—cultivating it, spinning it, and weaving it—were so primitive in China that the material was not produced in great amounts. A poor peasant girl escaping poverty and the oppression of her husband's family during the late Song changed that situation. Huang Daopo,[17] born in the mid-thirteenth century in Wuxing, Songjiang County, near Shanghai, ran away from her husband's home and hid on a ship on the Huangpu River. When the ship left shore, she revealed herself to the owner, who agreed to take her south with him. At Yazhou Island (present-day Hainan Island) she disembarked. The island was then inhabited primarily by the Li minority, who, instead of raising silkworms, cultivated cotton, which they would spin into splendidly colored cloths. Huang Daopo, fascinated by the results, determined that she would learn their techniques. She stayed in Yazhou for thirty years, mastering all there was to know. When she finally returned to her hometown, already under the Mongolian rule of the Yuan dynasty (1279–1368), she carried back cotton seeds, a treadle loom, and other equipment employed in cotton production.

Huang Daopo vitalized a new textile industry. She taught the women in

her native town to remove fibers from the plant with a simple machine, rather than manually, and improved the fluffing technique. She converted the single-spindle, manually operated spinning wheel originally used in Zhejiang to a three-spindle spinner. Her inventions were recorded by the writer Wang Zhen in his *Book of Agriculture*, written just eighteen years after she returned to Wuxing. Her techniques had caught on quickly in the neighboring towns, and the cotton industry brought prosperity to the once poverty-stricken area. In thanks to Huang Daopo, the people built a temple in her honor.

By the middle of the Ming dynasty, cotton had surpassed silk and linen as the leading material for clothing throughout China. For peasants, cotton was a sensible, durable, and inexpensive textile. Its popularity spread from the Shanghai region across the country, and it quickly became a favored base for dye-resist patterning.

Various names developed for dye-resist. In the Song dynasty, according to contemporary texts, the stencil method was often called *yao ban bu,* meaning "medicine spot cloth."[18] The word *yao* was also the name of a minority people who practiced dye-resist, and most probably they were the source for this name. In the Ming and Qing dynasties, the name "sprinkled flower cloth," obviously a reference to its patterns, was often used, as well as the still current terms "paste dyeing" and "blue ground white-printed flower cloth," which reveal the preference for the stencil technique and indigo dye.[19]

With the diminishing of the more elaborate and sophisticated techniques of dye-resist after the Song, the medium lost its popularity among the wealthy and official classes. For village people, however, who could not afford extensive embroidery but still enjoyed having decorated textiles, it was an ideal technique. The traditional and most common method of dye-resist designing among the Han Chinese people during the Ming and Qing dynasties and until the beginning of this century has been that of the stencil and bean paste. After a design has been decided upon, it is sketched onto and then cut out of a thick paper stencil. If the design is to appear clearly on both sides of the material, two identical stencils must be cut and the fabric subsequently squeezed between them. This is the proper pre-Song method known as *jiaran*. In the nineteenth and twentieth centuries, in rural areas, one side was usually sufficient. A thin net may be placed between the stencil and the fabric to help the pastes adhere to the material. Oil has also been applied to the stencil so that it can be used several times before deteriorating from the moisture of the paste. After laying the stencil on the fabric, the artisan spreads a mixture of bean paste

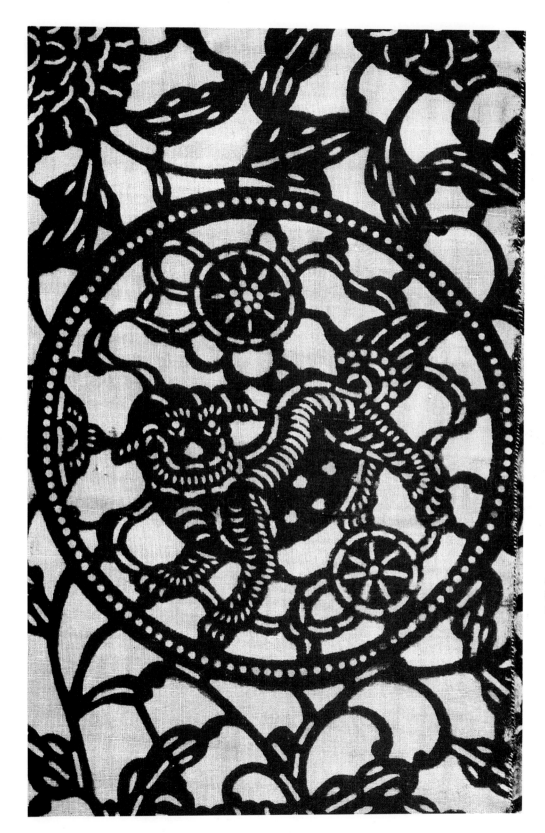

Fig. 184. Detail from dye-resist-patterned quilt cover of lion playing with ball. Early twentieth century. Cotton. Sichuan Province.

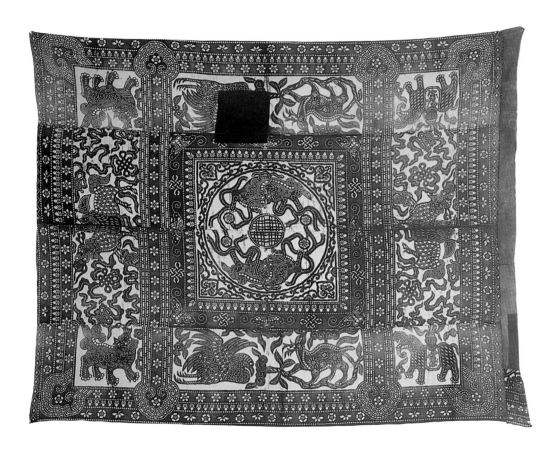

Fig. 185. Dye-resist-patterned quilt cover.
About the border march a variety of animals:
qilin *and deer, symbolizing the rise to official-
dom; elephants, from Buddhist influences; and
eagles and lions. In the center two more lions,
one male and one female, chase a ball. Nine-
teenth to early twentieth century. Cotton. Si-
chuan Province.* 53″ × 70″.

Fig. 186. *Detail of eagle from Figure 185.*

and lime through the perforations. If the design has been created from a number of stencils, or if one small stencil has been used over and over (as in Figure 187), the paste is applied piece by piece. After the whole design has dried completely, the fabric can be slipped into the indigo dye bath. Large works, such as quilt covers, are often made of four strips of cotton, which are sewn together either before or after the dye-resist design is made (as evident in Figure 185). The width of the strips is limited by the small hand looms, essential furniture for every household, on which women still weave the raw cotton material today.

Rural people used the dye-resist-patterned fabric for a diverse number of household necessities. The frontispiece to this chapter is a *bao fu,* a cloth for wrapping and carrying packages; the two opposite diagonal ends are tied together, and then the bundle can be slung over the shoulder and carried on one's back. Within the concentric squares, octagon, ten-pointed star, and circle, two men stand to greet each other in the traditional Chinese bow. The various borders and background patterns, each distinct from the next, harmonize well; the dense area inside the octagon balances the bolder area around it in the center, the artist having taken much care to create a design that would rarely, if ever, be laid out flat for display. Since the image is symmetrical, it appears that a stencil half the size of the whole piece was used and then flipped over to create the opposite side. In fact, a slight line can be distinguished down the center of the cloth.

Vigorous phoenixes swirl about the quilt cover of Figure 189. The two birds are the *feng* and the *huang,* the male and female of the mythical phoenix species, symbols of a harmonious marriage. Such covers, the most common dye-resist textiles, are usually made for a wedding and exhibit appropriate symbols for such an occasion; they encase warm cotton-padded quilts, much needed in winter months. Several stencils may have been used to make this work. The border was made from one stencil, laid on the material in four different places. The phoenix images were most likely made by cutting out the shapes of the birds, perforating holes for designs in those stencils, and then laying them one by one on the fabric. Unlike the images in most dye-resist designs, these are blue on a white background, calling for a stencil-cutting technique more complicated than for white on blue.

The door curtain of which Figure 187 is a detail keeps in warmth during the cold months and keeps out mosquitoes and heat during the hot summers. Its quiet overall pattern of geometric designs and flowers is appropriate for such a large expanse of color in a home. Its small, repeated images have been popular in dye-resist-patterned clothes also.

Fig. 187. Detail of a dye-resist door covering with repeated design motif. Nineteenth to twentieth century. Cotton. Sichuan Province.

Most of the patterns in these dye-resist designs are those common to the other folk arts. The *qilin*, the legendary animal said to bring sons who will become officials to heirless families, appears in the border of the quilt in Figure 191. Bats cleverly form the corner of another cover (Fig. 190), representing happiness and good fortune, *fu*; the coin, signifying prosperity, becomes the center point of the piece in Figure 44.

Background and border designs, used to fill in space that would otherwise be overwhelming as solid white, have evolved into distinctive Chinese dye-resist patterns. Many of these designs are a natural consequence of the qualities of the medium. This is true of the key pattern, shown in Figure 84; and particularly of the six-dotted plum blossom, which appeared in the earliest of Chinese stencil dye-resists. Because of the specific means of producing dye-resist designs with paper stencils, the images have certain limitations. They must be cut out of paper. If the line is too long, the stencil will become flimsy. A line completely encircling an area will cause the whole stencil to fall apart and become useless. Looking at Figure 181, for instance, one notices that the birds are created from a series of dashed lines, just as are the figures in Figure 191, surrounded by shapes made of dotted lines. With no fluid lines or large masses of solid color, resultant textiles have overall harmonious textures and appearances, quite suitable

Fig. 188. Papercut of woman with child. Much dye-resist patterning in China was done with papercutlike stencils, and many of the design challenges were therefore similar in the two media. The plum-blossom image made of six unconnected dots was a successful device for decorating empty space and is still used, as in this work, in papercuts being made today. Shaanxi Province. 5¹/₂" × 6".

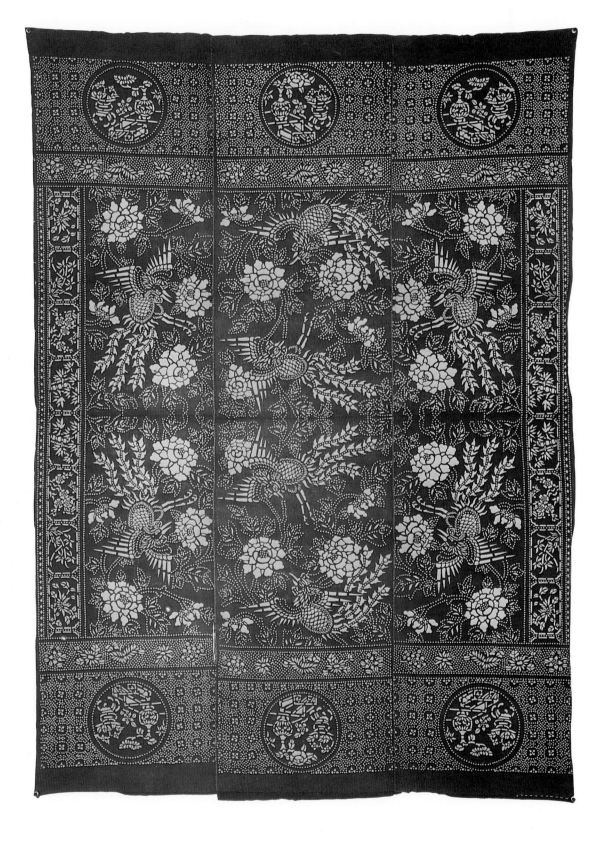

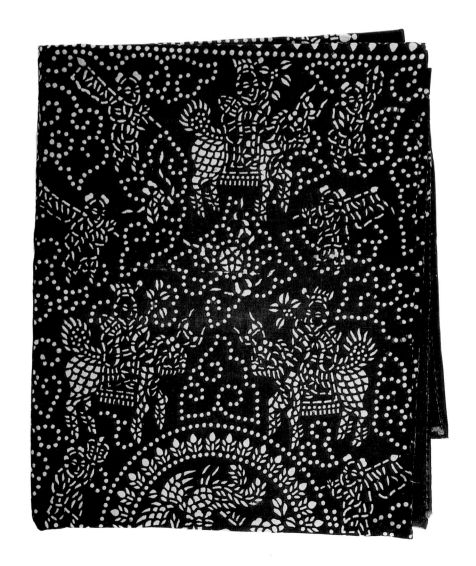

Fig. 189 (left). Dye-resist-patterned quilt cover of phoenixes arranged in a circular pattern, giving a flowing movement to the work. The quilt cover is made of three lengths of cloth; home looms in rural areas are not very wide. Nineteenth to early twentieth century. Cotton. Sichuan Province. 75″ × 53″.

Fig. 190. Detail of a corner of quilt cover cleverly formed by a bat, fu, symbol of good fortune. The bat's back is decorated with coins, symbols of prosperity. Nineteenth century. Cotton. Sichuan Province.

Fig. 191. Detail from dye-resist-patterned quilt cover of boys accompanying a qilin. Nineteenth to early twentieth century. Cotton. Jiangsu Province.

for the decorative and practical functions they serve.

Making dye-resist patterns with wax eliminates the obstacle of the stencil, since the wax is applied directly to the material. But this method almost completely fell out of favor among the Han Chinese after the Song dynasty, though the Miao minority of Guangxi Province still creates wax dye-resists on cotton today. Applying each detail of the design by hand, it may take a girl more than a year to create her wedding outfit. Dye-resist patterning on silk also faded among the Han when the art became common among the rural people; few of the wealthy ever wore dye-resist-patterned clothes after the Ming dynasty.

Today, at least among Han Chinese, dye-resist is no longer produced in the villages. An old piece occasionally may be spotted covering a bed or hanging in a doorway. The printed, multicolored, factory-made fabrics are preferred to the fading blue-and-white village-made works. Due to the recent urban interest in traditions, though, factories have started to manufacture material based on the old dye-resist designs. Some follow the original designs, while others are more modern, decorated, for example, with battleships. In the homes of those interested in preserving old customs, the traditional fabric is again used for beds and tablecloths. The quality of the factory-made works, however, is disappointing. Since they are produced with repetitious designs so they can be sold in long bolts, the challenge of creating a design to fit the large square or rectangular composition of a quilt cover or a smaller piece no longer exists. Moreover, the uniqueness of each work has been lost. Gathering dye-resist pieces in villages in China, I have never come across two pieces alike. If a woman depends on the products of a factory, she no longer has the personal, singular, dye-resist-patterned material to carry to her husband's family on her wedding day.

Fig. 192. Detail of quilt cover. In this work, the white is much more predominant than the blue, and the stencil had to have been the actual shape of the snowflakelike design to result in such an image. Nineteenth to early twentieth century. Cotton. Jiangsu Province.

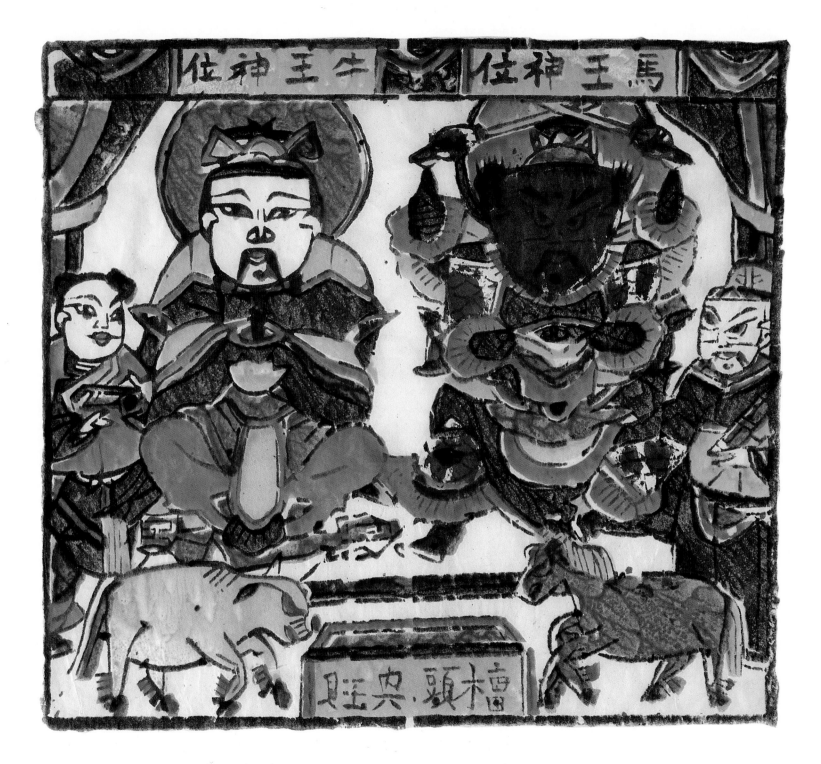

Woodblock Prints

On the twenty-third day of the last month of the lunar year, the Kitchen God makes his ascent to heaven. There he reports to the Jade Emperor, ruler of the spirit world, all the goings-on in each of the homes where his image has hung all year. In the hope that this deity will mention only the good occurrences, the family has a send-off party for him. In front of the woodblock print image of the god, they offer sacrifices of food, wine, candles, piles of spirit money, and the sweet smell of burning incense. They smear honey on the mouth of the image so that it will divulge only sweet words. Then they burn the image, the smoke of the combustion carrying the spirit to heaven. On the first of the New Year, when the Kitchen God returns to the home, similar offerings welcome him, complete with firecrackers; a new woodblock print of him is pasted on the wall above the stove.

Woodblock prints have hung for centuries in Chinese peasant homes, serving both to decorate the dirt walls and to fulfill religious needs. Often referred to as *nianhua,* or New Year's pictures, because new ones are pasted up primarily at that time of year, they grew out of religious developments — the advent of Buddhism and the expansion of Taoism — and advances in technology. Without the invention of printing, the aesthetics of the peasant home as well as its religious rituals would certainly be drastically different than they are today. The other folk art media we have discussed all entail a certain amount of technical innovation — the invention of paper for papercutting, the development of sericulture for embroidery — but the actual creation of these artworks is done individually, by hand. Unlike these other media, woodblock printing cannot, at least in China, be practiced by individuals in their own homes, for it requires the efforts of several people; at the least, three people are needed: a designer, a wood-carver, and a printer. Again unlike the other media,

Fig. 193. Woodblock print of guardian gods of horses and cattle. Zhuxian Zhen, Henan Province. 8½" × 9½".

woodblock prints in China have been traditionally made for sale, not merely for personal use. An exception to this rule has been the practice among rural peasants of getting together during the winter months, when there is little farm work, and printing these images. Since woodblock prints are such significant items of decoration and color as well as religious import in the home of a peasant, we include them here as folk art.

The art of carving and the reproduction of carvings—as in woodblock prints—date far back into Chinese history. During the Shang dynasty (16th–11th century B.C.), shamans, in their roles as oracles, carved messages from the spirits of ancestors into the bones of deer. To make decorated bronze vessels, their contemporaries etched images into clay molds.[1] Centuries later, artisans of the Han dynasty (206 B.C.–A.D. 220) carved stone reliefs on tombs, images not dissimilar to the woodblock carvings of more recent times.[2] Han monuments and records were also carved in stone. With the invention of paper during the Han period, records could be duplicated and distributed.[3] This earliest form of printing in China was performed by covering a stone with moistened paper and then dabbing it, when dried, with an inked pad, a technique still used today. Figure 56, a rubbing of a tomb door, was made recently with this ancient method of reproduction. Seals with images of animals and humans, and later characters, were also a primitive form of printing in use by the Han dynasty[4] and still used by painters, calligraphers, and individuals today. Carved stone covered with a pigment and then pressed onto a piece of silk or paper could reprint the same image, however small, over and over. Painters and calligraphers still use such seals today when signing their names to a work of art.

Fig. 194. Woodblock print of a poor village home. From Wu Youru hua bao.

In the Jin dynasty (265–420), Buddhist amulets were printed with this method and distributed.[5] Displaying images of the Sakyamuni Buddha, these charms were meant to bring good luck. In fact, Buddhism played a large role in the development of printing in China. The entrance of a new religion into an already developed civilization such as China's was not an easy one, and the printing of amulets most likely assisted in propagating this new philosophy.[6] As Buddhism expanded across China—by the Tang dynasty (618–907) there were more than forty-four thousand temples and monasteries in the country[7]—printing helped spread the many sutras, or Buddhist scriptures, to the multitudes of eager devotees. Religious images were popular, and Xuan Zhuang, the Buddhist monk who traveled to India and on whom "Journey to the West" is based, is said to have printed many portraits of the Buddha.[8] The oldest existing printed matter is in

Fig. 195. Woodblock print of guardian spirits of horses and cattle. Shandong Province. 5" × 4".

fact a scroll of the Diamond Sutra.[9] Found at Dunhuang, a monastery in Gansu Province, it is dated the fifteenth day of the fourth moon in the ninth year of Xiao Tong's reign, which corresponds to A.D. 868.

Agricultural and medical books, particularly almanacs, were circulating in secular society by the late Tang dynasty and were being sold in marketplaces.[10] By the Song era (960–1279), with its flourishing economy and many technological advances, movable type had been invented.[11] The Song prosperity also encouraged growth in pictorial woodblock printing, allowing it to become more accessible to the poorer classes. Woodblock prints and printed books were far more inexpensive and available than hand-painted or handwritten works. The woodblock print became more integrated into all levels of society. Almanacs, which contained agricultural, religious, and medical advice (when to plant, when to harvest, as well as what days were lucky for journeying or marrying), were printed in vast numbers during the Song dynasty and distributed to virtually every village.[12] They also contained many illustrations of daily peasant life. Such almanacs are still published and sold at New Year's time. While those available in mainland China contain much scientific information that refutes superstitions, Taiwan editions are very similar to their early forerunners.

The majority of woodblock prints were related to Buddhism and the native belief system. Taoism, which over the years has assimilated concepts from Buddhism, Confucianism, and ancient primitive cults, also underwent changes during the Tang, Song, and Ming (1368–1644) dynasties. With the competition of Buddhism, the Taoist pantheon expanded as well as solidified. According to Chinese belief, spirits of all mortals continue to exist after death and can influence worldly events. Worship of the dead is therefore beneficial to the living, and ancestor worship is very much a part of Chinese religion. Over the years, historical and legendary figures—because of personality traits or tales of their fantastic powers—have taken their places as deities. This pantheon is constantly growing, with new spirits joining the old ones. Recently a cult has even grown up around Yang Kaihui, Mao Zedong's first wife, who died in the 1940s. During the Cultural Revolution (1966–76), people would often bow to posters of Mao, certainly an extension of such worship. The technology of woodblock printing helped confirm the status of these deities by bringing their images into the villages and into each home, where they could be called upon and worshipped whenever necessary. The free distribution of Mao's portrait encouraged reverence for him, just as the portrait of the Kitchen God watching over every detail of life demands attention and respect.

Fig. 196. Wooden block used for making the black outlines of a woodblock print. Kaifeng, Henan Province.

Fig. 197. Woodblock print. Known as Si Mei Tu, *the "Four Beauties," it was printed during the Song dynasty. It is believed to be the earliest still-extant decorative print. This print was made to be pasted or hung on a wall. From Zhou,* Zhongguo gudai banhua baitu.

The mass printing of spirit images probably began in the Song dynasty. One of the first recorded examples is the printing of Zhong Kuei's portrait. Zhong Kuei was an unfortunately ugly but brilliant scholar of the Tang dynasty. He had placed first in the imperial examinations but because of his repulsive appearance was denied the usual reward of marriage to the emperor's daughter. Zhong Kuei was so distraught at this decision that he took his own life. In the underworld, all the spirits and ghosts revered him for his scholarly achievements. After the emperor Ming Huang (who reigned from 713 to 756) had a dream in which Zhong Kuei revealed his extraordinary powers to control demons, he ordered renowned artist Wu Daozi to paint his portrait.[13] In the Song dynasty, emperor Shen Zong (1069–1077) had the portrait printed and distributed to all his officials, according to the Song book *Writings on Meng Xi* by Shen Kuo.[14] Scholar Bo Songnian states that popular belief among all classes during the Song dynasty held that Zhong Kuei had become judge of the underworld and thus was feared by all ghosts.[15] His image became a powerful icon. Zhou Mi, writing in the Song dynasty,[16] speaks of pictures of Zhong Kuei being sold at New Year's time in the markets alongside pictures of tigers and other items for the yearly festivities. Most likely, these pictures were woodblock prints and the earliest forms of New Year's posters. Figure 199 is an example of Zhong Kuei. From a Qing dynasty (1644–1911) block in Yangzhou, Jiangsu Province, it includes a tiger, which, along with Zhong Kuei's hair-covered face, reinforces the image's evil-dispersing power. Even today it is pasted on walls on the fifth day of the fifth month—when evil spirits are believed most likely to pester mortals—and at New Year's to ward away evil.

The discovery in Gansu Province, at the beginning of this century, of the Song print "Four Beauties"—an elaborately detailed print of four handsome women in the style of aristocratic painting rather than naive folk art (Fig. 197)—indicates that single-sheet printing for the purpose of wall decoration instead of for use in books also began in this era.[17] Through the Song and then the Ming dynasties, the number of these images multiplied. Where hand-painted images or just calligraphy had been inscribed on walls or doors to represent deities or for pure decoration, woodblock prints were now pasted. More families established small workshops. Kaifeng, of Henan Province, then Nanjing of Jiangsu Province, and Weixian County in Shandong Province became important centers for the printing of New Year's pictures. And with the development of the art and the decreasing prices due to the quantity available, peasants were able to decorate their simple homes with a larger variety of artworks.

四十萬賢

活閻羅阮小七

選告身漁お津墨市觀

Fig. 198 (above). Woodblock print from Ming dynasty book illustrating scenes from The Water Margin, *a popular novel of the time. The woodblocks were most recently reprinted and published in 1979.*

Fig. 199. Woodblock print of Zhong Kuei, who, along with the tiger accompanying him, will frighten off evil spirits from homes where his image hangs. Jiangsu Province. 30″ × 25″.

The art of woodblock printing expanded further during the Ming and Qing dynasties. In the sixteenth century, color printing was invented. Some family-operated workshops grew into small village industries, where, in the cold seasons, all peasants could be included in some phase of production. Elsewhere more and more small family operations were established. Books of all types—encyclopedias, farmers' almanacs, painting manuals, poetry, and medical books—were printed, along with increasing numbers of gods' portraits, illustrations for novels, opera scenes, and fertility and fortune symbols.

In many parts of the country, the images of deities that are pasted up and then burned as sacrifices are known as "paper horses," a reference to the live horses that were sacrificed at funerals and other ceremonies in ancient China. By the time of Qin Shi Huangdi—the first emperor of the Qin dynasty (221–206 B.C.) whose tomb's multitude of terra-cotta soldiers is now famous—clay and wooden statues had begun to substitute for the cruel live sacrifices. And during the Tang dynasty, paper images of the gods, which could be burned, were replacing these objects, just as paper money was and still is burned at funerals instead of actual coins being placed in the coffins, as was done previously. At funerals today in Taiwan, elaborately constructed bamboo and paper mansions, cars, televisions, refrigerators, telephones, and other luxury items are burned to assist the spirit in the underworld.

Before the revolution in 1949, thousands of different gods could be counted among the paper horses pasted in the homes of Chinese peasants, merchants, and officials. All these images could be bought at shops specializing in such religious articles as incense, candles, paper money, and firecrackers. Clarence Day, an American teaching at Hangzhou Christian College in the 1930s and 1940s, collected more than two thousand different paper horses and observed that one shop might carry up to eight hundred different gods.[18] Each god represented a historical or legendary figure around whom a cult had formed that believed in his or her powers to assist mortals. For instance, Hua Te is worshipped for his skills in medicine and healing. This deity was a surgeon in the time of the Three Kingdoms (220–265) who, it is said, operated on the great general Guan Gong's arm while the patient played chess and felt no pain.[19] Other gods are importuned for relief from dysentery (Li Zhici), eye diseases (Yenguang Shenmu), smallpox (Dou Shen), and so on. Gods of agriculture, rain, and sun are turned to when they are needed, as are those of fertility or wealth. Patron gods of every profession are worshipped in the hope

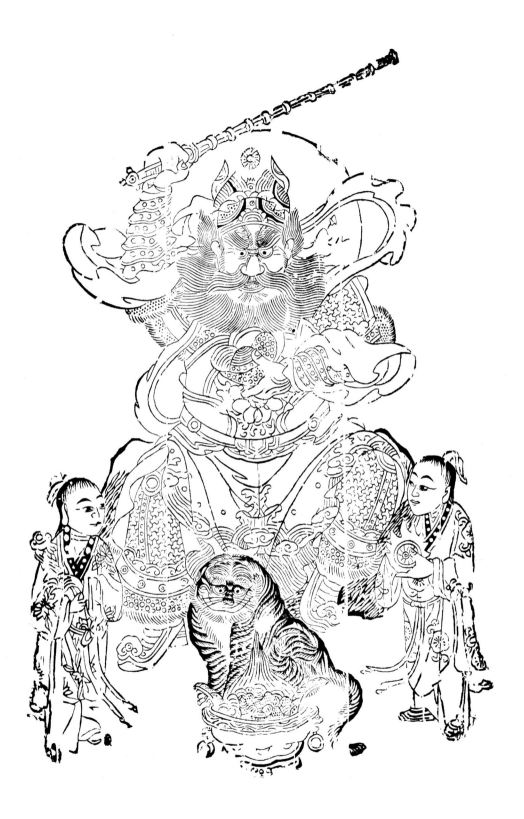

Fig. 200 (above). Woodblock print for paper money, from the same village as Figure 194, meant to be burned for the spirits in heaven and asking them to bring prosperity to those still on earth. Guangdong Province. 4½" × 4½".

Fig. 201. Woodblock print for paper money to be burned and sent as a message to the spirits. The messages alongside the horse ask to be raised to the rank of an official and guaranteed peace forever. The four characters above the horse indicate that one should invest a small amount with ten thousand returning profits. The requests to the spirits are in contrast to the humble beauty of the image. Guangdong Province. 4½" × 4½".

that they will assist the devotee's business. Lu Ban, the inventor of architecture, is the patron god of carpenters and is worshipped during the construction of any building. Ge Weng, an alchemist and color mixer of the fourth century, is the patron god of dyers. Lu Dongbin, one of the Eight Immortals, watches over druggists. There is even a patron god for bean-curd sellers, Huai Nanzi. There are also gods of places, wells, walls, and land, all of whom must be recognized and worshipped lest they get angry and cause trouble.

In a worshipping ceremony, the paper image of the god would be placed inside a small altar or folded about a block of wood placed at the back of an altar table. Figure 194, from a set of nineteenth-century illustrations, depicts a peasant's home. Despite the obvious poverty, above the stove is a small but well-kept altar for the Kitchen God. In front of such an altar, the devotee would lay offerings of food, wine, candles, incense, paper money, and firecrackers. It is believed that seeing all these luxuries in his honor and smelling the fragrant incense would induce the god to descend — through the smoke of the incense, which reaches toward heaven — and listen to the requests of the mortals who summoned him. When the ceremony ended and all favors had been asked of the god, the paper image would be burned with the paper money (in essence, a bribe), and the deity would ascend to heaven again via the smoke.

The most popular gods, present in almost every home and shop, are the Kitchen God, the door gods, and the God of Wealth. The Kitchen God (or God of the Hearth), Zao Wan Ye or Zao Shen, is most likely an outgrowth of the prehistoric god of fire combined with the local gods and gods of family morality. Because the Kitchen God is charged with observing behavior from his position above the stove — the center of Chinese family life — and reporting any misconduct to the Jade Emperor, he is worshipped twice a month as well as being paid obeisance by newlywed couples and families on the occasion of a newborn son. Most images of Zao Wan Ye show him with his wife, who is said to have deserted him because of his constant gambling but returned after he repented and led such a moral life that he was deified during the Zhou dynasty (11th century–256 B.C.). The two are usually seated behind an altar table bearing sacrifices made to them. The four or five young men who usually accompany the Kitchen God are his sons; they carry gifts that the deity may grant to those who worship him. Along the sides of his image are written the words "When going up to heaven say nice things, upon returning bring good luck." Above the image but on the same sheet is printed a

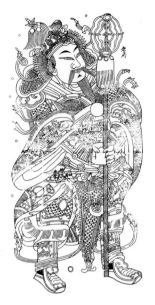

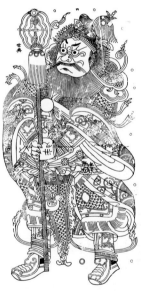

Fig. 202. Pair of door-god woodblock prints. Printed without color, these prints reveal the beauty and strength of the lines left by the wood's impression, giving a very different effect from the colored prints. Jiangsu Province. 35" × 26".

Fig. 203. One of a pair of door-god woodblock prints. Though the carving in this block is cruder than that in Figure 202, the lines have strikingly bold movement and appearance. Shanxi Province. 10½" × 8".

calendar for the year. Until recent government crackdowns on "superstitions" that began in the fifties and lasted until the early eighties,[20] every home had an image, or at least a red strip of paper with calligraphy, indicating the Kitchen God even if few other religious rituals were practiced in the house. In each locality this god is depicted differently, but in general he is portrayed as stern yet compassionate. In the Shanxi image of Figure 204, the wife appears friendly, and her husband more serious about his duties.

The door gods, whose duty it is to frighten evil spirits away from a home's entrances, are always depicted as fearsome. Some ride horses or even tigers, and others stand, but they always carry weapons and are poised to attack. As mentioned previously, the concept of door gods dates back to at least the Han dynasty. Images of guardians have been found on Han tombs,[21] and Han records explain that officials had images of Shen Tu and Yu Lei painted on their doors at New Year's time. The two figures guarding the entrance of a Northern Wei dynasty (386–534) sarcophagus in the shape of a house, now in the Museum of Fine Arts in Boston, are similar in stance and appearance to contemporary door gods on woodblock prints, indicating a long and consistent aesthetic tradition, though the names of the characters have changed through history. During the Tang dynasty, two favorite ministers of the emperor Tang Taizong, Hu Jingde and Qin Shubao, guarded their master's bedroom door after he had had a series of nightmares caused by what he claimed were evil spirits. The emperor later painted their images on his door, which proved for him as effective as having the ministers in person. This custom slowly trickled down to officials, and by the Song dynasty down to the lower classes. A Song dynasty painting by Li Song clearly shows the freshly painted door gods at the entrance to an official's home celebrating New Year's. Today it is usually Hu and Qin, rather than Shen Tu and Yu Lei, who appear on woodblock prints of door gods pasted on gates of villagers' homes. The determined pair from Zhuxian Zhen in Figure 206 are typically full of energy and vigor, Qin on his horse, Hu on a purple tiger. Qin is usually dressed as a civilian official with long-sleeved robes and a white face, while Hu wears the armor of a general and has a red or black face. In the example of Figure 202, Qin has a more scholarly look, and Hu is furiously ready for battle. Since the Qing dynasty, costumes from opera, so popular among all classes of Chinese society, have influenced the depiction of these two figures. Most twentieth-century prints show them with the painted masks of Chinese opera and with flags on their backs, a device used in opera to symbolize generals. Besides these martial door gods, there are

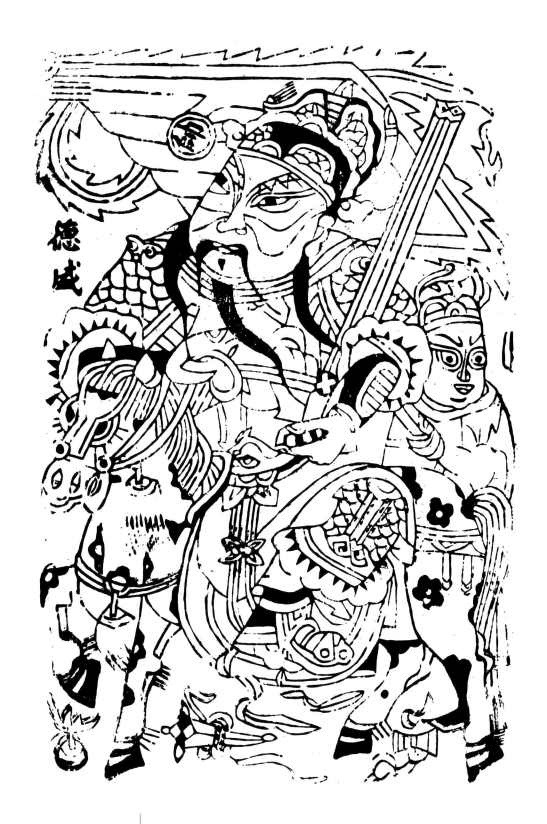

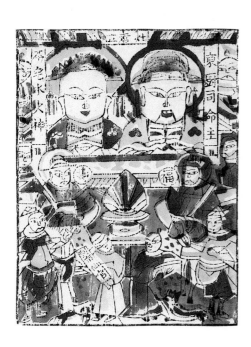

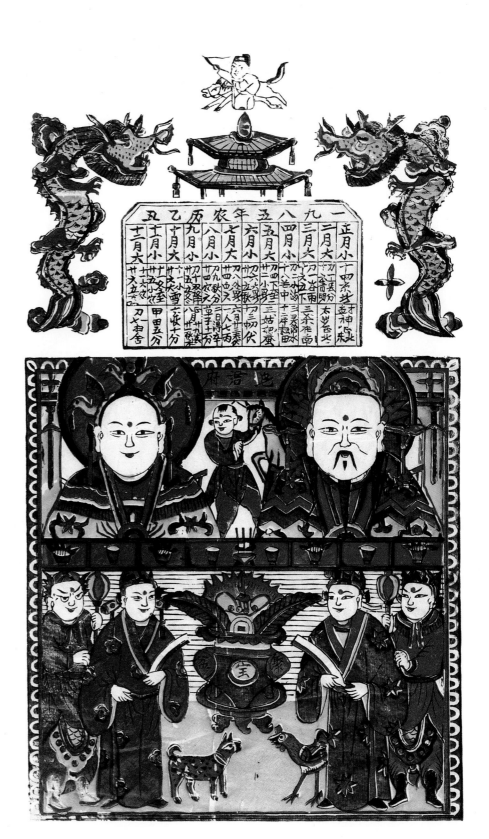

Fig. 204. Woodblock print of the Kitchen God and his wife to be pasted above the household stove. Shanxi Province. 10″ × 8″.

Fig. 205. Woodblock print of the Kitchen God and his wife. Below them are their four sons, a dog, a chicken, and a censer bearing a gold ingot, the riches this god promises if the family behaves well. Styles of his image differ from place to place, as can be seen by comparing this print with Figure 204. In the kitchen set used in the shadow theater (Fig. 150), characters on a red strip of paper pasted in an alcove above the hearth have sufficed. Shandong Province. 14½″ × 10″.

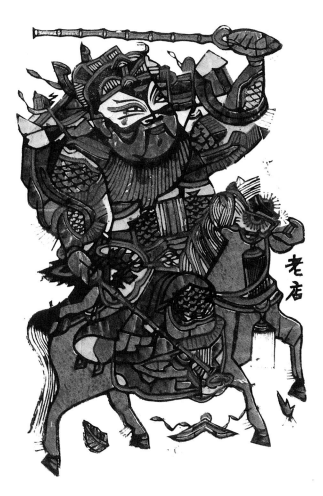

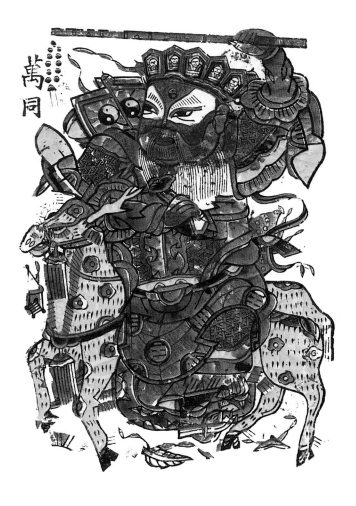

Fig. 206. Woodblock prints of door gods to be pasted at New Year's on the two doors of a household's main entrance to frighten away evil spirits. Zhuxian Zhen, Henan Province. 19½″ × 11½″.

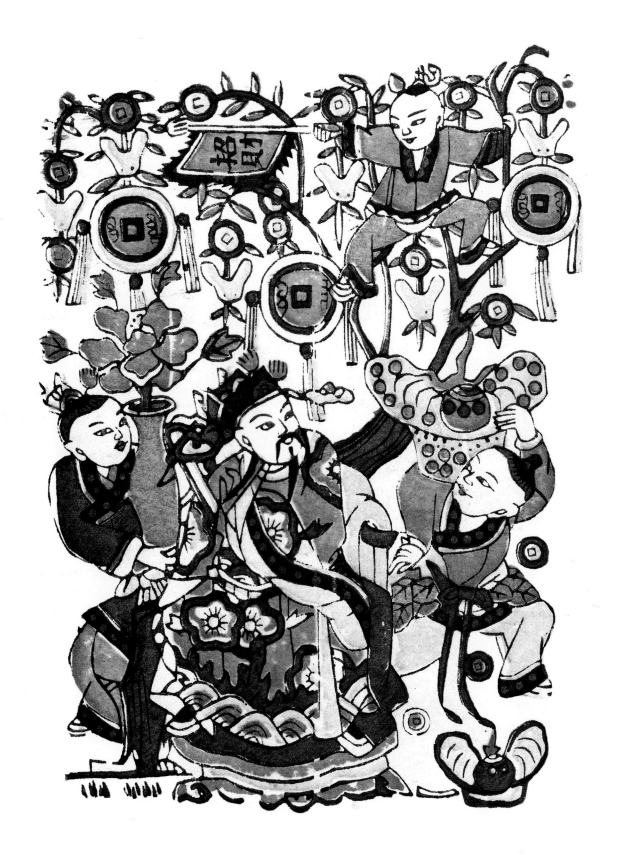

also literary ones carrying symbols of officialdom and wealth rather than weapons. Figure 63 shows a pair of such door gods endorsing officialdom, and longevity, as symbolized by the God of Longevity with his high forehead and long beard. Such prints would be hung on inner gates rather than the more penetrable outer doors.

The God of Wealth also has numerous forms and appellations, though his powers to grant riches are believed in throughout China. People from all walks of life lay luxurious offerings of food and wine before his image. It is said that he was appointed to this job because he had no heart and would therefore be impartial in judging who would be most fit for great fortune. One legend says he insulted the emperor, who then had him killed and his heart cut out.[22] Another legend holds that he was Bi Gan, a minister to the emperor Zhou Xin (1154–1122 B.C.) who in trying to save the emperor's favorite consort tore out his own heart, an act of goodness for which he was deified.[23] In Figure 207, a print from Shandong Province, the God of Wealth is sitting under a money tree, coins hanging from every branch. A child in the tree (which is also a dragon) holds a sign saying *yi ben wan li*: "One investment, ten thousand profit." Below, other children are raking and gathering up the multitudes of gold ingots and coins. In a more serious portrait of the God of Wealth from Hebei Province (Fig. 208), the deity sits like an official, gold in his hands and attendants rather than joyous children surrounding him.

Besides the images of gods, there are many other *nianhua* subjects. Symbols of good luck, explored in the first chapter, are often printed and hung on walls with a double purpose of luck and decoration. A woodblock print depicting a *qilin* with a child riding on its back, a fertility symbol, is often hung on a newlywed couple's door in the hope that it will bring them a son destined to become an official. *Wa wa*, or baby, pictures showing plump, healthy children clutching gold coins or riding fish (*yu*, a homonym for abundance) are themes unique to the woodblock print medium. During the Song dynasty evolved the *bai zi tu*, the picture of a hundred sons, also a common theme of woodblock prints. The *bai zi tu* of Figure 211 shows boys enjoying themselves and playing with horses, musical instruments, dragon lanterns, and other amusements. Around them, *qilin* form the picture's border.

Fig. 207. God of Wealth woodblock print in which the deity stands beneath a gold coin tree. The child on the right carries a large gold ingot on his back. Collection of the Fogg Art Museum, Harvard University. 8½" × 6½".

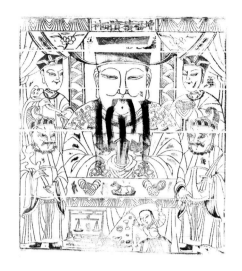

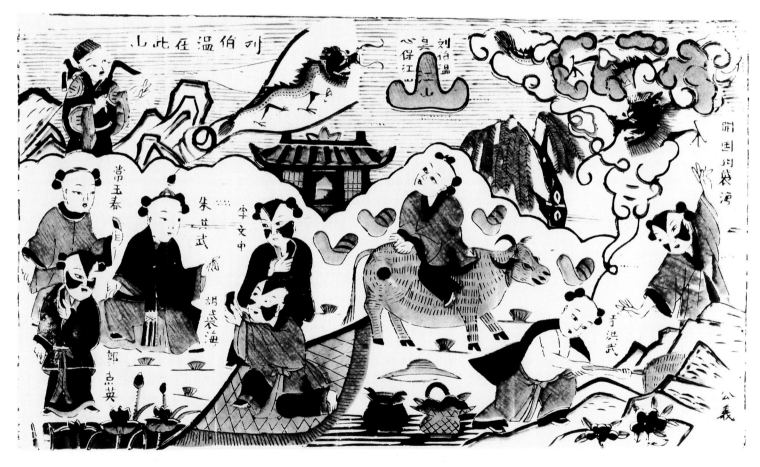

Fig. 208. Woodblock print of the God of Wealth sitting at his table on which are placed two gold ingots. Such an image would be pasted in a home or shop at New Year's in hope of bringing prosperity. Collection of the Fogg Art Museum, Harvard University. 19⅛″ × 17¼″.

Fig. 209. Woodblock print illustrating the story of Liu Bowen, a Ming dynasty official and general who helped the first Ming emperor overthrow the Yuan dynasty. Such an image would be hung to inspire a young child to rise to officialdom. Weifang County, Shandong Province. 9½″ × 16½″.

Fig. 210 (right). Woodblock print showing the God of Wealth and a money tree. Shandong Province. 17½″ × 12″.

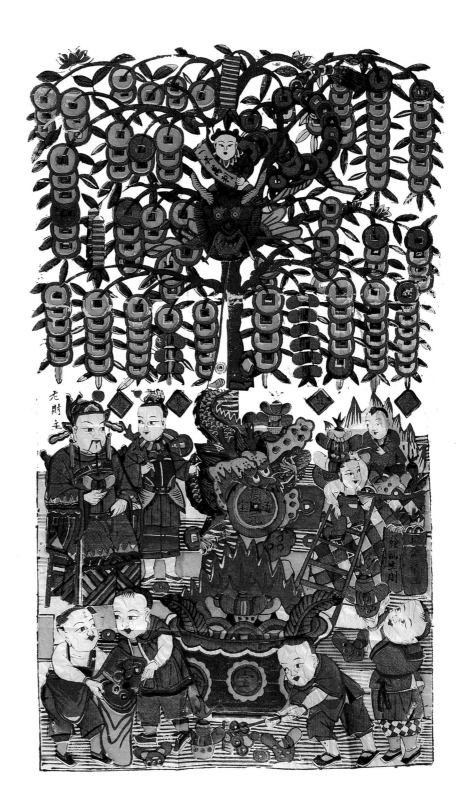

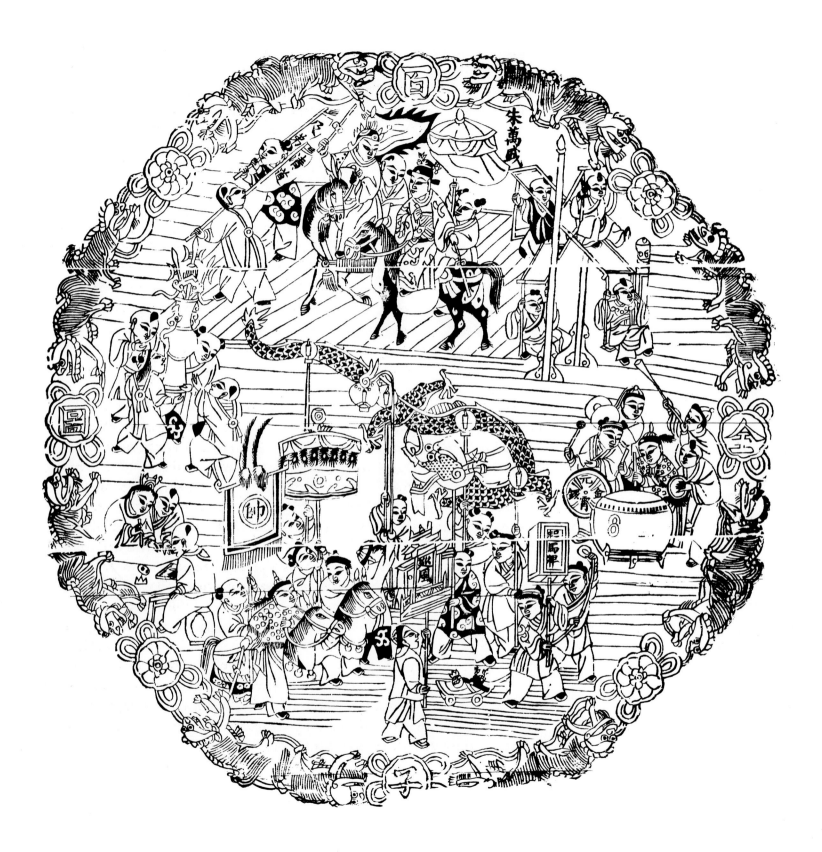

Landscapes and scenes of celebrations or of women in palaces were the result of influence by the official class on the rural poor. And with the development and spread of popular opera among all classes,[24] illustrations of age-old favorite tales became another much-loved topic in woodcuts. As in papercuts and embroidery, but more so in woodblock prints, the rituals of daily life were often portrayed; these were called *geng zhi tu,* "plowing and weaving pictures." The pictures showed both men and women at work, the men cultivating the fields and the women creating textiles. *Geng zhi tu* became popular beginning in academic painting of the twelfth century, spreading to the common classes with advances in printing reproductions, and glorified the morally good work of the farmer living up to Confucian ideals. Prints hanging in a farmer's home may indicate that the household has been hardworking all year and so should receive its just reward. Figure 213 is from a set of pictures called "Women's Ten Busy's." Here they are seen weaving and spinning cotton. The pictures' full composition allows for many actions to occur in one space. Unlike the usual expressions in Chinese folk art of hopes and ideals, these pictures are a reflection of the peasants' lives.

Besides decorating their often dreary homes, woodblock prints also played a more practical role in the peasants' religious lives. Simplified woodblock printing methods were used to produce paper money to be burned for ghosts, gods, and other ancestral spirits. Like all other products of folk media, the money differs from place to place. Some of it is metallic gold paper embellished with large block prints of dragons. Other money is simply crude yellow paper with a small square of metallic paper glued on with a stroke of color; roughly drawn animal figures are found on some paper currency. Figure 201 is a piece of paper money from Guangdong Province. The simple but vivacious horse will carry the currency to the spirits. Above him is the statement again of *yi ben wan li,* intending that the worship of the gods will bring the devotees prosperity. A Shanxi village's spirit money takes a completely different form (Fig. 212). Imitating actual currency, it is labeled "10 *yuan,* Bank of the Underworld, Negotiable in Hell, 1968." The crude print depicts spirits receiving offerings from an altar table. The cruder workmanship is acceptable, since this spirit money is never displayed but only laid out in front of a spirit's image or grave and then immediately burned.

Fig. 211. Picture of a Hundred Boys woodblock print, which expresses the joy of many male children, here shown frolicking at New Year's activities. Jiangsu Province. 25″ × 25″.

Fig. 212. Woodblock print for paper spirit money. The artist has designed the pieces to look like proper currency. They are labeled "10 yuan (the Chinese unit of money), Bank of the Underworld, Negotiable in Hell," and give the date 1968, which, interestingly, was the height of the Cultural Revolution, when such activities as burning spirit money were being heavily criticized. The image is of a man praying before an altar table. Above him a spirit flies. Shaanxi Province. 6½″ × 3″.

Fig. 213. Woodblock print made from a Ming dynasty block but recently reprinted of "Women's Ten Busy's," the ten activities that keep women busy. The spinning and weaving of cotton are still two of women's predominant responsibilities in the countryside today. 10″ × 7½″.

For a community bearing all the hardships of farming without machinery and often even without beasts to pull the plows, producing New Year's pictures is time-consuming but a high priority. The pictures are made for the villagers' own use and in some cases, if the workshop is big enough, for sale to neighboring villages. Production usually takes place during the slacker winter months. A family or a group of men (and rarely women) from one village work together to make the prints. In most workshops, several different types of workers are involved. Some might even be hired from outside, depending on the size of the workshop, particularly the artist who designs the print. Most of these men are of peasant background or, in more sophisticated setups, failed intellectuals who can refer to academic paintings or printed painting manuals when creating their designs. Certainly the more access the artist had to great works, the more refined his designs would be. More often than not though, the villagers borrow and improvise from a neighboring village's image.

The artist usually makes five to six sketches of his final design, one for each color and one for the black outlines. These sketches, done on white paper, are then pasted onto a smooth block of date wood, with the sketch facing the wood. Date wood is used because of its hardness, its even grain, its quantity in the north, and its resistance to cracking. When the paper has dried, it is sanded down only until the artist's lines can be seen. Then a professional carver etches the designs into the woodblocks, a job that can take up to twenty days, depending on the details and the number of colors. For instance, if the carver is working on the red block, he would carve away all those areas except where red is to appear, and so on for each color. Looking at the prints, one can see that the black outlines contain the most details, the rest of the image being made up largely of blocks of color.

The printing is done by another set of workers. Each block is inked with its colored ink and the paper pressed onto the blocks in succession. (In Western printing, the block is usually pressed onto the paper.) Each worker is responsible for one color. First the block bearing the black outlines is printed onto the white, red, or crude yellow handmade local paper. If red paper is used, no other colors are added. Otherwise, the colors are applied one by one. Each worker rolls up a stack of papers, inks each print, flips it back on to the roll, and then passes the whole stack on to a worker doing the next color. In more primitive workshops, the colors are not printed with woodblocks but through oiled paper stencils in a method similar to that in making dye-resist fabrics.

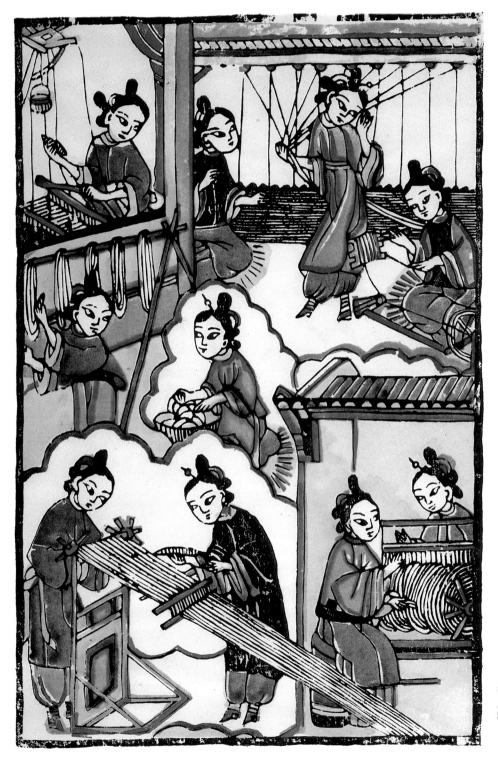

明嘉靖十年陶蕭隱士藏板

In the larger, family-run shops that specialize in selling these prints on a large scale, even occasionally year-round, the final step of producing the *nianhua* is usually done by young and old unskilled peasants wanting to earn a bit of extra money when there is no farm work to be done. They dot in the eyes and paint other minute details by hand. Figure 203 comes from an area in Shanxi Province where economics don't even allow for color. In Figure 205, perhaps more skilled workers and better financing contributed to a more sophisticated appearance; the colors are lying within their designated borders and not overlapping the others. The coloring and carving of the Kitchen God in Figure 204 may be more crude, but it still expresses a joy in the colors — note, for instance, the attention to detail in the multicolored incense burner before the gods — and the belief in the deities.

The quality of the paper and the dyes as well as the skilled hands of the artist and carver are all integral to the resulting print. Sometimes the paper absorbs too much of the inks, causing them to appear as large dots spotting the black outline and giving the images an almost comical appearance. Others, done for well-to-do families, can be so overburdened with detail and gold dots that the coarse effect of the woodcut is totally masked. Some of the most successful works are those done not by imitating the academic school of painting but by working with the hardness of the wood and the simple lines to create a strong portrait or scene. Figure 193, a charming composition of the gods guarding horses and cows, is worthy of worship (although not overrealistic) and is also very much a reflection of the needs and desires of the people who made it.

Because woodblock printing necessitated a larger workshop than the other folk arts and because, unlike the other media; its products were for sale, some regions eventually became more renowned and developed than others through competition. The development of some workshops into larger commercial businesses, which did not occur in the other folk arts, was due to the fact that the industry was almost exclusively male, for women did not get involved in the market economy. Having become a merchant, a man would be eager to expand his printing venture, hiring more workers and selling his wares to more distant counties. The most famous of the printing centers were Yang Liu Qing in northern China and Tao Hua Wu of southern China, which both began production at the end of the Ming dynasty. Yang Liu Qing was the county center for thirty-two

Fig. 214. Woodblock print for child's board game. Jiangsu Province. 7½" × 8".

villages in Hebei Province, not far from Tianjin. Two shops in Yang Liu Qing, both of which date back to Ming times, were to become the best-known in all of China for production of New Year's pictures: Dai Lian Zeng and Qi Jian Long. The workshops expanded, opening up branches first in Tianjin, then in Peking, and then in cities across the country; their prints were bought by peasants and aristocrats alike. By the Qianlong period of the Qing dynasty, their popularity had grown immensely, reaching its height at the turn of this century. To give an idea of the scope of these workshops, during the Qianlong era Dai Lian Zeng had more than a hundred peasants working in its shops just dabbing on colors and was producing up to a million prints a year. Their works included paper gods, door gods, opera scenes, *wa wa* pictures, and scenes of customs and festivities. As the Yang Liu Qing center developed, the shop could afford better and better artists, and by the Qianlong period its works were looking more and more like those done in the imperial academy. Because they were employed at workshops, these woodblock designers were considered of lower status than those who painted for the emperor's pleasure.

Tao Hua Wu was established after the Taiping Rebellion in Suzhou, in Jiangsu Province.[25] (There had been *nianhua* print shops in Suzhou previously, but a seven-day-long fire resulting from the war destroyed them and all the woodblocks.) Sensitive to southern tastes and located in Suzhou—an area full of wealthy merchants and officials' families—the workshops here produced prints that also show a refinement more advanced than those from the rural areas. As the prints' fame spread and the owners of the workshops prospered, Tao Hua Wu was also able to invite well-known artists to come and design their prints. At the end of the Qing dynasty, among others they invited Wu Youru, the artist who drew the pictures for the woodblock prints of Figures 28 and 163.

Besides Tao Hua Wu and Yang Liu Qing, the other important *nianhua* centers were Weifang in Shandong Province, which produced Figure 54, and Zhuxian Zhen, in Henan, where Figure 206 was printed.[26] In Zhuxian Zhen today, the Cultural Bureau of the nearby city of Kaifeng has taken over the printing of the blocks, creating fine works, while the peasants in the surrounding area have begun again themselves to produce the blocks and prints. The Cultural Bureau models its blocks on the old designs. The peasants' works are cruder, as can be seen in comparing Figures 193 and 206 from the village and Figure 213 from the city, but seem more authentic and expressive of the folk intentions of the prints. Moreover, the bureau's workshop produces only several types of the prints, their stated

purpose being to preserve tradition.[27] However, they do not produce such spirits as the gods of cows and horses or the Kitchen God because they could be used for superstitious and religious purposes. In Zhuxian Zhen, the small workshop has therefore begun producing these other necessary images. Usually using the same blocks that have been passed down for generations, a group of men may form their own private collective and then sell their prints in the markets. So despite the efforts of the Cultural Bureau—on the part of the state—to restrict the styles and themes of modern prints, the peasants have remained faithful to their own traditions.

The style and forms of *nianhua* continued to change with the times. The *nianhua* of the 1920s and 1930s produced in Shanghai reflect the advancements in printing techniques learned from the West. The peasants, when they could afford it, preferred this glossier look.[28] On the other hand, Lu Xun, the revolutionary writer and thinker of the same time, admired the traditional Chinese woodcut and promoted it. "I think we should study the stone relief art of the Han, and the book illustrations of the Ming and Qing. Moreover, pay attention to the *nianhua* pictures enjoyed by the common people. If we integrate all this with the new methods from Europe, we can probably produce a better woodcut art."[29] In his encouragement of the medium in China, he arranged exhibits of European and Russian woodblock prints (eighty thousand people in one week attended the last one before his death in 1936) and published books on both new and traditional Chinese woodblock printing.[30] During the thirties he also set up classes to teach art students how to cut their own woodblocks, something artists in China had never learned. To Lu Xun it was important that the carvers were no longer anonymous workers but artists.[31]

A few years later, when many of those students went to the Communist base in Yan'an, in northern Shaanxi Province, they established the Lu Xun Art Academy in memory of their teacher.[32] There, along with painting, music, and drama, woodblock printing was taught and practiced, primarily as a medium to propagandize the new ideals. *Nianhua,* already an intimate part of peasant life, were infused with new themes: some agricultural and educational, others promoting the new leaders of the Communist party. As Lu Xun had advocated, these young artists borrowed both from traditional Chinese folk art and Western prints—particularly the works by Kaethe Kollwitz and the depictions of the poor and the suffering, which the roughness of the woodcuts conveyed so well. After the revolution the

woodblock printers, like other folk artists, were encouraged in their new and revolutionary styles. Radicalism led to disregard for traditional styles and themes and even to the burning of many of the old blocks. The situation relaxed after the fall of the Gang of Four, who controlled the country until 1976, but with the Spiritual Pollution campaign of 1983, it is rumored, more blocks were burned at Wei Fang and elsewhere.[33]

Now that private enterprise has returned, peasants have been taking out the woodblocks they hid away during the Cultural Revolution, which may have belonged to their fathers and grandfathers. According to Wang Jindong, a historian of *nianhua,* one present-day printer he interviewed was using blocks more than two hundred years old.[34] But many images must still be carved for those blocks that were destroyed.

Traditionally, the Chinese refer to buying *nianhua* as "inviting in the gods." From the market, a villager will bring home the deities and then paste the bright images onto the dark, smoke-stained dirt walls. As one villager explained, a few prints at New Year's time transform the entire mood of a home.[35] A few years ago, it was the free, glossy portraits of Mao and other leaders that covered those walls. Today more traditional and more warmly worshipped figures are being welcomed back.

Fig. 215. Woodblock print of a pair of dui lian, *couplets to be hung on either side of a household's entrance. The artist has cleverly made each character of the couplet into an image that reflects the character's meaning. The couplet, a well-known poem, reads, "[In the] bamboo forest [a] bird calls, [the] bright moon rises, / [In the] blue mountains, rain passes, white clouds fly." Henan Province. Each print 35" × 6".*

Folk Art Today

The art created in Chinese villages has undergone many changes over the millennia, in style as well as in content, and it will continue to be molded by the ever-changing social and cultural environment. The modern era in China—with its sudden swings between extreme respect for the folk arts in the 1930s and 1950s and the destruction of all tradition during the Cultural Revolution (1966–76), combined with the introduction of an industrial culture—has left an indelible and extremely unfortunate imprint on village culture. But before looking at the vicissitudes of the twentieth century, let us examine how earlier political and economic conditions influenced these arts.

During the Song dynasty (960–1279), the Chinese economy expanded drastically, spurred by new technological inventions that, in turn, affected the folk arts. Suddenly more goods than ever before were on the market and available at reasonable prices to a large part of society. The lower classes could afford more paper, silk, and thread to use in decorating their homes for the New Year. With the development of woodblock printing, door gods and other deities' images could be hung in many people's homes. These eventually replaced most hand-painted images, even in wealthier homes. The mass-produced item was not as individual as a hand-painted work, but its introduction allowed more people to have more decoration at less expense.

Artisans have continued inventing methods for reproducing their works over the years, creating some uniformity in several areas of folk art. The development of the stencil in dye-resist allowed for reproducing designs, as did the lampblack method of copying papercuts. However, because of slow transportation in the pre-automobile age, geographical isolation, and the absence of mass production, styles tended to remain local, and new designs were constantly created.

Fig. 216. Entrance to a store selling marriage papercuts, all with the double happiness characters, xi xi, and all lacking the spontaneous individual styles made by the villagers for themselves. 1984. Kaifeng, Henan Province. Photo by Nancy Berliner.

Fig. 217. Shadow puppets probably made in the 1930s by a troupe performing tales promoting the Communist message. The woman is wearing a Communist or Nationalist outfit of that era. The puppet was mixed in with a traditional and much older shadow puppet set, which also included, however, a landlord puppet of the same vintage. Shaanxi Province. 12" high.

Political and historical conditions have also influenced the arts. Qin Shubao and Hu Jingde, the ministers of the Tang dynasty (618–907) who were honored by having their images painted on doors to frighten away evil spirits, still stand guard today in most rural homes. Before their popularity, the images of Shen Tu and Yu Lei were the most common on entranceways. The change at one time certainly had political significance, with the images also reflecting what or who contemporary society considered a source of power. The interest in protecting the home has remained, but history and society have changed the appearance of the protectors from tigers to ministers and even, in modern times, to patriotic Communist warriors.

The twentieth century has brought electricity and news to remote villages; mass communication and rapid transportation have made even more pronounced the effects of recent history on the folk arts. Factories, antisuperstition campaigns, the influx of Western culture, and the Mao cult have all had their turns at altering the face of peasant culture. Industrialization brought plastic toys, glossy printing, printed textile goods, and many other objects that seem to replace the need for handmade goods. Even those still involved in painstaking hand production often express a reverence for these factory-made objects and a consequent embarrassment about homemade works, supposedly symbols of poverty or primitiveness. During the 1920s, many intellectuals had gone abroad to Japan or Europe to study and returned home suddenly aware of their own country's backwardness.[1] Their desire to help China rise out of her poverty-stricken and what many termed feudal state—referring to both the system of government and traditional values—certainly resulted in some improvements, such as social welfare, modern industry, and emancipation for women. But in their haste, many violently dismissed much of Chinese culture. A look at a report in the Zhejiang Provincial Gazette from December 19, 1928, reveals the impact some officials of the new Nationalist government intended to have on the populace of their country:

> Superstition is a hindrance to progress. The appeal to the authority of the gods is a policy to keep people ignorant. Our party [the Guomindang, or Nationalists], struggling for revolution, has opposed those who hindered the development of the sovereignty of the people. For this reason ambitious warlords, rotten officials, etc., have been eradicated. So also harmful superstitions and temple beliefs must be driven out.
>
> The principle for recognition of temples is that we approve of retaining those dedicated to great men of the past who have contributed

discoveries of arts and sciences, those who can be held up before the people as examples of filial piety and justice for their emulation. Secondly, those dedicated to religious leaders who have founded religions on the basis of right and truth, and have been popularly believed by the people.

The principle for confiscation of temples is likewise twofold: that we should do away with the old prehistoric religions which cannot be proved, or which have no contemporary meaning or value.[2]

Among the category of religious figures to be done away with, the government included Zao Shen, the Kitchen God; Song Zi Niang Niang, the goddess who provides children; Cai Shen, the God of Wealth; and the gods of wind, clouds, thunder, rain, the sun, and the moon. "All of the above," the report continued, "temples and idols should be razed to the ground so that nothing remains."

Such attitudes, along with industrialization and the advent of Western movies, decorative arts, attire, and even religion, succeeded in eliminating much folk culture from China's urban areas during the thirties and forties. For the first time in millennia, folk culture was considered old-fashioned in some circles, especially those well connected to foreigners. Many of the urban and well-to-do quickly followed suit. People went to movies instead of the shadow theater. Women found other amusements besides making papercuts and embroideries. Some were educating themselves; others were going out more, exercising the new freedoms of a more open society. Outright destruction of folk art increased, reaching its height during the Cultural Revolution, when papercuts were burned along with traditional brush paintings and anything that smacked of the traditional. If some leaders of that time had had their wish, none of the art forms discussed in the preceding chapters would still exist.

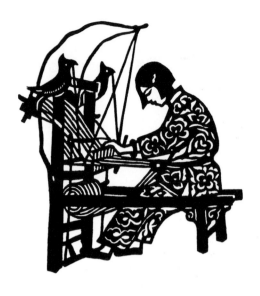

Fig. 218. Papercut of a girl at a loom done in 1943 by Li Qun and Niu Guiyang, members of the Communist brigade in northern Shaanxi. The artists have portrayed a village scene, but the image is in proper Western perspective, revealing its creator's urban origins. Moreover, the girl's hair is cut short in the liberated style, not braided into two plaits, as in popular village fashion. Although obviously not a pure piece of folk art, the piece was made by excellent artists and is visually pleasing, while many of the later "papercuts" by urbanites are not. From Jiang, Yan'an Papercuts.

Fig. 219. Papercut made by a professional artist imitating the folk medium but expressing Communist motifs. From Wang and Li, Xin jianzhi yishu.

In the decades before the Communists succeeded in overthrowing the Nationalist government, however, they introduced a respect for the folk arts that had never been equaled among Chinese intellectuals. Under the influence of Western socialist and revolutionary writers and philosophers — such as Herbert Spencer, Bernard Shaw, and Karl Marx — some young Chinese began to pay attention to the lower stratum of society.[3] At first this was purely political, but eventually the Communists interested themselves in peasant culture. When the Communists established their base in Yan'an, many artists joined their cause. Several in particular were intrigued by the art of the villagers, so refreshing compared with the restrictive, traditional brush arts. Well-known poet Ai Qing, then a painter just returned from study in Paris, and fellow painter Jiang Feng began collecting papercuts from the villagers whom they were assisting with land reform. Exhibitions were arranged and even several books published.[4] Having rejected traditional Chinese elite culture, these artists were looking for new art forms and became inspired by papercuts, which they found unpretentious and naive. Soon city artists, encouraged in the thirties by revolutionary historian Lu Xun, began making their own papercuts and woodblock prints.

The new works carried different messages than the traditional folk art. Instead of symbols of fertility and prosperity, the ideology of the Communists predominated. Education, farming, and appreciation of the party were the common themes. Communist artists justified their subversion of folk art by claiming that its new messages would help the peasants as much as images of the God of Wealth. Soon they were encouraging the peasants to also make works with such motifs. Figure 219, from the 1940s, is an example of the results: two peasants are offering Chairman Mao the fruits of their harvest in thanks for his liberating them. Some traditional aesthetics are still in play — the key design around the border, with bats of good luck in the corners — but the treatment of the figures is more three-dimensional than usual in traditional folk art, revealing a Western or Soviet influence. The charming peasant styles with their lack of concern for perspective were sacrificed for more objective realism, which the then-prevalent Soviet socialist ideals called for. This twist in style was mirrored in all the folk arts. New Year's posters showed Communist leaders rather than deities. The artisans who created them — most of them activists from the city assisted by local craftsmen — also insisted on more realistic portrayals and eventually slicker, factory-printed jobs. Folk art had become a propaganda vehicle for a new set of beliefs. In a sense it had been reduced and commercialized, as well as removed from its original purpose.

Fig. 220. Papercut by a nonvillager. The characters on the blackboard read "Study Production." The two figures are stiff, in too-perfect perspective, and lack the native spontaneity and creativity in working out the structure of the cuts. From Jiang, Yan'an Papercuts.

In a famous speech, from the Yan'an Forum on Literature and Art, Mao Zedong proclaimed that "art must serve the people."[5] In the sense most often interpreted, this means that art is not for art's sake nor for the artist's, but only to be given to, understood, and enjoyed by the workers, soldiers, and peasants. All abstract or expressionist art, the Communists believed, would be incomprehensible to nonartists and therefore should not exist. Only realistic and optimistic works were to be allowed. This policy, which extended from oil painting to folk art, stood firm for almost thirty years.[6]

The organization of all members of society into units controlled by the party helped enforce this policy after the Communist takeover in 1949. In their modified, "ideologically correct" versions, the folk arts began to play a larger role in the cities. Arts and crafts centers, schools, and academies were established, and for the first time many such institutions emphasized the folk arts. However, once again revolutionary themes and refined urban styles were practiced. Some of these centers took in well-known folk artists —including shadow puppeteers, papercutters, and dough sculptors—and promoted their work. But by the fifties and certainly the sixties, the subjects of their work became more and more restricted. After the Cultural Revolution, leaders from these centers put such artists' talents on display

Fig. 221 (above). A papercut by the artist Gu Yuan (now known for his woodblock printing) done in 1943, when he was with the Communists in northern Shaanxi. The piece has still preserved some folk feeling, and the figures are all wearing outfits common to that region. The woman is dressed in a dye-resist jacket with a bun on her head, and the man has a towel wrapped around his head. The slogan, however, "Know a Thousand Characters," is definitely part of the Communist campaign for literacy. From Jiang, Yan'an Papercuts.

Fig. 222. From Folk Arts of New China, this papercut displays the problems of the "new" folk art of the forties and fifties in China after the revolution. The four characters across the top of the cut read "Home of a Soldier's Family"; the two enclosed in the lanterns read "Glory and Pride." The expressive individual style of the original village papercuts is completely absent from the piece.

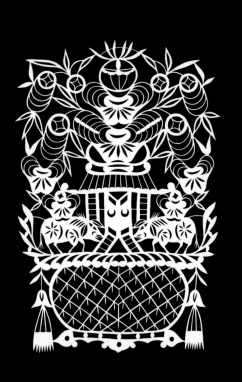

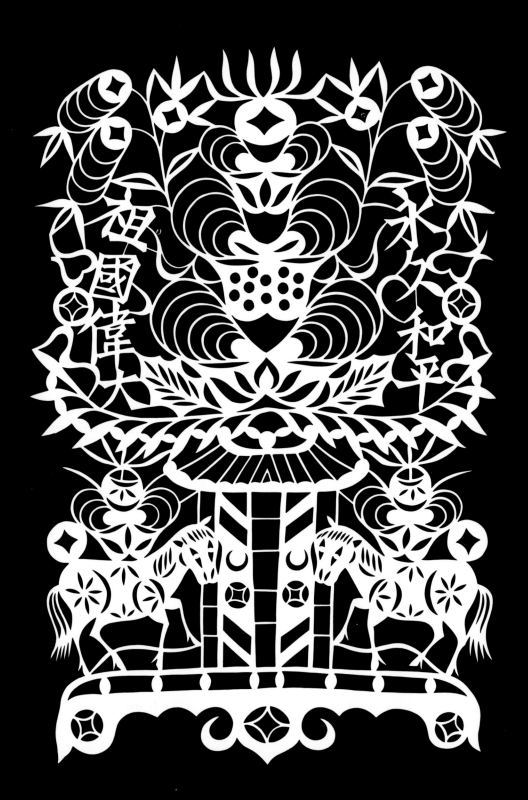

for other purposes. In some centers today, professional papercutters perform for tourists or create items for sale abroad, but their works are dramatically different from the cuts done by women in the villages. These modern papercuts are slick or cute, but never rough or naive in nature. The traditional folklore and its quaint look are neglected. In Figure 224, however, the artist was able to have his traditional regional style approved by tactfully adding the characters "Our Great Motherland, Eternal Peace" to express his patriotism. (Compare this with his more traditional piece in Figure 223, far left).

During the Cultural Revolution, women in the villages were pressured to make papercuts illustrating Mao or sunflowers, motifs of the new society (sunflowers were said to represent the people, who always look up toward the sun, which is Mao). Papercuts of tractors or happy, hardworking villagers were also permissible. Instead of the usual deities that served as door gods, glossy, factory-produced posters of new Communist heroes stood guard outside villagers' homes. The twentieth-century figures of Yang Zirong and Li Yuhe took the place of Qin Shubao and Hu Jingde. Yang was a Communist general whose part in the new regime was portrayed in "Zhi Qu Wei Hu Shan" ("Taking Tiger Mountain"), one of only eight model operas allowed to be performed during the Cultural Revolution.[7] In the opera, Yang goes to the northeastern part of China after the revolution to weed out all the bandits and Guomindang soldiers hiding there. Li was the leader of a railroad strike, and his exploits were recounted in "The Red Lantern," another of the model operas. He was most famously played by the actor Hao Liang, whose picture became the new door god and who became vice-minister of the Ministry of Culture during the Cultural Revolution.

When those eleven years ended with the death of Mao and the fall of the Gang of Four in 1976, some of the old posters of Mao and other leaders remained on village walls for their bright, decorative coloring. In most villages, however, where the peasants have time and possibly lack enough money to afford urban goods, they have returned to their traditional ways and motifs. Girls again spend years embroidering the trousseau and dowry that they will present to the young man their parents have arranged for them to marry. Liu Hai, the *qilin*, and the pomegranate—symbols of wealth, male offspring, and fertility—all still figure largely in the works being produced today, despite birth control campaigns and past policies discouraging private wealth. Funerals in the countryside have once again become lively occasions lasting several days, with bands, banquets, and large amounts of decoration revealing a fervent belief in age-old rit-

Figs. 223 and 224. Two papercuts by the same artist, done in the 1950s. Although both are in traditional style, the one on the right includes an ideologically correct slogan, which would have saved its maker from political criticism: "Our Great Motherland, Eternal Peace." Hebei Province. Both 12" × 7½".

Fig. 225. Woman working at a home loom, weaving cotton for her family's use. 1984. Village in Henan Province. Photo by Nancy Berliner.

Fig. 226. Printing colors in the traditional manner in a Kaifeng state-owned and -operated workshop. Color is applied to the woodblock with the large straw brush, and then the print is pressed onto the block. 1984. Henan Province. Photo by Nancy Berliner.

ual. While the government disapproves of extravagance for weddings and funerals (many official papers stated this view in 1982 and 1983, when such spending reemerged with the growth of private enterprise), it is beginning to recognize the intimate connection between these arts and the people's lives. A recent poster in Beijing urging families to have only one child showed a young boy with his head resting on the traditional tiger pillow, which wards away evil spirits. More concrete efforts by the government include increased support for research on the folk arts, the establishment of a newsletter for papercut researchers in 1984 and a convention for the same group, and instructions to rural cultural centers to collect more folk art from local artists in an effort to preserve traditional artworks.

Even if, as some might claim, villagers are now using the traditional symbols and forms more out of habit than from any belief in their potency, the message is still clear: there is desire and joy in the free creation of beauty, and it is instinctive in the humblest levels of society. Though it might be scolded or bullied, it cannot be crushed. Whether it will fade with the eventual influx of factory-made cloths and plastics is difficult to guess; even before Communist rule, a decline in folk art was already in motion. In the thirties, C. Schuster, a Chinese folk art researcher from Harvard University who collected cross-stitch embroideries in northern Sichuan, noted that it was difficult to find samples. "Missionaries who have lived there for decades are often unaware of their existence," he remarked in a 1937 issue of *Asia* magazine.[8] This, he explained with obvious disappointment, was "because the art is dead." Cross-stitch embroidery is still being done in some corners of Sichuan Province today, however, and the waning of the folk arts—which, when they are done, are done with such vitality—may never be total. A young woman in Sichuan's Kaixian County fashioned the striking innersole of Figure 175 for her husband-to-be to wear on their wedding day just two years ago. The mere fact that the Chinese people have continued embroidering, cutting papercuts, and making woodblock prints gives a hint of the strength of the folk and their traditions.

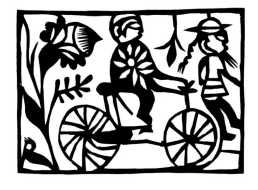

Fig. 227. Papercut done in a very traditional folk style but depicting a contemporary scene of a man bicycling. The elderly man, walking by the side, interestingly, wears a queue, the braid men wore in the Qing dynasty. The artist perhaps was accustomed to making her cuts of people in traditional dress and was not concerned that such costumes would be unsuitable for a more modern image. Northern Shaanxi Province. 3" × 5".

Chronology

Chinese people usually refer to periods of time by their dynastic reign names rather than by the number of years away from a reference point (such as the birth of Christ). In this book I have followed the Chinese pattern. For readers' reference, the order of equivalent Western dates for the dynasties is as follows:

Xia	21st – 16th century B.C.
Shang	16th – 11th century B.C.
Zhou	11th century – 256 B.C.
Spring and Autumn	770 – 476 B.C.
Warring States	475 – 221 B.C.
Qin	221 – 206 B.C.
Han	206 B.C. – A.D.220
Three Kingdoms	220 – 265
Jin	265 – 420
Southern and Northern	420 – 581
Northern Wei	386 – 534
Sui	581 – 618
Tang	618 – 907
Five Dynasties	907 – 960
Northern Song	960 – 1127
Southern Song	1127 – 1279
Yuan	1279 – 1368
Ming	1368 – 1644
Qing	1644 – 1911
Republican	1912 – 49
People's Republic of China	1949 –
Cultural Revolution	1966 – 76

Notes

Foreword

1. Aldous Huxley, "On Craftsmanship," first published in his *Beyond the Mexique Bay* (1934); reprinted in Morris Philipson, ed., *Aldous Huxley on Art and Artists* (New York: Harper and Brothers, 1960), 86–97.
2. William Rubin, ed., *"Primitivism" in Twentieth Century Art: Affinity of the Tribal and the Modern*. 2 vols. (New York: Museum of Modern Art, 1984).
3. "On a Revolution in Chinese Literature" (1930); quoted in Hu Shih, *The Chinese Revolution* (Chicago: University of Chicago Press, 1934), 54.
4. *Mao Tse-tung on Literature and Art*, 3rd ed. (Beijing: Foreign Languages Press, 1967), 18.

Introduction

1. Ai Qing, *Minjian yishu he yiren* (Folk art and artists) (Xinhua Shudian, 1946), and Chen Suliang, *Chuanghua* (Window flowers) (Gaoyuan, 1946).
2. Richard Darson, preface, in *Folktales of China* (Chicago: University of Chicago Press, 1965), xvii.

Symbols and Legends

1. Wu Hung, "A Sanpan Shan Chariot Ornament and the Xiangrui Design in Western Han Art," *Archives of Asian Art* 37 (1984): 38–58.
2. The robe was found at the Mawangdui site in Hunan Province. The most thoroughly illustrated book on the subject is: Hunan Sheng Bowuguan (Hunan Province Museum), eds., *Mawangdui yihao Hanmu* (The number one Mawangdui Han tomb) (Beijing: Wenwu Chubanshe, 1973).
3. Wu Bingan, *Minsuxue conghua* (Collected notes on the study of folk customs) (Shanghai: Wenyi Chubanshe, 1982), 4.
4. Alfred Koehn, *Filial Devotion in China* (Beijing: At the Lotus Court, 1943), first page of introduction.
5. Henry Dore, *Researches into Chinese Superstitions* (Shanghai: Tusewe Printing Press, 1914), vol. 6, 672.
6. J. J. M. de Groot, *The Religious System of China* (Leyden: 1892), 941.
7. Prince John Lowenstein, *Swastika and Yin Yang* (London: China Society, 1942), 2.
8. C. A. S. Williams, *Outlines of Chinese Symbolism and Art Motives* (Shanghai: Kelly and Walsh Ltd., 1941), 414.
9. Lei Guiyuan, *Zhongguo tuan zuofa chutan* (Explorations into Chinese designs) (Shanghai: Shanghai Renmin Meishu Chubanshe, 1979).
10. Williams, *Outlines of Symbolism*, 381.
11. Wu Chengen, *Journey to the West*, ed. and trans. Anthony C. Yu (Chicago: University of Chicago Press, 1977).
12. Dore, *Researches into Superstitions*, 505.
13. Ibid., 718.
14. Ibid., 505.
15. Ibid., 718.
16. Wen Fong, ed., *Great Bronze Age of China* (New York: Alfred A. Knopf, 1980).
17. Tseng Yu-ho Ecke, *Chinese Folk Art II in American Collections* (Honolulu: University Press of Hawaii, 1977), 120.

18. de Groot, *Religious System*, 941.

19. Ibid.

20. As quoted in ibid., 941.

21. As quoted in Tseng, *Chinese Folk Art*, 119.

22. As quoted in de Groot, *Religious System*, 941.

23. Arthur de Carle Sowerby, *Nature in Chinese Art* (New York: John Day, 1940), 69.

24. Recorded in *Zizhi tongjian gangmu* (The elucidation of historic annals) as noted in Dore, *Researches into Superstitions*, 677.

25. For descriptions of like customs, see Arthur H. Smith, *Village Life in China* (New York: Fleming H. Revell Co., 1899), 170.

26. Recorded in *Zhu shu ji* (The bamboo annals), a third-century B.C. text, noted in Dore, *Researches into Superstitions*, 666.

Papercuts

1. Pan Jixing, "The Invention and Development of Papermaking," in *Ancient China's Technology and Science* (Beijing: Foreign Languages Press, 1983), 176–83.

2. Related in Shi Wenying, *Zhongguo jianzhi zhi xingshi ji yanbian yanjiu* (Chinese papercut forms and development research) (Taibei: Zhongguo Wenhua Xueyuan, 1977), 3.

3. Pan, "Invention of Papermaking," 176.

4. As explained in discussion with Jin Zhilin, August 1985, in Xian, Shaanxi Province.

5. Shi, *Zhongguo jianzhi*, 4.

6. Ibid., 9.

7. Ibid., 6.

8. The best illustrated book on Dunhuang is by the Dunhuang Wenwu Yenjiusuo (Dunhuang Cultural Relics Research Institute), *Dunhuang bihua* (Dunhuang murals) (Beijing: Wenwu Chubanshe, 1959). Also useful on this subject is Shanghaishi Xiqu Xuexiao Zhongguo Fuzhuangshi Yanjiuzu, comp. (History of Chinese Clothing Research Group of the Shanghai Traditional Opera School), *Zhongguo lidai fuzhuang*) (Chinese clothing and adornment in various dynasties) (Shanghai: Xuelin Chubanshe, 1984).

9. Shi, *Zhongguo jianzhi*, 16.

10. Ibid., 6.

11. Ibid., 15.

12. Ibid., 16.

13. Ibid., 42.

14. Zhou Mi, *Wulin jiu shi* as quoted in Shi, *Zhongguo jianzhi*, 43.

15. As noted by Shi, *Zhongguo jianzhi*, 43.

16. Ibid., 18. *Dongjing meng hua lu (wai sizhong)* (1147) (reprint, Shanghai: Gudian Wenxue Chubanshe, 1956).

17. Shi, *Zhongguo jianzhi*, 19.

18. "Papercuts made in North China tend to be bolder, while those from the South are more likely to have fine details," writes Florence Temko in her book *Chinese Paper Cuts* (San Francisco: China Books, 1982).

19. Wang Laoshan's works were produced in a limited edition, with an introduction by Gu Sai, entitled *Wang Laoshan Xiqu Kezhi* (Wang Laoshan's opera paper carvings) (Shanghai: Renmin Meishu Chubanshe, 1955).

20. According to Jin Zhilin, noted researcher of papercuts who has lived in the region for years, as mentioned in discussion August 1985.

Shadow Puppets

1. As noted in Sun Kaidi, *Cangzhou ji* (Cangzhou collection) (Beijing: Zhong Hua Shu Ju, 1965), 262.

2. The story was originally recorded in the *Historical Annals* written by Sima Qian (born 145 B.C.). Scholars such as Berthold Laufer (*Oriental Theatricals* [Chicago: Field Museum of Natural History, 1923], 36), Genevieve Wimsatt (*Chinese Shadow Shows* [Cambridge: Harvard University Press, 1936], ix), and Lotte Reiniger (*Shadow Theatres and Shadow Film* [London: Batsford Ltd., 1970], 15), all point to it as the initial shadow "play."

3. Laufer, *Oriental Theatricals*, 37.

4. Sun, *Cangzhou ji*, 259–60.

5. As noted in ibid., 260–61.

6. Ibid., 259–60.

7. Ibid., 260–61.

8. Ibid., 272.

9. As mentioned in ibid., 267.

10. Zhou Mi, *Wulin jiu shi* (1280; reprinted in *Dongjing meng hua lu* [wai sizhong], Shanghai: Gudian Wenxue Chubanshe, 1956), 262.

11. In Wimsatt, *Chinese Shadow Shows*, 29, she relates a discussion with a shadow puppeteer, Mr. Li. According to him, "A shadow showman must have acquaintance with the Classics and familiarity with the history and traditions of China. That is the reason there are no women in this field. Women, having no education, cannot make a success in the work."

12. Laufer, *Oriental Theatricals*, 37–38.

13. Ibid., p. 38.

14. Sun, *Cangzhou ji*, 264.

15. Wimsatt, *Chinese Shadow Shows*, 27.

16. Ollie Blackham, *Shadow Puppets* (London: Barrie and Rockliff, 1960), 70.

17. As noted in Sun, *Cangzhou ji*, 263.

18. In *Chinese Puppet Theatre* (London: Faber and Faber, 1961), Sergei Obraztsou discusses possible influences the shadow theater may have had on aspects of the live theater.

19. Barrow calls the show he saw a pantomime, a term often applied to shadow theater in the eighteenth and nineteenth centuries in Europe. The scene he describes is also plausible in terms of the characters and monsters often portrayed in Chinese shadow theater. John Barrow, *Travels in China* (London: 1804), 203.

20. Sun, *Cangzhou ji*, 263.

21. Personal communication, August 1983.

22. Wimsatt, *Chinese Shadow Shows*, 33.

Embroidery

1. Youngyang Chung, "The Origins and Historical Development of the Embroidery of China, Japan, and Korea" (Ph.D. diss., New York University, 1976), 11.

2. Wu Shan, ed., *Zhongguo xinshiqi shidai taoqi zhuangshi yishu* (Chinese Neolithic pottery decorative art) (Beijing: Wenwu Chubanshe, 1982), 12.

3. Herrlee G. Creel, *The Birth of China* (New York: Reynal and Hitchcock, 1937), p. 88.

4. For a more in-depth explanation of the sericulture process, see William Willets, *Chinese Art* (London: Penguin Books, 1958), vol. 1, 207–30.

5. Chung, "Origins of Embroidery," 69.

6. Ibid., 76.

7. Ibid., 88.

8. Hunan Sheng Bowuguan (Hunan Province Museum), eds., *Mawangdui yihao Hanmu* (The number one Mawangdui Han tomb) (Beijing: Wenwu Chubanshe, 1973).

9. Willets, *Chinese Art,* 205.

10. Chung, "Origins of Embroidery," 104.

11. Youngyang Chung, *The Art of Oriental Embroidery* (New York: Charles Scribner's Sons, 1979), 12.

12. Chung, "Origins of Embroidery," 125.

13. Ibid., 126.

14. Ibid., 131.

15. Zhou Mi, *Wulin jiu shi* (1280; reprinted in *Dongjing meng hua lu (wai sizhong),* Shanghai: Gudian Wenxue Chubanshe, 1956).

16. The best description of the various stitches employed in Chinese embroidery is in the Appendix of Wang Yarong, *Zhongguo minjian cixiu* (Chinese folk embroidery) (Hong Kong: Shangwu Yinshuguan, 1985).

17. C. Schuster, "A Comparative Study of Motives in Western Chinese Fold Embroideries," *Monumenta Serica* 2 (1936–37), 21–80.

18. Mentioned in discussion in Hancheng, Shaanxi Province, August 1985.

Dye-Resist Printed Fabrics

1. Wu Ming, "Tulufan chutu de sizhiwuzhong de Tangdai yinran" (Tang dynasty printed and dyed works among silk textiles excavated at Turfan), *Wenwu* 10 (1973): 37–47.

2. Ibid.

3. Chen Weiji, ed., *Zhongguo fangzhi kexue jishushi* (The history of Chinese textile sciences) (Beijing: Kexue Chubanshe, 1984), 249.

4. Ibid.

5. Ibid., 250.

6. Ibid., 262.

7. Ibid.

8. Chu Nan, "Spinner and Weaver Huang Dao Po," *Departed But Not Forgotten* (Beijing: Women of China), 1984.

9. Shen Congwen, "Tan Ran Xie" (Talking about dyeing and tying), *Wenwu Cankao Ziliao* 9 (1958): 14.

10. Chen Weiji, *Zhongguo fangzhi,* 277.

11. Shen, "Tan Ran Xie," 15.

12. Ibid., 14.

13. In fact, similar dye-resist techniques were being utilized in glazing pottery during the Tang dynasty. After an underglaze had been applied and dried, designs were drawn onto the work with wax. Next, on top of this first glaze and the wax, a second coat of glaze would be applied, but it would not adhere to the areas covered with wax. The final result would be a two-colored design similar to the colored dye-resist silks of the same period.

14. Chen, *Zhongguo fangzhi,* 278.

15. Shen, "Tan Ran Xie," 15.

16. Ibid.

17. Chu, "Huang Dao Po."

18. Shen, "Tan Ran Xie," 14.

19. Ibid.

Woodblock Prints

1. For a discussion of the archeology of ancient China, see Chang Kwang-Chi, *Shang Archeology* (New Haven: Yale University Press, 1968).

2. See Zhang Wanfu, *Han hua xuan* (Selection of Han paintings) (Tianjin: Renmin Meishu Chubanshe, 1982).

3. Xing Runchuan, "The Invention and Development of Printing and Its Dissemination Abroad," in *Ancient China's Technology and Science* (Beijing: Foreign Languages Press, 1983), 383–91.

4. Wang Bomin, *Zhongguo banhua shi* (The history of Chinese block printing) (Hong Kong: Nantong Tushu Gongci, n.d).

5. Ibid., 11.

6. Jacques Gernet, *A History of Chinese Civilization,* trans. J. R. Foster (Cambridge: Cambridge University Press, 1982), 333.

7. Ibid., 295.

8. Xing, "Invention of Printing," 385.

9. Wang, *Zhongguo banhua shi,* 15.

10. Xing, "Invention of Printing," 384.

11. Ibid., 387.

12. Gernet, *History of Civilization,* 333.

13. Clarence Day, *Chinese Peasant Cults Being a Study of Chinese Paper Gods* (Shanghai: Kelly and Walsh, 1940), 5.

14. Ibid.

15. Bo Songnian, "Songdai Henan diqu minjian yishu" (Henan Region–Song dynasty folk art), *Meishu Yanjiu* (Art research) 2 (1984): 29–32.

16. Zhou Mi, *Wulin jiu shi* (1280; reprinted in *Dongjing meng hua lua (wai sizhong),* Shanghai: Gudian Wenxue Chubanshe, 1956).

17. Wang, *Zhongguo banhua shi,* 23.

18. Day, *Chinese Peasant Cults,* 5.

19. Ibid., 39.

20. The Communist government has always opposed superstitious activities, believing that they are unscientific and that they therefore retard society's progress. At different times, various gestures have been considered superstitious and banned. All Buddhist and Taoist temples were closed during the Cultural Revolution and many images of deities destroyed. Anyone attempting to engage in worship was punished. Door gods, kitchen gods, and similar deities were all considered superstitions, as were any symbol images other than those reflecting the Communist ideologies. Restrictions loosened considerably in the eighties.

21. Zhang, *Han hua xuan,* 90.

22. Day, *Chinese Peasant Cults,* 116.

23. Ibid.

24. Opera was popular among all sections of society. In the urban areas, wealthy families would hire troupes to perform in their homes. Less well-off peasants in the countryside would contribute to a fund to pay a troupe to perform their shows for the whole village, which would include acrobatics and martial arts as well as singing and acting.

25. Liu Ruli, *Taohuawu muban nianhua* (Taohuawu woodblock New Year's prints) (Shanghai: Renmin Meishu Chubanshe, 1961).

26. Wang Jindong, "Henansheng muban nianhua diaocha xiaoji" (A few notes on an investigation into Henan Province woodblock New Year's prints), *Meishu Yanjiu* 2 (1984): 23–24.

27. As the workers stated in discussions at the workshops, January 1985.

28. This is evidenced by the continued proliferation of such prints in peasants' homes today regardless of their political content.

29. Shirley Hsiao Ling Sun, "Lu Hsun and the Chinese Woodcut Movement: 1929–1936" (Ph.D. diss., Stanford University, 1974), 166.

30. Ibid.

31. Ibid., 156.

32. Ibid., 49.

33. As related to me by the husband of a worker in Weifang, September 1984.

34. Wang, *Zhongguo banhua shi,* 23.

35. In conversation, January 1985, in village between Zhengzhou and Kaifeng, Henan Province.

Folk Art Today

1. Sun Yatsen, known as Sun Zhongshan, was among those returning from abroad. Many books discuss the writings and eventual political movements that arose with such people's encouragement. For general background see Jacques Gernet, *A History of Chinese Civilization,* trans. J. R. Foster (Cambridge: Cambridge University Press, 1982), 645.

2. Translation printed in Clarence Day, *Chinese Peasant Cults Being a Study of Chinese Paper Gods* (Shanghai: Kelly and Walsh, 1940), 190.

3. See Jonathan Spence, *The Gates of Heavenly Peace* (New York: Viking Press, 1981).

4. Jiang Feng and Ai Qing together wrote a book publishing the papercuts they had collected. The first edition was of limited quantity, and it was reprinted in 1946 under the title *Collection of Papercuts from the Northwest* by Chen Guang Printing House in Shanghai. In the same year Ai Qing and Zhou Yang also wrote *Minjian yishu he yiren* (Folk art and artists), published by Xinhua Shudian.

5. See Mao Tse-tung, *Problems of Art and Literature* (New York: International Publishers, 1950), 27. "Literature and art are created for the workers, peasants and soldiers. Our primary duty to them is not to 'add flowers to the embroidery' but to 'send coal to the snowbound' . . . no art and literature is independent of politics."

6. In 1983, newspapers and magazines were still publishing articles complaining that abstract art was incomprehensible to the majority of people and therefore needn't be exhibited or created. By 1985, such guidelines were relaxed. Art schools began to allow their students to paint more expressionistically, and artists such as Robert Rauschenberg were showing their works at the National Gallery in Beijing.

7. Television, movies, and the live stage performed only these eight same stories over and over, certainly stifling the creative imaginations of those used to seeing and hearing the wealth of traditional stories and legends.

8. C. Schuster, "Peasant Embroideries of China," *Asia* 37 (1937): 28–31.

Glossary

Buddhism. The religion and philosophy based on the search for enlightenment and release from suffering through meditation; first propagated by the Sakyamuni Buddha. Though it originated in India, Buddhism spread rapidly in China after its introduction there at the end of the Han dynasty. Since then, many schools of thought have developed, ranging from the esoteric — encouraging celibacy, meditation, and even vows of silence — to popular cults in which devotees could make offerings to deities, such as Guanyin, in hope of receiving sons or prosperity in return. With so many varieties of schools, the religion was able to make inroads in many levels of society. It influenced China's elite culture and thought as well as that of the folk sector, and had a great impact on aesthetics and architecture.

chan. Legendary toad with three legs that spits gold coins; companion of Liu Hai, the Living God of Wealth.

chou. The clown or jokester of the four character types in Chinese opera and shadow theater.

chuanghua. "Window flowers," a term for papercuts that are commonly pasted on windows.

Confucianism. A philosophy-religion, based originally on the writings of Confucius (Kongzi, c. 551–479 B.C.) and his disciples. Confucius modeled his philosophy of statehood on that of the early Zhou dynasty. Harmony in the land was dependent on respect for the hierarchy. Subjects were to respect the emperor, sons respect their fa-

thers, and wives respect their husbands. The importance of filial piety (respect for one's parents) was essential in Confucianism. The Confucian philosophy was debated and discussed at many times in history, resulting in new interpretations and uses of the thought system. A religion of sorts developed around the cult (though Confucius himself did not encourage the worship of spirits), and most towns in China, until 1949, had Confucian temples, primarily used by officials and scholars.

dan. The female character role in Chinese opera and shadow theater.

doudou. A child's apron, often lavishly embroidered by mothers.

dui lian. Red strips of paper inscribed with poems that are hung on doorways for good luck.

feng huang. The mythical phoenix, whose appearance was said to speak well of the current ruler. The male of the species is *feng*, the female *huang*.

fu. The word for blessings and fortune, it is also a homonym with the word for bat; the animal has come to represent the concept of luck in folk art.

guan. Official, and a homonym with the word for grasshopper, *guanr-guanr*, which has come to represent rising to a high rank in government.

guaqian. Papercuts hung in a series from the top of a doorway at New Year's time. (Also known as *menqian*.)

gui. A spirit, ghost, or monster in the Chinese underworld.

jiaran. A dye-resist patterning technique. The material is placed between two identical stencils; bean paste is then applied on both sides, so that the design appears on both the front and the back of the material.

jiangran. A dye-resist technique in which a bean paste is applied to the material to resist the dye.

jing. The military character in Chinese opera or shadow theater, whose face is painted.

kang. An oven-bed, made of bricks with flues from the oven running it to keep the family warm while sleeping or doing routine activities. In the winter, as many tasks as possible are done sitting on the *kang.*

lu. An official's salary, also a homonym with the word for deer. Thus the animal has come to symbolize the hope of rising to the rank of an official and being able to receive an official's salary.

nianhua. Woodblock-printed New Year's pictures.

piying. Leather shadows, shadow puppets.

qianghua. Papercuts decorating walls.

qilin. A legendary creature said to bring childless families sons who will become officials.

sheng. The noble, upright character role of the Chinese opera and shadow theater.

shou. Longevity.

Taoism. A belief system and a philosophy. The philosophy is based on the teachings of Lao Zi (though whether he was a real person has yet to be determined), of the fifth century B.C., and Zhuangzi, of the fourth century B.C. The indigenous religion of the common people, exclusive of Confucianism and Buddhism, is also referred to as Taoism. It includes a large pantheon of deities and spirits as well as malicious forces that can bring happiness or disaster to mortals. In practice and belief, this system differs greatly from the philosophical Taoism, which encourages retreat from the world and society.

wan. A character, similar to a backward swastika, that is an ancient form dating back to Neolithic times and is also a Buddhist symbol. *Wan* literally means "ten thousand" in Chinese and has come to represent immortality in folk art.

xi or *xi xi.* Meaning "happiness" or "double happiness," this character is often used to decorate objects for weddings.

yin/yang. A polarity; the constant interchanging of the *yin* and the *yang* is necessary for all life to exist. *Yin* is the negative, dark, female aspect of all things, *yang* the positive, aggressive, light aspect.

Bibliography

Works in English

Alexeiev, Basil M. *The Chinese Gods of Wealth.* London: The China Society, 1928.

Barrow, John. *Travels in China.* London: T. Cadell and W. Davies, 1804.

Blackham, Ollie. *Shadow Puppets.* London: Barrie and Rockliff, 1960.

Bordat, Denis. *Les theatres d'ombres.* Paris: L'Arche, 1958.

Cammann, S. "Embroidery Techniques in Old China." *Archives of the Chinese Art Society of America* 16 (1962): 16–40.

Chai, Fei. *Indigo Prints of China.* Beijing: Foreign Languages Press, 1956.

Chavannes, Edouard. *The Five Happinesses: Symbolism in Chinese Popular Art.* Trans. Elaine S. Atwood. New York and Tokyo: Weatherhill, 1973.

Chen, Jack. *Folk Arts of New China.* Beijing: Foreign Languages Press, 1954.

Chu Nan. "Spinner and Weaver Huang Dao Po." Chap. 4 in *Departed But Not Forgotten.* Beijing: Women of China, 1984.

Chung, Youngyang. *The Art of Oriental Embroidery.* New York: Charles Scribner's Sons, 1979.

———. "The Origins and Historical Development of the Embroidery of China, Japan, and Korea." Ph.D. diss., New York University, 1976.

Day, Clarence. *Chinese Peasant Cults Being a Study of Chinese Paper Gods.* Shanghai: Kelly and Walsh, 1940.

———. "The Cult of the Hearth." *China Journal* 10 (1929): 6–11.

———. "Paper Gods for Sale." *China Journal* 7 (1927): 277–84.

de Groot, J. J. M. *The Religious System of China.* Leyden: E. J. Brill, 1892.

Dore, Henry. *Researches into Chinese Superstitions.* 8 vols. Shanghai: Tusewe Printing Press, 1914.

Ecke, Tseng Yu-ho. *Chinese Folk Art II in American Collections.* Honolulu: University Press of Hawaii, 1977.

Gamble, Sidney D. *Chinese Folk Plays from the Ting Hsien Region.* Amsterdam: Philo Press, 1970.

Gernet, Jacques. *A History of Chinese Civilization.* Trans. J. R. Foster. Cambridge: Cambridge University Press, 1982.

Gilman, R. "Folk Embroideries." *Art News* 33 (1935): 13.

Granger, A. G. "Rescuing a Little Known Chinese Art." *Natural History* 41 (1938): 52–61.

Hawley, William. *Chinese Folk Design.* Hollywood, Calif.: 1949.

Institute of History of Natural Sciences and Chinese Academy of Sciences, comp. *Ancient China's Technology and Science.* Beijing: Foreign Languages Press, 1983.

Jiang Feng. *Yan'an Papercuts*. Beijing: People's Fine Art Publishing House, n.d.

Koehn, Alfred. *Filial Devotion in China*. Beijing: At the Lotus Court, 1943.

———. "Harbingers of Happiness: The Door Gods of China." *Monumenta Nipponica* 10 (1954): 81–106.

Kuo, Nancy. *Chinese Papercut Pictures: Old and Modern*. London: Tiranti, 1964.

Laufer, Berthold. *Oriental Theatricals*. Chicago: Field Museum of Natural History, 1923.

Liu Guojun. *The Story of Chinese Books*. Beijing: Foreign Languages Press, 1985.

Obraztsou, Sergei. *Chinese Puppet Theatre*. London: Faber and Faber, 1961.

Pruitt, Ida. *Old Madam Yin*. Stanford: Stanford University Press, 1979.

Reiniger, Lotte. *Shadow Theatres and Shadow Film*. London: Batsford Ltd., 1970.

Schuster, C. "A Comparative Study of Motives in Western Chinese Fold Embroideries." *Monumenta Serica* 2 (1936–37): 21–80.

———. "Peasant Embroideries of China." *Asia* 37 (1937): 28–31.

Sowerby, Arthur de Carle. *Nature in Chinese Art*. New York: John Day, 1940.

Stalberg, Roberta Helmer. *China's Puppets*. San Francisco: China Books, 1984.

Stevens, Keith G. "Chinese Miniature Silver Deities." *Arts of Asia* 1 (1981): 91–95.

Sun, Shirley Hsiao Ling. "Lu Hsun and the Chinese Woodcut Movement: 1929–1936." Ph.D. diss., Stanford University, 1974.

Swiderski, Richard M. "The Aesthetics of a Contemporary Chinese Shadow Theater." *Asian Folklore Studies* 43 (1984): 261–73.

Temko, Florence. *Chinese Paper Cuts*. San Francisco: China Books, 1982.

University of California at Los Angeles Museum of Cultural History. *Asian Puppets, Wall of the World*. Los Angeles: University of California at Los Angeles Museum of Cultural History, 1976.

Willets, William. *Chinese Art*. 2 vols. London: Penguin Books, 1958.

Williams, C. A. S. *Outlines of Chinese Symbolism*. 1931. Reprint (as *Outlines of Chinese Symbolism and Art Motives*). New York: Dover Publications, 1976.

Wimsatt, Genevieve. *Chinese Shadow Shows*. Cambridge: Harvard University Press, 1936.

Yang, C. K. *Religion in Chinese Society*. Berkeley: University of California Press, 1961.

Works in Chinese

Ah Wei. *Piying xi* (Shadow puppet theater). Beijing: Chao Hua Meishu Chubanshe, 1955.
阿维　皮影戏，北京朝花美术出版社。

Ai Qing. *Minjian yishu he yiren* (Folk art and artists). Xinhua Shudian, 1946.
艾青　民间艺术和艺人，新华书店。

Bai xiao tu shuo (One Hundred Filial Pieties' Pictures and Stories). Beijing: He Ji Yin Shu Guan, 1937.
百孝图说　北京和记印书馆。

Bao Jiahu. "Minjian zhi hu" (Folk tigers). *Minjian Gongyi* (Folk crafts) 1 (1984): 50–51.
鲍家虎　民艺之虎，民间工艺。

Beijing Fangzhi Kexue Yanjiusuo (Beijing Research Institute of Textile Science), ed. *Zhongguo gudai tu'an* (Chinese ancient designs). Beijing: Renmin Meishu Chubanshe, 1979.
北京纺织科学研究所　中国古代图案，北京人民美术出版社。

Bo Songnian. "Songdai Henan diqu minjian yishu" (Henan region Song dynasty folk art). *Meishu Yanjiu* (Art research) 2 (1984): 29–32.
薄松年　宋代河南地区民间艺术，美术研究

Cheng Zheng. "Jianzhi de yishu yuyan" (Papercut's art language). *Minjian Gongyi* 1 (1984): 52–56.
程征　剪纸的艺术语言，民间工艺。

Chen Qilu. *Yang Liu Qing ban hua* (Yang Liu Qing woodblock prints). Taibei: Xiong Shi Tushu Youxian Gongci, 1976.
陈奇禄　杨柳青版画，台北，雄狮图书有限公司。

Chen Suliang. *Chuanghua* (Window flowers). Gao Yuan Shudian, 1947.

陈叔亮　窗花，高原书店。

Chen Weiji, ed. *Zhongguo fangzhi kexue jishushi* (The history of Chinese textile sciences). Beijing: Kexue Chubanshe, 1984.
陈维稷，中国纺织科学技术史，北京科学出版社。

Chen Yuyin. "Suzhou Taohuawu muban nianhua de yishu qiji ying xiang" (Suzhou's Taohuawu woodblock New Year's prints and other impressions). *Wenwu* (Cultural relics) 2 (1960): 31–36.
陈玉寅　苏州，桃花坞木版年画的艺术及其影响，文物杂志。

Deng Yu. *Sichuan minjian tiaohua tu'an* (Sichuan folk embroidery designs). Chongqing: Chongqing Chubanshe, 1984.
邓敔　四川民间挑花图案，重庆，重庆出版社。

Gao Cheng. *Shi wu ji yuan*. 1078–1095. Reprint. Taibei: Shangwu Chubanshe, 1982.
高承　事物记源，台北，商务出版社。

Huang Jun. *Shinu hua de yanjiu* (Research on paintings of women). Beijing: Beijingshi Gongyi Meishu Yanjiu Suo, 1982.
黄均　仕女画的研究，北京，北京市工艺美术研究所。

Huang Ke. "Zhongguo chuantong minjian nianhua jian" (A brief on traditional Chinese New Year prints). *Meishujia* 30 (1983): 57.
黄可　中国传统民间年画笺，美术家。

Huang Xinkang. *Shaannan tiaohua* (Southern Shaanxi Province embroidery). Xian: Shaanxi Renmin Meishu Chubanshe, 1982.
黄钦康　陕南挑花，西安，陕西人民美术出版社。

Hu Wanxiang. *Huang Kaotian jianzhi jifa* (Huang Kaotian's papercutting techniques). Changsha: Hunan Meishu Chubanshe, 1982.
胡万卿、黄辈天　剪纸技法，长沙，湖南美术出版社。

Jie Yanfeng. "Gaomi minjian chuantong jianzhi" (Gaomi traditional folk papercuts). *Meishu* (Art) 4 (1983): 17–22.
焦岩峰　高密民间传统剪纸，美术。

Lin Hanjie. *Minjian lan yin huabu tuan* (Folk blue-printed cloth pictures). Beijing: Renmin Meishu Chubanshe, 1953.
林汉杰　民间蓝印花布图案，北京，人民美术出版社。

Li Shuzhi. "Weixian muban nianhua shiliao shiling" (Historical data on Wei County New Year's woodblock prints). *Meishu Yanjiu* 2 (1984): 17–22.
李述之　维县木版年画史料拾零，美术研究。

Liu Dangui. *Sichuan piying* (Sichuan shadow theater). Chengdu: Sichuan Renmin Chubanshe, 1983.
刘丹桂　四川皮影，成都，四川人民出版社。

Mao Benhua. "Tongbo piying zaoxing" (The forms of Tongbo shadow puppets). *Meishu Yanjiu* 2 (1984): 25–28.
毛本华　桐柏皮影造形，美术研究。

Meng Yuanlao. *Dongjing meng hua lu (wai si-zhong)* (My dream memories of the former capital Bian-Liang). (Includes *Wulin jiu shi* and other Song dynasty books.) 1147. Reprint. Shanghai: Gudian Wenxue Chubanshe, 1956.
孟元老　东京梦华录，〈外四种〉，上海，古典文学出版社。

Ming Chen Hongshou shui hu ye zi. (*Ming Chen Hongshou Water Margin* cards). 1657. Reprint. Shanghai: Renmin Meishu Chubanshe, 1979.
明陈洪授水浒叶了，上海，人民美术出版社。

"Shaanxi Huangling minjian jianzhi zuozhe de hua" (Shaanxi Province, Huangling County's folk papercutters' words). *Meishu* 8 (1982): 41–43.
陕西黄陵民间作者的话，美术杂志。

Shanghaishi Xiqu Xuexiao Zhongguo Fuzhuangshi Yanjiuzu (History of Chinese Clothing Research Group of the Shanghai Traditional Opera School). *Zhongguo lidai fuzhuang* (Chinese clothing and adornment in various dynasties). Shanghai: Xuelin Chubanshe, 1984.
上海市戏曲学校中国服装史研究组，中国历代服装，上海，学林出版社。

Shen Congwen. "Landi baibu de lishi fa-zhan" (The history and development of blue and white cotton textile). *Wenwu Cankao Ziliao* (Cultural Relics Reference Materials) 9 (1958): 15–18.
沈从文　蓝地白布的历史发展，文物参考资料。

Shi Wenying. *Zhongguo jianzhi zhi xingshi ji yanbian yanjiu* (Chinese papercut forms and development research). Taibei: Zhongguo Wenhua Xueyuan, 1977.
施文英　中国剪纸之形式及演变研究，台北，中国文化学院。

Song Yingxing. *Tian gong kai wu* (Manifestations of nature's work). Reprint. Taibei: Shangwu Yinshuguan, 1967.
宋应星　天工开物，台北商务印书馆。

Sun Kaidi. *Cangzhou ji* (Cangzhou collection). Beijing: Zhong Hua Shu Ju, 1965.
孙揩弟　沧州记，北京中华书局。

Teng Fengqian. *Minjian jianzhi chuantong zhuti wenyang yu "wuhoulifa"* (Folk papercut's traditional thematic patterns and "nature's calendar method"). Beijing: Zhongyang Gongyi Meishu Xueyuan, 1983.
风谦　民间剪纸传统主体文纹与物候历法，北京，中央工艺美术学院。

Wang Bomin. *Zhongguo banhuashi* (The history of Chinese block printing). Hong Kong: Nantong Tushu Gongci, n.d.
王伯敏　中国版画史，香港，南通图书公司。

Wang Jindong. "Henansheng muban nianhua diaocha xiaoji" (A few notes on an investigation into Henan Province woodblock New Year prints). *Meishu Yanjiu* 2 (1984): 23–24.
王金栋　河南省木版年画调查小记，美术研究。

Wang Qian and Li Fan. *Xin jianzhi yishu* (New papercut art). Hong Kong: Hongtian Chubanshe, 1949.
王谦、李凡　新剪纸艺术，香港，红田出版社。

Wang Shucun. "Qiantan Shaanxi menshen, nianhua, wanju gushi santi" (A shallow talk on three story topics of Shaanxi Province door gods, New Year prints, and toys). *Zhuangshi* (Decoration) 4 (1982): 4–5.

王树村　浅谈陕西门神年画，玩具故事三题。装饰杂志。

———. "Zhongguo xiqu hua" (Chinese opera pictures). *Meishujia* 30 (1983): 50–57.
王树村　中国戏曲画，美术家。

Wang Yarong. *Zhongguo minjian cixiu* (Chinese folk embroidery). Hong Kong: Shangwu Yinshu Guan, 1985.
王亚蓉　中国民间刺绣，香港，商务印书馆。

Wu Bingan. *Minsuxue conghua* (Collected notes on the study of folk customs). Shanghai: Wenyi Chubanshe, 1982.
乌丙安　民俗学丛话，上海，文艺出版社。

Wu Min. "Tulufan chutu de sizhiwuzhong de Tangdai yinran" (Tang dynasty printed and dyed works among silk textiles excavated at Turfan). *Wenwu* 10 (1973): 37–47.
武敏　土鲁番出土的丝织物中的唐代印染，文物杂志。

Wu Shan, ed. *Zhongguo xinshiqi shidai taoqi zhuangshi yishu* (Chinese Neolithic pottery decorative art). Beijing: Wenwu Chubanshe, 1982.
吴山　中国新石器时代陶器装饰艺术，北京，文物出版社。

Wu Youru hua bao (Treasures of Wu Youru's paintings). Shanghai: Zhonghua Tushuguan, 1916.
吴友如画宝　上海，中华图书馆。

Xinjiang Weiwuerzu Zizhiqu Bowugan (Xinjiang Uighur Autonomous Region Museum). "Xinjiang Tulufan Asitana Beichumuqun fajue jianbao" (Xinjiang fragments excavated in Asitana at Turfan). *Wenwu* 6 (1960): 13–21.

Xinjiang Zizhiqu Bowuguan (Xinjiang Autonomous Region Museum). "Tulufan xian Asitana-Halahezhuo gumu chongqingli jianbao" (Report on the ancient tombs in Turfan County Asitana-Halahezhuo). *Wenwu* 1 (1972): 8–29.
新疆自治区博物馆土鲁番县阿斯塔那哈拉和卓古墓群清理简报，文物杂志。

Xue Yonglu. "Huang Ling minjian jianzhi" (Huang Ling folk papercuts). *Meishu* 8 (1982): 50.
薛永录　黄陵民间剪纸，美术杂志。

Xu Yunbei. "Fazhan minjian gongyi meishu shiye" (The cause of developing folk arts and crafts). *Minjian Gongyi* 2 (1984): 82–86.
徐运北　发展民间工艺美术事业，民间工艺。

Yuan Ke. *Zhongguo shenhua chuanshuo* (Chinese traditional myths). 2 vols. Beijing: Zhongguo Minjian Wenyi Chubanshe, 1984.
袁柯　中国神话传说，北京，中国民间文艺出版社。

Ye Youxin. "Shandong minjian gongyi meishu de yishu tese" (The special characteristics of Shandong folk arts and crafts). *Meishujia* (Artist) 30 (1983): 58–63.
叶又新　山东民间工艺美术的艺术特色，美术家。

Zhang Daoyi. *Zhongguo minjian jianzhi* (Chinese folk papercuts). Beijing: Jinling Shuhuashe, 1980.
张道一　中国民间剪纸，南京，金陵书画社。

Zhang Wanfu. *Han hua xuan* (Selection of Han paintings). Tianjin: Renmin Meishu Chubanshe, 1982.
张万夫　汉画选，天津，人民美术出版社。

Zhang Wei. "Shaanxi piying" (Shaanxi Province shadow puppets). *Zhuangshi* 4 (1982): 7.
张维　陕西皮影，装饰。

Zhang Yingxue. *Yangliuqing nianhua* (Yangliuqing New Year's pictures). Beijing: Wenwu Chubanshe, 1984.
张映雪　杨柳青年画，北京文物出版社。

Zhou Mi. *Wulin jiu shi*. 1280. Reprint included in *Dongjing meng hua lu*. Shanghai: Gudian Wenxue Chubanshe, 1956.
周密　武林旧事，上海，古典文学出版社。

Zhou Wu. *Zhongguo gudai banhua baitu* (One hundred pictures of Chinese ancient woodblock prints). Beijing: Renmin Meishu Chubanshe, 1982.
周芜　中国古代版画百图，北京，人民美术出版社。

Illustration Sources

The following images originally appeared in different works (please see Bibliography for complete publication data):

Figure 157 (page 158) and Figure 198 (page 202) in *Ming Chen Hongshou shui hu ye zi*, a Ming dynasty book of illustrations reprinted in 1979.

Figure 28 (page 45), Figure 67 (page 81), Figure 163 (page 164), and Figure 194 (page 198) in *Wu Youru hua bao*, 1916.

Figure 80 (page 93) in Beijing Fangshi Kexue Yanjiusuo, ed., *Zhongguo gudai tuan*, 1979.

Figure 131 (page 133), an eighteenth- or nineteenth-century etching, in Denis Bordat, *Les theatres d'ombres*, 1958. Reprinted by permission of L'Arche Presse, Paris.

Figure 197 (page 201), a twelfth-century woodblock print, in Zhou Wu, *Zhongguo gudai banhua baitu*, 1982.

Figure 218 (page 228), Figure 220 (page 230), and Figure 221 (page 231) in Jiang Feng, *Yan'an Papercuts*, n.d.

Figure 222 (page 231) in Jack Chen, *Folk Arts of New China*, 1954. Reprinted by permission of Foreign Languages Press, Beijing.

Figure 219 (page 229) in Wang Qian and Li Fan, *Xin jianzhi yishu*, 1949.

Figure 179 (page 182), Figure 182 (page 185), and Figure 183 (page 185) in Chen Weiji, ed., *Zhongguo fangzhi kexue jishushi*, 1984.

Figure 79 (page 92) and Figure 90 (page 100) have been published in *Craft Magazine*.

A photograph of Figure 141 (page 141) was published in the April 1986 issue of *Orientations* magazine.

Figure 87 (page 98) in *Wenru* 6 (1960), 19.

Figure 139 and Figure 140 (page 143) reproduced by permission of Louise and Peter Rosenberg.

Figure 137 (page 138), Figure 138 (page 139), and Figure 169 (page 170) reproduced from original drawings by Zeng Xiaojun.

Figure 216 (page 226), Figure 225 (page 234), and Figure 226 (page 234) are photographs by Nancy Berliner.

Figure 207 (page 210) and Figure 208 (page 212) reproduced courtesy of The Harvard University Art Museums (The Arthur M. Sackler Museum). Gift of Langdon Warner.

Index

References to illustrations are printed in boldface type.